MARK ROTHKO

Mark Rothko

Toward the Light in the Chapel

———◆◗◆◗◆———

ANNIE COHEN-SOLAL

Yale

UNIVERSITY

PRESS

New Haven and London

Yale University Press books may be purchased in quantity for educational,
business, or promotional use. For information, please e-mail sales.press@yale.edu
(U.S. office) or sales@yaleup.co.uk (U.K. office).

Set in Janson Oldstyle type by Integrated Publishing Solutions.
Printed in the United States of America.

Library of Congress Cataloging-in-Publication Data
Cohen-Solal, Annie, 1948–
[Mark Rothko. English]
Mark Rothko : toward the light in the chapel / Annie Cohen-Solal.
pages cm. — (Jewish lives)
First published in French as Mark Rothko by Actes Sud (Arles, France, 2013).
Includes bibliographical references and index.
ISBN 978-0-300-18204-0 (hardback)
1. Rothko, Mark, 1903-1970. 2. Painters—United States—Biography. I. Title.
ND237.R725C6413 2015
759.13—dc23
2014037767

A catalogue record for this book is available from the British Library.

This paper meets the requirements of ANSI/NISO Z39.48-1992
(Permanence of Paper).

10 9 8 7 6 5 4 3 2 1

for Archie

CONTENTS

Author's Note, ix

Color illustrations follow page 86

AUTHOR'S NOTE

WHEN I began my research, the existing bibliography on Mark Rothko was sparse, consisting mostly of James E. B. Breslin's biography dating from 1993—an undeniable starting point—and many interesting exhibition catalogues. I was particularly lucky, though, to benefit from the voice of Rothko himself thanks to the recent publication of two major books: *The Artist's Reality*—the manuscript he wrote in 1940, which was transcribed and introduced by the artist's son, Christopher—and *Writings on Art*—the artist's correspondence and notes from the years 1934 to 1969. As for Rothko's paintings, David Anfam's catalogue raisonné, *Mark Rothko: The Works on Canvas*, which wasn't published until 1998, became an essential document. In navigating through these and many other diverse sources, my personal perspective on Rothko evolved as I investigated how young Marcus Rotkovitch, as a cultural agent crossing geographic boundaries, managed to shape the intellectual and

cultural landscape of the United States in a truly pioneering way and how, in turn, the experiences of displacement, migration, and exile influenced his artistic production. In writing this book, I hope to stimulate a conversation that will yield more focused considerations of his work and create a special space to contemplate the themes and strategies that converge in his oeuvre—personal and professional relationships, life and work, thematic transpositions across disciplines and interests. All of the important documents and many academic studies, exhibition catalogues, catalogues raisonnés, oral interviews, and other materials (all cited in the bibliography) have been gathered and presented with this migratory force and transposition of thought in mind. Lacking this comprehensive context, the construction of a monograph in the frame of the Jewish Lives series would have been impossible.

1

The Charismatic Yacov Rotkovitch—
A Jew of the Empire: 1903–1913

We should think about late imperial Russian Jewry
not only as more Russian and more imperial than
previously thought, but also as enthusiastic partici-
pants in the life of a modern society that afforded
them the possibility of a 'vibrant cultural life'.
—Kenneth B. Moss

On September 25, 1903, Marcus Rotkovitch was born in
Dvinsk, a northwestern city of the Russian Empire, the fourth
child of Yacov Rotkovitch, a local pharmacist, and his wife,
Anna Goldin. Forty years later, in New York City, Marcus
would choose to become Mark Rothko, the name by which he is
known today. While, in 1903, the birth of the youngest child of
this bourgeois family was greeted with joy by his older siblings
—Sonia, thirteen; Moses, ten; and Albert, eight—the celebra-
tion was tempered by their father's growing anxiety about the

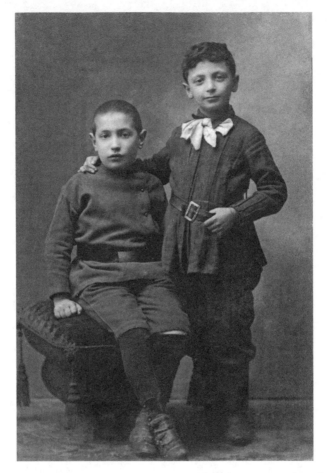

Marcus Rotkovitch (seated), four years old, with a cousin in Dvinsk,
c. 1907 (Unknown photographer. Copyright © 2013 Kate Rothko Prizel
and Christopher Rothko)

current political situation. A horrendous massacre of Jews that
had taken place five months earlier in Kishinev—yet another
symptom of the explosive situation in czarist Russia—certainly
foreshadowed the fate of Jewish families living within the Pale
of Settlement.

This territory had been established by the Empress Cath-

erine II a little more than a century earlier, following claims from Muscovite merchants against the many Jewish dealers, "known for their deceit and lies," who had recently settled in Belorussia.[1] "Jews in Russia are compelled by law," the sovereign stated in 1791, "to reside inside the Pale of Settlement, or the territory comprising some fifteen governments, or provinces, of western and southern Russia, extending south from the coast of the southern Baltic to the Crimea, and westward from Charkov and Smolensk to the borders of Roumania, Galicia, and Prussian Poland."[2] The five million Jewish subjects of this area the size of Texas—a small minority of the total population[3]—would sporadically be excluded from property ownership in the shtetls[4] from the 1880s, with these regulations frequently circumvented by bribery and the like.

On Sunday, April 19, 1903, the first evening of Russian Easter, the Jewish population of Kishinev (today Chişinău, the capital of Moldova) fell prey to a pogrom of unprecedented scale. In the Pale of Settlement, news of the Kishinev massacre spread like wildfire. Many writers, Jews and non-Jews alike, including Tolstoy and Gorky, rallied to oppose what they saw as a point of no return. And even Trotsky—who, in London with Lenin, was immersed in the creation of the social democratic congress—expressed his deep concern. While recalling "the acute impression of the Kishinev events" in the June issue of *Iskra* magazine, the Marxist theorist set out to expose "the deluge of monstrous rumors spread by the police"[5] in the wake of the slaughter. But we owe to the poet Hayyim Nahman Bialik, sent by the Jewish Historical Commission to investigate the pogrom, the most stirring account of this tragedy in his epic poem *The City of Slaughter*. The *New York Times* reported the following week that "the anti-Jewish riots in Kishinev, Bessarabia, are worse than the censor will permit to publish," calling them a "well laid-out plan for the general massacre of Jews on the day following the Russian Easter." That evening, the

article described, "the mob was led by priests, and the general cry, 'Kill the Jews,' was taken-up all over the city. The Jews were taken wholly unaware and were slaughtered like sheep. . . . Babies were literally torn to pieces by the frenzied and bloodthirsty mob." "The local police," the newspaper insisted, "made no attempt to check the reign of terror. At sunset the streets were piled with corpses and wounded."[6]

In fact, the Kishinev pogrom culminated a century of tensions, persecutions, and latent hostility against the Jewish population confined to the Pale of Settlement. Such escalation was evidenced in the complicity between Vyacheslav Plehve, the minister of the interior, and Pavel Krushevan, the editor in chief of the local newspaper, *Bessarabets*, whose repeated insults —"Death to the Jews!" "Crusade against the dishonorable race!"—and accusations of conspiracy against the Empire certainly stirred, according to Karl Schmidt, the city's mayor, antisemitism among the Russian population. Soon after the massacre, it was revealed that the newspaper was being funded by the minister himself. For quite some time, jealous craftsmen and hostile civil servants had grown increasingly antagonistic toward Jews. When, in April 1903, Kishinev's Jewish population was unfairly accused of murdering Christian children and using their blood "for ritual purposes," injustice was at its highest, paving the way to the ensuing pogrom.[7] But how did the Kishinev massacre affect a family such as the Rotkovitches, living in such a different cultural environment and, especially, hundreds of miles away? Did they react to it in any way? Did they feel directly threatened? In the archives, no such evidence has been found. The following pages will focus on Yacov, a charismatic Jew of the empire, and the father of this enlightened family.

For more than a century already, throughout the reigns of Czars Alexander I and Nicholas I, Jewish citizens had suffered the consequences of unfair laws, including the conscrip-

tion policy established by the former in 1827, which forced Jewish boys and men between the ages of twelve and twenty-five to abjure their religion and join the army for a minimum of twenty-five years. Partially excluded from both the rural and the urban economy, Jews often turned to small and basic craftsmanship in the shtetls, where life was centered on the market and synagogue. In 1855, the accession of Czar Alexander II brought almost immediate relief to the Jewish subjects, giving them a ray of hope that would last for a quarter of a century, until 1881.

It was during this period, in 1859, that Yacov Rotkovitch, father of the future Mark Rothko, was born in Michalishek (known today as Mikoliskis, Lithuania), a shtetl of 250 families located in the northern part of the Pale. Through perseverance and determination, exploiting all available assets of his time, Yacov managed to attend university in Vilnius (Vilna) and become a pharmacist. Later in life, he found himself in Saint Petersburg, where he met Anna Goldin, eleven years his junior. A German speaker, she also belonged to a rare group of Jewish families who, being deemed "useful" to the Empire, benefited from the czar's liberal policies: for them, exclusively, were lifted restrictions to schooling, professional advancement, and employment in government positions, and they were also granted the right to reside in cities such as Saint Petersburg and Moscow. Politically, Imperial Russia did not grant equal rights for all: until 1917, legal distinctions continued to exist between nobility, merchants, and peasants, and hence the special regulations for Jews remained part of this larger legal framework.[8] Anna was only sixteen when she married Yacov, but her status allowed him to pursue his strategy of social ascension. This period of calm, however, was short-lived: the recent emancipation of some Jewish citizens, which gave them conditional access to professional bodies, rekindled tensions and jealousy among the Russian population. The czar's assassination in 1881

provided a new opportunity to scapegoat Jews, and a new wave of violence ensued. In May 1882, on the assumption that the riots were the by-product of Jewish economic exploitation of the peasantry, new restrictive laws were instituted. They included shrinking the Pale of Settlement and imposing quotas on secondary education for Jewish males, etc. . . . In the final years of the nineteenth century—with a 150 percent increase in population in the Pale between 1820 and 1880—poverty was on the rise, so much so that the Jewish subjects, left with no hope, started leaving their own country. Displaced according to the vagaries of the Russian Empire's changing policies, the Rotkovitches eventually settled in Mishalishek, the very shtetl where Yacov was born; it was there that Yacov and Anna saw the birth of their first children: Sonia in 1890 and Moses in 1892. Two years later, the family moved to Dvinsk, a large city of the Russian Empire's Baltic governorates, twenty-five miles northeast of Mishalishek, where Albert was born in 1895, followed by Marcus in 1903.

Protected by its fortified walls, and overlooking the Dvina (Dauga) River, Dvinsk thrived as a city of seventy-five thousand inhabitants. It was at the crossroads of three railway lines, connecting it to Saint Petersburg (to the northeast), Riga (to the northwest), and Libau ([Liepaja] to the east)—an ideal geographic situation—and was marked by its three massive train stations. Travelers took advantage of Dvinsk's dynamism as a major trading hub en route from the Baltic Sea to the Gulf of Finland and Moscow, including its biweekly market where country folk sold vegetables, cheeses, chickens, and fish from their wooden carts. Entirely devoted to commerce, Dvinsk could boast, in 1912, more than six thousand workers and a hundred industries specializing in textiles, leather, watchmaking, and building materials. No wonder, then, that its population doubled between 1905 and 1913, thereby reflecting its rise as one of the most politically active cities within the Pale of

Settlement at the turn of the twentieth century. In Dvinsk's old park, rallies by social democrats followed demonstrations by revolutionaries and speeches by Bundists or representatives of various Zionist organizations.

Little is known about Yacov Rotkovitch. The few photos of him depict a serious-looking intellectual, with a large forehead, a carefully trimmed dark beard, and little wire-rimmed glasses. We are told that he was a voracious reader, as were his wife and children; that their library contained more than three hundred volumes; and that, another revealing sign of their status, they spoke Russian at home. The people of Dvinsk greatly appreciated the free-spirited pharmacist, and not just because of the remedies he provided them. His natural ability as a writer turned him into a sort of public scrivener in the city, a mentor who wrote letters and supplications on people's behalf. The popular and charismatic pharmacist, whose languages included Hebrew and German, has also been described as an "idealist" who volunteered at the hospital, as well as a politically radical man who favored progressive ideas and who closely followed the peaceful demonstrations held in the city. As to his wife, Anna, photos of her show an elegant and dignified woman in white-collared dresses. A "very secular" person, according to her granddaughter Kate, she is also remembered as "a power-house" and "the most cheerful member of the family" by her great-granddaughter Debby.[9]

The Russian Empire of Marcus Rotkovitch's childhood was a troubled one, destabilized by both an economic crisis and the constitutional crisis of 1905. With a widespread sense of chaos among the population, antisemitism resurfaced, along with many hundreds of pogroms taking place in 1905 and 1906. Antisemitism, espoused by numerous newspapers and rekindled by the Black Hundreds militia, again struck the Jewish population, particularly revolutionaries and students, causing a thousand deaths and wounding several thousand in more than three

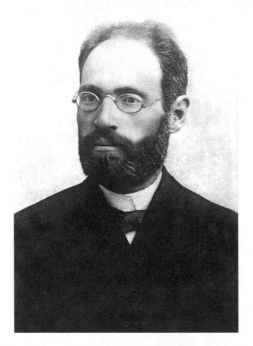

Yacov Rotkovitch, 1913 (Unknown photographer. Copyright © 2013
Kate Rothko Prizel and Christopher Rothko)

hundred cities.[10] On learning that czarist troops had slain 130
peaceful demonstrators in Saint Petersburg on January 9 (New
Style date: January 22), 1905—a tragedy known since as Bloody
Sunday—socialist sympathizers, particularly among the Jewish
population, turned to collective action. They declared a gen-
eral strike, to which the Russian government, already weakened
by the Russo-Japanese war and a spiraling economy, answered
with the issuance of the October Manifesto (which granted ad-
ditional civil liberties) and the institution of an elected consul-
tative assembly, the Duma, to ratify all laws.

On January 15, 1906, the city of Dvinsk greeted the new
promise by the czar to establish this deliberative body with a

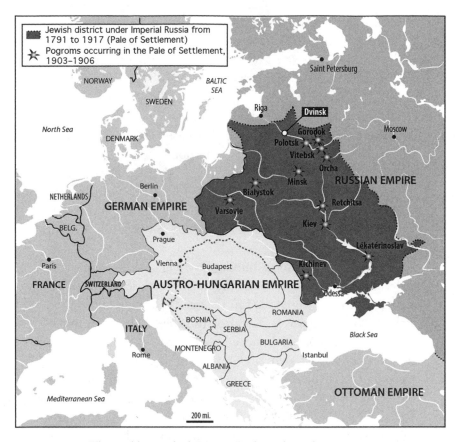

The world into which Marcus Rotkovitch was born in 1903.

spectacular festive gathering, which was repressed by the authorities and resulted in nine executions. Although Dvinsk's Jews had been spared in the massacres, the city was in turmoil, with various rallies organized by the Poalei Zion, a Marxist-Zionist labor movement, and, more important, by the Jewish Socialist Labor Bund, whose strongest and most active chapter was located there because of the sizable local Jewish workforce. It is likely that in October 1905 Yacov Rotkovitch joined the Bund during the impressive rally organized in support of the victims who had been slain only a week earlier. However,

this last demonstration, also repressed by the police, triggered a downward spiral of violence: martial law was declared, along with a curfew, and any gathering of more than three people was prohibited. "My father was a militant social democrat," Rothko would later say. "He was profoundly Marxist and violently anti-religious, partly because in Dvinsk . . . the orthodox Jews were a repressive majority."[11] Indeed, Yacov Rotkovitch organized clandestine meetings at his home to discuss the ideas of the Bund, whose pamphlets he secretly read at the synagogue when he found himself bored.[12] Gradually, however, the hopes of the enlightened bourgeoisie, who, just like Yacov, believed in the assimilation of the Jewish people into the Russian Empire, grew fainter.

During 1905 and 1906, hundreds of pogroms erupted in the Pale. In October 1905, during the most brutal of them, almost six hundred Jews were killed in Odessa. And, even outside the Pale, on June 1, 1906, in Bialystok (on the border of Belorussia and Lithuania), two hundred people were murdered, seven hundred were wounded, and hundreds of houses and shops were destroyed or looted. Day after day, the pogroms grew closer to Dvinsk: Minsk, Orsha, Vitebsk, Gorodok, Polotsk, Riga, Rechitsa . . . Did Yacov Rotkovitch feel the pressure closing in? Marcus was not yet three months old at the time of the Bialystok massacre, and it seems that the event precipitated his father's religious turnaround. Indeed, from that very moment the opinions of the Dvinsk pharmacist began to change, even to harden. "I was certainly aware that my grandfather was affected by the pogroms of 1905," Kate Rothko would comment one day while discussing her family's history. "I don't think they reached Daugavpils [Dvinsk's name after 1920] itself, but they certainly were close enough that people were very scared. And I understand they had a great effect on my grandfather, who had been a pretty secular man. The whole thing drove him to become a bit more religious."[13] Whatever the cause, Yacov

suddenly decided to return to his Jewish community and join forces with it. In a radical shift, he enrolled Marcus in a Talmudic school, which was in stark contrast to the educational settings he had chosen for his first three children. While his siblings attended nonreligious institutions—Sonia a Russian school, and Moses and Albert a secular Jewish one—Marcus would go to the Talmud Torah,[14] Yacov firmly decided.

Many questions remain unanswered about this period. Did the family provide Marcus a private Hebrew tutor at home in his earliest childhood? Later, did he attend a traditional *heder* or a liberal one?[15] In any event, those years at the Talmud Torah—from ages four to ten—made a lasting impression on the young Rotkovitch. But what could such a religious reversal have possibly meant to the liberal-minded pharmacist of Dvinsk? Ever since Yacov left the shtetl, nothing in his increasingly assimilated lifestyle could have foretold a return to tradition or, in his granddaughter's words, to this sudden "burst of piety."[16] As suggested by historian Michael Stanislawski, such transformations often happened "in response to the new theories of nationalism and socialism [which were] then gripping the minds and hearts of many," and not the direct result of "physical attacks against the Jews."[17] In fact, didn't Yacov Rotkovitch epitomize, to all appearances, the "new social type"[18] described by historian Irving Howe? Indeed, assimilation had increasingly become the ultimate aspiration of many Jewish people who had moved out of the shtetl. "Yet by a final historical reckoning," Howe explains, "the nascent labor and socialist movements achieved something of great consequence for the Jews. In these early struggles there began to emerge a new social type who would become the carrier and often the pride, of Yiddish culture: the self-educated worker-intellectual, still bearing the benchmarks of the Talmud Torah, forced to struggle into his maturity for those elements of learning that his grandsons would accept as their birthright, yet fired by a vision

of a universal humanist culture and eager to absorb the words of Marx, Tolstoy, and the other masters of the nineteenth century."[19] Undoubtedly, a complex set of circumstances got the better of Yacov Rotkovitch's natural development: the poverty plaguing the Pale of Settlement affected the business of the pharmacist, whose "legendary generosity," according to his daughter Sonia, did very little for his financial success.[20] Besides, the fear that his two older sons "would be drafted into the army, where Jews could be killed for sport," surely completed Rotkovitch's transformation and accounted for his decision to enroll Marcus in the Talmud Torah.[21] Given that Talmudic students were usually exempt from the army, wasn't this gesture the ultimate way to protect his younger son?

Whatever the reasons, buttoned down in black from head to toe, young Marcus started studying at the heder from age four. Whether he was taught by Rebbi Reuvele Dunaburger, Rabbi Yosef Rosen (Dvinsk's Hassidic rabbi for half a century), or Meier Simcha Hacohen (the rabbi of the Mitnagdim, who was the leader of the "opposition" to Hassidic Judaism for thirty-nine years), remains unknown. Regardless, all three strong personalities were considered outstanding Talmudists. While Sonia was pursuing a dentistry degree in Warsaw as her brothers were busy studying in Vilnius, little Marcus spent intense days studiously learning Hebrew, immersed in prayer books, under the watchful eye—and, more often than not, the threat—of the *melamed*. Talmudic school defines itself as the study of a discipline, but also as a precocious intellectual exercise in which, according to tradition, studying has a beginning but no end, for the Torah is unfathomable. After learning how to read Hebrew, students are initiated to prayers: the *mishna* (oral law), then the *gemara* (discussion and commentary on these laws), before taking up the Pentateuch at six or seven; finally, at thirteen, the age of the Bar Mitzvah, one leaves the heder to study at the yeshiva.[22] Intellectual accomplishment and

prestige composed the essential elements of Talmudic study. According to Abraham Heschel, "Jews did not build magnificent synagogues [but] they built bridges leading from the heart to God" and those "studying the Talmud felt a kinship with its sages. . . . In almost every Jewish home in Eastern Europe, even the humblest and poorest, stood a bookcase full of volumes; [books] were furnaces of living strength, time-proof receptacles for the eternally valid coins of spirit."[23]

Giorgio Agamben, the Italian philosopher, has most accurately captured the historical context that gave rise to the Jewish passion for study. "Talmud means study," he writes:

> During the Babylonian exile, with the Temple destroyed and themselves forbidden to sacrifice, the Jews entrusted the preservation of their identity to study rather than to worship. Torah, indeed, did not at first mean Law but teaching, and even the term "Mishna," the set of rabbinical laws, derives from a root whose central meaning is "repeat." When the Edict of Cyrus gave permission to the Jews to return to Palestine, the Temple was rebuilt, but by then the religion of Israel had been marked forever by the piety of the exile. Alongside the single Temple, where blood sacrifice was celebrated, arose numerous synagogues, places for meeting and for prayer, and the dominium of the priests yielded to the growing influence of the Pharisees and Scribes, men of the book and of study. In 70 A.D., the Roman legions again destroyed the Temple. But the learned rabbi Joahannah ben-Zakkaj, slipped covertly out of Jerusalem through the siege and obtained permission from Vespasian to continue the teaching of the Torah in the city of Jamnia. The temple has never been rebuilt since, and study, the Talmud, has become the real temple of Israel.[24]

This complex relationship to the Talmud is in fact a key to understanding the life and work of Mark Rothko.

A family photograph shows Marcus Rotkovitch at age ten,

but, bundled in his dark, austere clothing, sitting at the feet of his mother and holding a book (most likely a Torah), he looks closer to fifty. How did the child adjust to life at the Talmud Torah? How did he tolerate being the only one in the family to endure such austere discipline? As an honor and a source of pride, or as an anomaly and a punishment? How could a four-year-old child reconcile the confined atmosphere of his school and the openness of his assimilated family? "One has to be blind not to see the light of the Messiah," were the words of Rabbi Pinhas of Korets. While hearing such sayings all day long, how was Marcus Rotkovitch able to forge his own identity at night, in the contrasting environment offered by his family? Is it any surprise that later on, recalling his childhood, he would tell again and again the likely embellished stories that he would wear a backpack to avoid getting hit by the stones the children of Dvinsk threw at him in the streets, and that one of the Cossacks who had come to repress the demonstrations in the city struck him in the face with a whip? In the bourgeois apartment of the Rotkovitches, located at 17 Shosseynaya Street in Dvinsk, the whole family could feel the effects of the father's decision. As for Anna, she did not seem to have gone through a similar transformation, as suggested by the various fights the couple reportedly had at the time, in particular on the subject of the *kashrout*.[25]

Marcus Rotkovitch was seven when his father decided to leave Dvinsk for the United States; nine when his two brothers followed Yacov there, on December 21, 1912;[26] and ten when, with his mother and twenty-three-year-old sister Sonia, he finally left his birthplace for America. "I was never able to forgive this transplantation to a land where I never felt entirely at home," he would later say. Rothko's great-niece Debby Rabin puts the uprooting in these terms: "Until then, they had lived a comfortable life," she writes. "My grandmother [Sonia] was a dentist, and in love."[27] Surely, beyond their personal attach-

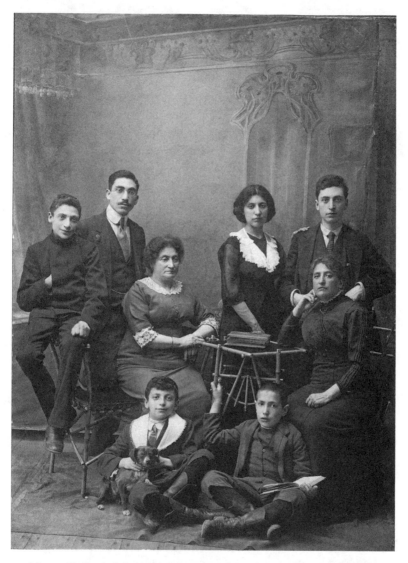

Marcus Rotkovitch (seated on floor at right), age ten, with some relatives and family members, 1913. His sister, Sonia Rotkovitch, is behind him, standing, and his mother, Anna Rotkovitch, is behind him, seated (Unknown photographer. Copyright © 2013 Kate Rothko Prizel and Christopher Rothko)

ments, each of the Rotkovitches had to cope somehow with the oppressive context of the time as well as with the tensions between modernity and Jewish identity. How, otherwise, could they have embraced their father's dictate that the family's only chance for salvation would come from leaving? In 1910, a commemorative ceremony in the Jewish cemetery of Dvinsk honored the "fallen comrades" of the 1905 revolution. "Long live the national and social liberation of all peoples!" read the flags, in both Russian and Yiddish, carried by the demonstrators. Did Yacov Rotkovitch attend this demonstration, just before leaving for the United States? At that point, he was eager to explore the possibilities offered to him in Portland, Oregon, where his younger brother Sam—who had changed his name to Weinstein—was the co-owner of a prosperous textile company. Such were Yacov Rotkovitch's successive responses to what he perceived as external threats to his family: first, a return to religion; then, a relocation to the United States of America, where he died of colon cancer on March 27, 1914, six months after Marcus joined him.

In trying to fathom the complex sphere of influences that shaped the Rotkovitch family's dramatic upheaval—from the Kishinev pogrom in 1903 to Yacov's death in 1914—one instantly recalls *Job: The Story of a Simple Man*,[28] Joseph Roth's superb novel, picturing a sort of parable to their own saga. Indeed, despite the sharp social difference between Mendel Singer—the novel's humble teacher at the Talmud Torah of Zuchnow, a shtetl in czarist Russia—and Yacov Rotkovitch— the liberal-minded pharmacist in the city of Dvinsk—both of their families equally suffer from the humiliations of the Jews in the Pale of Settlement, are terrorized by the brutality of the local Cossacks, and have their values overturned by persecution. In the end, they both immigrate to the United States, thanks to the financial support of a family member already settled there, in order to save their sons from conscription and

their daughters from marrying a *goy*.[29] "On the Sabbath evening," Roth writes, "Mendel Singer took leave of his neighbors. They drank the yellowish green schnapps that someone had brewed himself. . . . All wish Mendel good luck. Some gaze at him doubtfully, some envy him. But all tell him that America is a glorious land. A Jew can wish for nothing better than to reach America."[30]

Once the decision was made, it was followed by the endless formalities of obtaining a passport and then exhausting travel by carriage, train, and boat in the hope of reaching the New York shore, a moment well captured by Roth in his novel: "'Now,' said a Jew, who had already made this journey twice . . . 'the Statue of Liberty appears. It's a hundred and fifty feet tall. . . . In her right hand she's holding a torch. . . . And the best part is that this torch burns at night and yet can never burn out. Because it's only lit electrically. That's the sort of trick they do in America.'"[31] In leaving for the New World in 1913, Marcus Rotkovitch, age ten, was among the two million people forced by the vagaries of European history to migrate to the West.

Around the same time, in 1908, the Betsalel (Bezalel) Association was founded for the promotion of the fine arts in Palestine. A man who was born in 1865 in Griva (Greve, Latvia)—a village adjacent to Dvinsk—and who had received a Talmudic education there before becoming a rabbi in Zhoimel (Zeimelis, Lithuania) and then in Bauska (Boisk, Latvia), addressed a long letter to the Betsalel's founders, stressing the historical reasons that had hindered the development of the arts in the Jewish religion. At the time, he was expected to start teaching in Jaffa, Palestine. "A ray of sunshine enlightened us in the midst of the thick fog that darkens our world today," he wrote.

> Here and there, in the dispersion of our brothers, there is nothing but disorder and darkness; blood is spilled, bodies are trampled, skulls are crushed, houses, shops and all the

ornaments are pillaged and looted. . . . All these actions of the Jewish youth did nothing to advance the cause of freedom: over there, in a blood-stained Russia, everything was erased from the spirit, as if it were a matter of an old debt . . . One of the obvious signs of this resurrection is the important work that must result from your association: the resurrection of Hebraic art and beauty in the land of Israel. . . . The important realm of the fine arts can truly open the gates of subsistence to many families. It will also develop the sense of beauty and purity to which the sons of Zion are particularly disposed. It will give crushed spirits a clear and enlightening vision of the beauty of life and nature. . . . When our ancient people came into the world, it found humanity wrapped in the swaddling clothes of infancy, with only a savage sense of beauty, lacking purity and nobility. Beauty by itself stands the risk of being transformed by the hands of the uncultured crowd into a vulgar kind of pleasure if it is entirely cut off from scientific and moral truth.[32]

How not to pause over the remarks of Rabbi Avraham Yitzhaq Ha-Cohen Kook, later known as Rav (Rabbi) Kook? In the Old Testament, the etymological connection between "word" (*dibour*) and "desert" (*midbar*), where God first appears to the Jewish people, highlights the predominance of the word as sole capacitor of revealing the sacred, as opposed to painted representations, forbidden by the second commandment. In this regard, Rav Kook's affirmation marked a rupture. To him, far from perverting the Jewish people, careers in art and the quest for beauty set out a promising future for them. At this very moment, was not five-year-old Marcus, then engaged in Talmudic studies, about to fulfill Rav Kook's prophecy?

In June 1913, together with his mother and sister, Marcus Rotkovitch left Dvinsk for good. They were charged a kopek per person to cross the Dvina by ferry, taking the train to Libau (Liepāja) on the Baltic sea, then embarking as second-class pas-

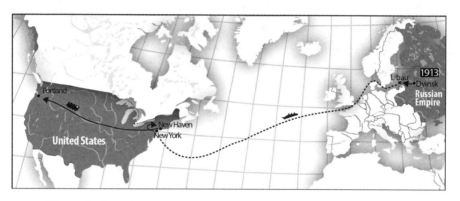

Marcus Rotkovitch's journey to the United States with his mother and sister,
from Dvinsk to Portland, Oregon, June–September 1913.

sengers on the SS *Czar.* On August 17, 1913, the three immi-
grants arrived in New York, where their name was changed
to *Rothkowitz.*[33] They spent their first ten days in New Haven,
Connecticut, with their Weinstein cousins. Then, each wearing
a tag around his or her neck that read "I do not speak English,"
they embarked on what Mark Rothko would later vividly recall
as an "exhausting, unforgettable" journey from New York to
Portland, Oregon. "You don't know what it is to be a Jewish
kid dressed in a suit that is a Dvinsk not an American idea of a
suit, traveling across America and not able to speak English,"[34]
Mark Rothko would somewhat bitterly tell his friend Robert
Motherwell decades later.

2

A Diligent Student in Portland,
Oregon: 1913–1921

Spring's green witchery is weaving
Braid and border for thy side;
Grace forever haunts thy journey,
Beauty dimples on thy tide;
Through the purple gates of morning
Now thy roseate ripples dance,
Golden then, when day, departing,
On thy waters trails his lance.
—"Beautiful Willamette,"
Samuel L. Simpson (1845–1899)

ON MARCH 12, 1912, the *Oregonian*, one of Portland's daily newspapers, published a cartoon depicting the image of a man with a receding hairline, close-set eyes, and a big moustache etched onto the trunk of a large, bushy tree: Ben Selling. This efficient and talented German-born businessman was the owner

Marcus Rothkowitz in Portland.
(Copyright © 2013 Kate Rothko Prizel and
Christopher Rothko)

of a clothing department store at the corner of Fourth Avenue
and Morrison Street, which he founded decades earlier. He was
also one of the most prominent citizens of the city and was
running for senator that year on the Republican ticket against
the incumbent, Jonathan Bourne, Jr. Above all, Selling was the
most active philanthropist in Portland's divided Jewish com-
munity. He tried, in every possible way, to bridge the gap be-
tween the German Jews, who had begun settling in the city as
early as 1855, before Oregon was even granted statehood, and
the recently arrived Eastern European immigrants. In 1903,
he had led a successful campaign to support the survivors of
the Kishinev pogrom, raising the most funds of any city in the
United States. His good deeds also included distributing free
meals to the city's unemployed, creating a new Sephardic syna-
gogue, and fund-raising for the victims of flooding in China,

famine in Japan, and the 1915 Armenian genocide. Still, the largest check Selling ever signed in Portland was made out to the order of Neighborhood House, a charitable organization founded by the Council of Jewish Women, located in an impressive 1910 red-brick building.

It was there, at the corner of Second Avenue and Wood Street, where Moses and Albert Rothkowitz learned English; where Marcus, five years after his arrival in Portland, launched a debate club with his friends Max Naimark, Aaron Director, Gus Solomon, and Gilbert Sussman; where, finally, his mother took American citizenship classes, one of the many courses like sewing, embroidery, cooking, bridge, gymnastics, and Bible study offered by the organization. Upon arriving in Portland, the Rothkowitz family benefited from the active social networks created by chain migration, a frequent phenomenon among Russian Jews in which they would find solidarity with both their own family and the American Jewish community. Indeed, the new immigrants immediately received support from their relatives and peers, who settled them into a close-knit neighborhood where they not only found numerous opportunities, but were also bound by the community's obligations.[1] Years earlier, in the shtetl of Mishalishek, the harsh fate suffered by Yacov Rotkovitch's family had resulted in especially warm gestures of solidarity: because of the early deaths of the children's parents, Yacov's youngest brother, Samuel, was raised by his older sister Esther and later adopted by her husband, Abraham Weinstein, whose family name Samuel took before immigrating to Portland. When Yacov joined his younger brother and his Weinstein nephews in the United States, he discovered that they were thriving in the "*shmates* business"— the garment trade—with their firm N. & S. Weinstein (for Nathan and Samuel). He also benefited from the extended network connections of his brother-in-law, Abraham.

After landing at the Weinsteins of New Haven, and set-

tling near the Weinsteins of Portland, the three last Rothkow-
itzes would complete their integration into the American way
of life through the many Jewish organizations operating in Or-
egon's largest city, especially the ones run, sometimes without
much refinement, by women. For instance, it was from the
"Sauerkraut Song," a traditional Nova Scotia tune combining
gastronomy and folklore, that the elegant Anna Rothkowitz,
then far from the sophistication of Saint Petersburg, began to
learn English:

> Now if you only listen to ye spake about
> I'm going for to tell ye how to make the sauerkraut.
> The kraut's not made of leather as eff'rey one supposes
> But of that little plant what they call the cabbage roses.
> Sauerkraut is bully; I told you it is fine.
> Methinks me ought to know 'em for me eats 'em all the
> time.
> The cabbages are growing so nice as it could be.
> We take 'em and we cut 'em up the bigger as a pea.
> Me put 'em in a barrel and me stamp 'em with me feet.
> We stamp and we stamp for to make 'em nice and sweet.[2]

By 1910, when 2 percent of Portland's population were Jew-
ish, the German Jews had already been establishing dynamic
businesses there for six decades, including ventures in tex-
tiles, furniture, tobacco, import-export, and retail department
stores. The length of a company's name displayed on its sign
was proportional to that firm's success; among the various busi-
ness names were "Fleischner, Mayer, & Co.," "J. Durkheimer
& Co., General Merchandise," "Meier & Frank," "Goldsmith
Brothers, Jewelry, Diamonds & Silver Ware," "Heilner Com-
mercial and Commission Company," "Lipman, Wolfe & Co.,"
and "Carl Adler's Crystal Palace." The companies had also de-
veloped sophisticated advertising techniques, as in the case of
Sylvan Durkheimer, who devised innovative strategies for ne-
gotiating new lines of credit that became of the utmost impor-

tance to Oregon's farmers. Such involvements rapidly turned many of these businessmen into civic leaders: Bernard Goldsmith was the mayor of Portland from 1869 to 1871, followed by Philip Wasserman (1871–1873) and Joseph Simon (1877). "In no other state in the Union has the Jew adjusted himself to his environment better than Oregon," the historian Jacob Rader Marcus notes. "There is no other state in which the Jew reached such high positions in the political life of the Commonwealth. . . . The foundations were laid strong and deep by the pioneers who built the Jewish community."[3]

No wonder, then, that the German Jewish community, the secular vanguard of European Jewry, produced the first generation of women philanthropists in the United States. The *yekes*, as German Jews were sometimes called, in reference to the stiff coats they used to wear, assimilated so rapidly, some becoming Freemasons, that their wives often followed in the footsteps of the American suffragists. In this regard, the historian William Toll asserts that Jewish women "simply eclipsed the men in their understanding and organization of welfare, and they thereby gained a far larger civic role."[4] In 1910, eight upper-middle-class women of German descent posed for a picture in front of the Portland section of the National Council of Jewish Women to celebrate their accomplishments as co-presidents of the organization. Wearing elegant dresses and sporting floral and feathered black hats, Mrs. L. Altman, Mrs. Ben Selling, Mrs. Alex Bernstein, Mrs. Julius Lippitt, Mrs. Rose Selling, Mrs. S. M. Blumauer, Mrs. Max Hirsch, and Mrs. Isaac Swett look at the lens with the assurance of active and liberated women with strong personalities. In their social orbit, the sisters Ida and Zerlina Loewenbert were the souls of Neighborhood House and the South Portland Library, respectively, for nearly four decades. While Marcus and his mother regularly came to borrow books from Zerlina's library, located in a small white house built in 1913 and featuring a pleasant wrap-

around front porch, it was Ida, as the editor in chief of the elegant glossy magazine the *Neighborhood*, who first took an interest in young Marcus, frequently asking him to write for her publication.

Topographically, Portland's Jewish community followed a clear social stratification. The neighborhoods were naturally divided east and west by the Willamette River, but class distinctions obeyed a strict north-south logic. The flatter north side, where upper-middle-class families of German origin enjoyed a life of privilege in large, beautiful houses, contrasted with the hilly south side, where East European émigrés were confined to identical one-story wooden row houses. South Portland, though, which some called Little Odessa, provided a perfectly self-sufficient environment for most of its inhabitants, and one could live there for years speaking Yiddish, Russian, or Polish without having to learn a word of English. "People chose to live close to each other," Augusta Kirshner Reinhardt recalls, "and it was a wonderful way to live, really, very much as we think of a shtetl, because in this small area, anything that anybody needed for good living was available within walking distance. There was the library within a few blocks, there was the synagogue within a few blocks, there were the grocery stores, the laundry, the hospital, the community center, you name it and we had it in our so-called ghetto. It was sweet living and really everybody helped each other."[5] South Portland was connected to the rest of the city only by the First Avenue cable car, which ran parallel to the Willamette River and whose driver, Olag Krogstad, a tall Norwegian man, became very popular among the local children. Little Odessa's isolation contributed to its status as a separate, peripheral neighborhood, with its own bustling and ethnic appeal. "Come Shabbes, come Saturday," remembers Israel Boxer, an immigrant from Odessa, "Mrs. Gurian and her sister, Esther, would come in the house. When they smelled our bagels they would come across the street. Mother would have

fresh-baked cookies or fresh-baked bagels, and they would sit in their Shabbes clothes. I can remember this; I can remember the smell, I can remember the odor of Shabbes. You know, the chicken soup, and the freshly baked bread and the gefilte fish, and the house, a very humble home, but immaculate."[6]

Though the Rothkowitzes fully understood the benefits of receiving such abundant and varied support from the community, it is unlikely that Marcus, his mother, or his sister ever shared similar nostalgic feelings. We don't know the precise location of the Old World Drug Store and Ice Creamery that Yacov Rothkowitz managed in the last years of his life; most certainly it was in Little Odessa, far from the German-Jewish north side—a further sign of their decline. Although part of the upper middle class, in Portland the Rothkowitzes felt relegated to the position of mere tradesmen; although progressive Jews, they were forced into an orthodox neighborhood; although urban cosmopolites, they had to cope with a parody of a shtetl, where daily life exuded schmaltz and nostalgia. Intellectually, the Rothkowitzes identified with the German Jews, but were often offended by their condescending attitude. So they stuck to their neighborhood, where everyone marveled at Dora Levine's fish market, whose front window displayed large aquariums with carp, salmon, and cod—all things required to prepare gefilte fish or salmon kubiliak, just like back home. They bought their bread at Harry Mosler's bakery on First Avenue at the corner of Caruthers; their cheeses at Calisto & Halperin, the famous Jewish and Italian delicatessen between Caruthers and Sheridan; and their meat from either Simon Director, Isaac Friedman, or Joseph Nudelman, the three kosher butchers. Their hair was cut by Wolf the barber, their teeth were checked by Dr. Labby the dentist, and they spent their Saturday evenings in the Gem Theater on Sheridan or in the Berg Theater on Grant, both of which showed silent movies for five cents. During those years, they occupied three differ-

ent homes: first, at 834 Front Avenue, just a few yards away from Neighborhood House; then, 232 Lincoln Street, near the nursing home; and finally, 538 Second Street, at the corner of Shaarie Torah synagogue.

This first orthodox synagogue of the Pacific Northwest was founded in 1905 by traditional Russian Jews, and its rabbi, Joseph Faivusovitch, and cantor, Yonia Glantz, both of Lithuanian origin, had been trained in the same tradition as little Marcus Rothkowitz. Despite these obvious connections, it is there that the now eleven-year-old child put a clear end to his years of religious training. Page 13 of the March 28, 1914, issue of the *Oregonian* soberly announced: "DIED ROTHKOVITZ—At his late residence, 834 Front Street, Jacob Rothkovitz age 55 years. Announcement of funeral later." After his father's burial, on March 29, in the cemetery of Ahavai Sholom synagogue, Marcus recited the Kaddish daily at Shaarie Torah, until, one day, he simply decided that he would never again set foot there. "The other family members were completely secular," his son, Christopher, explained to me during an interview, "so it was a real source of resentment for him, all the more since he was the one who had to say the Kaddish by himself."[7] How not to linger over the powerful father-son relationship in the Rothkowitz family? Strangely enough, while in most Jewish families tradition called for the eldest son to carry the heavy burden of honoring his father's memory, in this instance Marcus would be the one to bear it. This responsibility started back in Dvinsk, with Yacov's return to religion and subsequent decision to send his son to Talmud school. It continued in Portland, once the father had completed his mission of saving his older sons from conscription and his family from the pogroms. Yacov collapsed, leaving to his youngest son the responsibility of the Kaddish, the Jewish mourning ritual, which starts with the traditional words: "May His great name be blessed for ever and in all eternity." He also inherited from Yacov questions of unfathomable

depth: How not to fail his father's memory? How not to betray his hero? How, in the meantime, to survive such a diktat, at the young age of eleven?

Meanwhile, the Rothkowitz family was evolving: Moses Rothkowitz became Morris, then Mish Roth, and opened J. M. Ricen, his own drugstore, at 315 First Avenue, near his mother's house; Albert Rothkowitz became Albert Roth and started working as a clerk for N. & S. Weinstein; Sonia became Mrs. Allen and started a dental practice; Anna decided to change her name to Kate. As for Marcus, he began a process of secularization.[8] This would come naturally, for he was enrolled at the Failing School, a public institution directed by Miss Fannie Porter, a model educator who acted as a "surrogate mother to the children." According to those who knew her, Miss Porter understood that "the best type of Americanization was the integration of the foreign elements that made up a group. She realized that each foreign child possessed a specific nature that his country owed it to itself to maintain and develop."[9] She also organized an experimental introduction to art program that included museum tours and lectures. It was undoubtedly at this innovative school, a product of American democracy, where Mark Rothko was initially exposed to art. Marcus Rothkowitz's path toward his new identity would be paved with such encounters; some, like this one, magical, and others, as we shall see, more pernicious.

For three years Marcus, the youngest of the Rothkowitzes, attended the Shattuck School in the northwest of Little Odessa, a more liberal district than the south and a place where families felt they were achieving a measure of upward social mobility. In 1917, at the age of fourteen, he moved up to Lincoln High School, where he finally experienced his first true encounter with the non-Jewish world, as only 10 percent of the nine hundred students were Jewish. "At Lincoln High School, I personally discovered that there was a whole other world,"

Jack Hecht, one of the Jewish students, would explain. "In those days, it was like a melting-pot of Portland. You had the kids from South Portland; you had some very wealthy children from the Heights, from Lake Oswego, from Dunthorpe. . . . I was invited to their homes. I saw how, so to speak, the other half lived. . . . You were accepted as an equal because you were all the same age."[10] Next to the school, which drew children from all social and religious backgrounds, on Southwest Park, between Montgomery and Mill Streets, stood the imposing white Victorian house of the brothers Ralph and Isaac Jacob, who had made their fortune in wool mills. While attending high school, Marcus, a teenager already marked by adversity, found a new social order, beginning with the discrimination practiced by Lincoln High School's exclusive clubs. "Anyone who has a name ending in 'off' or 'ski' is taboo and branded a Bolshevik,"[11] his friend Max MacCoby lamented in the *Cardinal*, the school magazine, underscoring the control over student organizations exercised by the white Anglo-Saxon Protestant youngsters. In such an environment, what recourse had Marcus Rothkowitz, he who so appreciated intellectual debate but who was not allowed to participate in Lincoln High's Tologeion Debating Society, from which Jews were excluded? Despite the restrictions, at age eighteen he managed to make his voice heard: with remarkable vehemence, he developed his ideas in the *Cardinal*.

Had he realized the extent of the project he was throwing himself into? Was he not in fact taking on an impossible challenge? For he proposed to revive the magazine's Contributors' Club, turning it into "an open forum for the expression of ideas, [and] opinions of everyone in the school." By stimulating "the ability to think clearly and to set our thoughts in convincing order," Marcus hoped the club would prevent him and his fellow students from falling "prey to the smooth tongues of politicians or self-seeking economists."[12] As unobtainable as

his ambition may have seemed, how not to admire the maturity of an adolescent who bluntly decided to confront tradition? While blaming a pedagogy strictly centered on technical knowledge, the young activist enthusiastically favored critical thinking skills that could eventually foster civic awareness and the ability to "perform well the sacred duties of every member of a society." Indeed, in the preceding months, at Neighborhood House, the young Rothkowitz had succeeded with remarkable and precocious determination in establishing his own debate club with his closest schoolmates.

There, far from the disillusionment of Lincoln High, in this Jewish community house of Little Odessa, Marcus Rothkowitz was free not only to launch a forum for debate, but also to demonstrate, for the very first time, his literary and political creativity. Written at the age of sixteen, his short story "Doubon's Bride" is highly autobiographical. Published by Ida in the *Neighborhood*, it depicts the unraveling of a French refugee family during World War I, from the death of the father on the battlefield to the long-awaited reunion among lost relatives—between the mother and the daughter, and the eldest and the youngest sons. Some of the descriptions from the story's resolution stand out as true confessions: "A small band of refugees were wearily dragging themselves along one of the many roads to Paris. . . . A shadow of fear caused by the horrors experienced and by the perils lived thru the past two years were heavily traced upon their countenances. . . . Two years earlier, when the war was declared, the father went to defend the flag of France. Six months later notice was received that he had died gloriously on the battlefield. The little family bore the loss bravely."[13]

A year later, in another issue of the magazine, Marcus's short one-act play *Duty* dabbles in a similarly tragic vein. It features the father of a young man sentenced to death as he desperately attempts to save his son from being hanged in the ten

minutes preceding the execution, pleading his case to the governor and the prosecuting attorney. The telephone rings; the son is cleared of all charges, but it's too late: the execution took place just three minutes earlier. In *Duty*, the budding writer introduces some particularly dramatic phrases about paternal love, revealing, in the reversal of father-son roles, an illusory attempt to erase his own father's death seven years earlier. "For God's sake Governor, aren't you human? Haven't you a heart? Yes you have a little boy. Put yourself in my place. I've spent my whole life, health and fortune on that boy. I've starved to keep the taste of hunger from his mouth. I've frozen to keep him warm. I've nursed him thru illness and guided him thru his troubles. He was my hope in life. He was my ambition. He was my only interest on this earth. . . . You can't let my son die."[14]

Beyond these early literary forays, Marcus Rothkowitz was also able to demonstrate political leadership, as evidenced by the editorial he wrote for the first anniversary of the *Neighborhood* in 1920. Aside from the somewhat grandiloquent style of a young man attempting to assert himself, is it not his whole family history he is implicitly referring to in the following text?

"A Year's Perspective"

The world is experiencing the most terrible and unstable periods of human history. This period is by no means ended by the completion of the war. . . . Every country is experiencing within itself a war, tho not so conspicuous, but just as injurious as the former. These events are not to be easily forgotten or lightly passed upon. They are engraved and impressed upon the minds and hearts of not only those who have been and are active in this struggle, but even more so upon those of the generation of the world of to-morrow. There are deep scars in their hearts, which will forever remind them of these days. And it is to these young men and women that the world must lift its eyes and hopes for the reconstruction of the destroyed. They, in five or six years

will be the sailors to man the ship of state. They are going to rebuild our cities, replow our overturned fields, re-erect our bridges and repair the morale and homes of the whole world. These young men and women are influenced by motives which will guide them in the course of work, and these motives will be greatly affected—in fact entirely dependent upon the views of things they are acquiring today. They have been tracing the course of events in the world for the last five years. They have been seeing the diplomatic and political intrigues, which were so dearly paid for with human blood. Today they are witnessing the rise of new ideals, the frequent clashes between those and the old orders, which has prompted them to think and draw their own conclusions. Now what attitude are they assuming in regard to these matters? What side are they going to adopt in this titanic struggle? Their hands and hearts are full of ideals and hopes to the point of overflowing. They want to express them. But where?

The Neighborhood House recognized these facts and this prompted the idea of a community publication. Also there was an ambitious group of young men and women in the neighborhood, who although they might have not reached physical maturity are capable of thinking mature thoughts and expressing them in a mature manner. And thru direct cooperation of these two parties, just twelve months ago, today "The Neighborhood Staff," entirely of boys and girls was organized and the first *Neighborhood* was published. The fundamental purpose of the paper has been and is to have an open forum for the expression of youthful ideas. A careful survey of the columns of our little paper will show that these principles have been lived up to, for not only conflicted views as world affairs have been dealt with, but also matters involving our national policies, troubles between capital and labor, affairs vital to the state, city, the community, the Jews as a nation and race have been discussed from opposing viewpoints. Through the kind cooperation of the

public our little publication has been able to grow with every issue for an entire year. We hope that the same helpful spirit will prevail. Has our little venture into the world of politics and literature been successful? It is not for us to say, but we leave the answer to our readers. However, we must say, that should the answer be in the affirmative, we will all feel that our hard work has been repaid a hundred fold.[15]

The rejection from Lincoln High School's clubs spurred Marcus to take action. Determined to reject the role of victim, he decisively launched a discussion forum at Neighborhood House and took on a project to rebuild the world through study, literary creation, and political engagement. The thirteen-year-old furthered his rapid integration into Portland life thanks to working such jobs as newspaper boy, or "newsie," like many other boys his age, to earn pocket money. The local dailies—the *Telegram*, the *Journal*, the *News*, and the *Oregonian*—were booming. With the rising tensions inside the Austro-Hungarian Empire that would lead to World War I, newspapers saw their readership increase significantly. "When I first came to Portland in 1911 [at age nine]," Scotty Cohen recalls, "the first thing I did was I sold newspapers at First and Alder. In them days, I got the papers at three for a nickel. When I sold them, I made a dime. . . . When I made a dime, I'll go to First and Madison where there was a cook; he used to sell a big sack of brown mashed potatoes for a nickel. The other nickel I took home for mother. . . . We had very hard times in them days, very, very, hard times. I really had to help the family and how!"[16] A photo of the time shows fifty adorable Portland newspaper boys, smiling and proud, posing on a staircase in front of one of the city's schools, before the start of a benefit concert for the Portland Newsboys Association. All the boys are dressed in gray overcoats, some wearing a cap while others are bare-headed. There's a certain irony in imagining twelve-year-old Marcus, the young Talmudist from Dvinsk, as

a newspaper boy stationed in front of the Weinsteins' factory, between First and Alder, shouting the headline of the *Oregonian* on March 15, 1917: "Rasputin Dead, Revolution in Russia."

Perhaps this job contributed to raising Marcus's political awareness. "It was as a newsboy, in August, 1914," young Manly Labby declares, "that I first learned how group action could be used to achieve economic betterment, that strength lay in union for a common cause. . . . We discussed the problem [with the circulators] openly, on the streets, in school, in classes, wherever we saw each other."[17] Of course, Marcus Rothkowitz also had to face the stiff competition among newsies to get control of the best intersections, where the crowds converged as they left work and hurried to catch the trolley on their way home. Marcus became involved with the South Parkway Club—"the little club with a big heart," as it was called—founded by older paperboys from Neighborhood House in 1916. Among other activities, the young immigrant from Dvinsk also worked for his Weinstein cousins' New York Outfitting Company, at the corner of North 118th and Post Streets, unenthusiastically stacking pairs of pants. It goes without saying that Marcus understandably felt stifled in such surroundings, and it is with mixed feelings that, over time, he began to react to his obligations.

While the diligent student from Lincoln High grew into a passionate young intellectual and, in his capacity as a newsboy hawking papers in the street, thrived at informing Portland passersby of world events, Europe was in the throes of the deepest upheaval it had ever known. Following the assassination of Archduke Franz Ferdinand in Sarajevo on June 28, 1914, the continent was at war. After four years of combat and the horrific tally of almost nineteen million dead, the Austro-Hungarian Empire would be dismantled. Around the same time, the Russian Empire Marcus had known would also come to an end: following the czar's abdication in Moscow on March 15, 1917, and the October Revolution, the Russian Provisional

Government of Alexander Kerensky came to power, establishing for a time the Bolsheviks in opposition to the Soviets.

The year 1913, during which the last three Rothkowitzes reached Portland, saw President Woodrow Wilson define the United States' relationship with the rest of the world. But not until April 4, 1917, would the United States declare war on Germany. This entry into the conflict would inspire violent nationalist demonstrations among Americans who believed the country had no direct interest in the current conflict. According to the historian MacColl, Portland in particular became "the patriotic center of the North West," with George Baker, the reactionary mayor at the time, going so far as to wish for "the extermination of the IWW [Industrial Workers of the World] members congregated in this city."[18]

It was precisely both the IWW and Emma Goldman who captured Marcus Rothkowitz's attention at a time when xenophobic hysteria overtook a country that previously had been wide open to immigrants. Indeed, in 1915, the Ku Klux Klan, inactive since the Reconstruction era, reawoke in the South; in 1916, Madison Grant defended his racial history theory in *The Passing of the Great Race*; in the 1920s, the country no longer welcomed mass immigration; and in 1921 Congress restricted foreign immigration by establishing a quota system. Did Marcus attend the extraordinary speaker Emma Goldman's four August 1915 lectures on anarchism, education, maternity, and birth control at Turn Hall between Fourth and Yamhill Streets in downtown Portland? "EMMA GOLDMAN IS PUT UNDER ARREST" was the proud headline of the *Morning Oregonian* on Saturday, August 7, as the newspaper rejoiced that she had been able to utter only the first sentence of her speech on birth control before being arrested. We don't know whether Marcus was indeed in attendance that day, but we are left to wonder: how did the anarchist's projects and denunciations inspire the budding young intellectual? Goldman valued inner freedom and

mistrusted institutional powers. Rothkowitz, who sympathized with her ideas, was amazed by the fact she was born in an Orthodox Lithuanian family thirty-four years before him.

"LEO M. FRANK IS TAKEN BY MOB" read the headline of the *Morning Oregonian* on Tuesday, August 17, 1915, referring to the lynching of a thirty-one-year-old Jewish man by a mob of fifty men who took him from a Georgia prison. The political, social, and ethnic tensions Marcus had formerly experienced in Dvinsk now reached the city of Portland. Through his fights, readings, and writings, he began to forge himself a strong and original identity, while revisiting his childhood years. One of his poems from that time reads,

> Those primitive barbarous people
> They live again in my blood,
> And I feel myself bound to the past
> By invisible chains.[19]

In the face of the geographical and cultural upheaval he had just experienced, and despite difficulties like learning a fourth language in record time, losing his family's social status, suffering the death of his father, and experiencing rejection, the young Talmudic student from Dvinsk found in Portland a perfect fit to complete his intellectual training. "The city and its surroundings were praised for their natural beauty," explains the painter Otto Fried, who immigrated to Portland sixteen years after the Rothkowitzes, "with the Willamette crossing the whole city, flowing into the Columbia River a little further and, in winter, Mount Hood covered in snow, overlooking the landscape."[20] Marcus loved going for walks in the forested hills that surrounded Portland, and often spoke fondly of his youth, witnessing "the endless space of the landscape of Oregon lying covered by wintry snows, in front of the monumental emptiness that is nothingness and at the same time a part of 'all.'"[21] In only eight years he succeeded, in spite of his initial linguistic

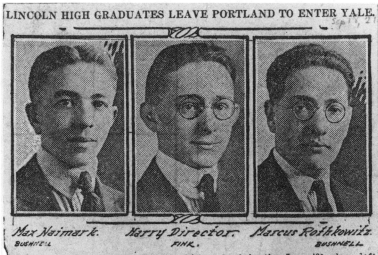

LINCOLN HIGH GRADUATES LEAVE PORTLAND TO ENTER YALE.

Max Naimark. Harry Director. Marcus Rothkowitz

Three graduates of the Lincoln high school in the June '21 class left Portland last week to enter Yale. They are Marcus Rothkowitz, Max Naimark and Harry Director, three Russian boys, none of whom has been in this country longer than seven years.

All three made brilliant records in scholarship during the time they were in Lincoln high and passed their college entrance examinations soon after graduation. They will stay at Yale four years. They intend to become professional men, but have not yet decided upon their life work.

Max Naimark has been in the United States only four years. He spent ne year in the elementary schools and three years in high school. All three ook the college preparatory course in high school.

Marcus Rothkowitz on the day of his graduation from Lincoln High School, Portland, Oregon, June 1921 (Unknown photographer. Copyright © 2013 Kate Rothko Prizel and Christopher Rothko)

handicap, in finishing the nine-year school program, studying philosophy, math, sciences, Greek, French, drama, and music. In May 1921 Marcus Rothkowitz was admitted to Yale, the Ivy League inner sanctum, along with his pals Aaron Director and Max Naimark—receiving a full scholarship.

3

———◆◆◆———

The Years of Chaos: 1921–1928

I think we shall have to change our view, in regard to the
Jewish element. We should do something to improve
them. They are getting there rapidly. If we do not educate
them, they will overrun us. . . . A few years ago every single
scholarship of any value was won by a Jew. . . . We must
put a ban on the Jews.
—Frederick S. Jones, Dean of Yale College

How COULD a young man of eighteen years—the image
of a 1920s intellectual, with a high forehead, an intense gaze
behind round glasses, and a combed-back mass of wavy black
hair—who entered with such enthusiasm into Yale, this temple
of knowledge, so severely flounder there? Why would this vo-
racious student, craving intellectual debates, so confident in his
abilities after his string of successes in Portland, completely fail
to find his place at this elite university? Why did the trajec-

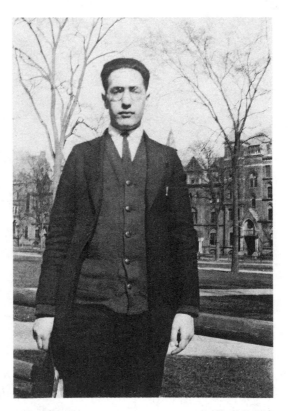

Marcus Rothkowitz at Yale University, c. 1923 (Unknown photographer.
Copyright © 2013 Kate Rothko Prizel and Christopher Rothko)

tory of Marcus Rothkowitz, who for the past eight years had
been thrown into a dynamic, frenzied integration into Ameri-
can society—from Dvinsk to Portland—falter so easily at this
point, in less than two years in New Haven, which would surely
seem to have so much to offer him? Was it due to his youthful
idealism and ingenuousness? To a matter of timing? Not just
that. What, then, lay behind the dismal failures of his freshman
and sophomore years at Yale?

In the 1920s, American writers, poets, and painters started
extolling the beauty of the United States, which experienced a

period of exceptional economic prosperity following the end of the First World War. But at the same time, the country turned in on itself. These were jittery years of heightened nationalism, tinged with xenophobia and typified by fear of "Reds" (communists) and distrust of immigrants. Consequently, Congress passed three successive, highly restrictive immigration laws: the Immigration Act of 1917, which introduced a literacy test; the Emergency Quota Act of 1921; and the National Origins Act of 1924. It was in the midst of these developments, in late August 1921, that Marcus R. began his studies at Yale, and his personal journey must be viewed through the lens of the peculiar demographics of Jewish immigrants over the previous four decades. The number of Jewish citizens rose from three thousand in the early nineteenth century to a quarter of a million in 1880, the result of the arrival of numerous German Jews who quickly and effectively assimilated throughout the country. Following the wave of pogroms in the Russian Empire, the influx of Jews coming from Eastern Europe took the form of massive immigration. Between 1881 and 1920, 2.3 million additional migrants reached the "golden door" of Ellis Island.[1] And Marcus R. was among them.

In Portland he had done everything he could to fit in, relying on his intellect to construct an identity for himself in his new country. He learned English, abandoned the synagogue, worked at menial jobs, wrote intense articles, took political stances, fought the battles of a young rebel, acquired a small amount of recognition in Little Odessa—thanks to the community network of Neighborhood House and the publication of his fiery and precocious writings—and attended the chemistry classes of Lincoln High's popular teacher Mr. Thorne (a Yale graduate). It was through Mr. Thorne that Marcus met Dr. Angier, the dean of Yale University, who had come to Portland to recruit bright, young graduates in Oregon. In a private meeting he had told the high school students that "*money*

was no object as long as [applicants] *had brains and were good students.*"[2] And so Marcus boarded the train to New Haven along with Aaron Director and Max Naimark. In fact, Yale was not all that unfamiliar to him. His Aunt Esther's husband, Abraham Weinstein, had made a fortune in the schmates[3] business in New Haven, and, among their nine children, four had already been admitted to Yale: Jacob, Alexander, and Daniel earned their bachelor degrees in 1908, 1909, and 1920, respectively; the last one, Isadore, was still in his junior year. Furthermore, young Marcus had stayed with the Weinsteins in their New Haven home for ten days when he first landed in the United States.

But Marcus Rothkowitz was not a Weinstein, and in the months that followed his arrival in New Haven he was to become a pariah. He soon discovered that everything he had been told about this prestigious institution was a lie. He further understood that what mattered, in fact, was not so much being *admitted* into the elite school, but rather being *accepted* there, and *fitting in.* In the course of a few weeks, he would learn that "the Yale social system was based more on breeding than on merit,"[4] particularly when it came to sports. He was soon to discover the cynicism and hypocrisy of a caste-based microsociety that sought to protect and reproduce itself, in particular by excluding new, upwardly mobile immigrants who, in those years of rampant nationalism, were deemed threatening to the system. With the unpleasant feeling that he would, at best, be "tolerated" in this prestigious school, he gradually sank back into perceiving himself as a wretched stowaway, a second-class citizen, a Russian Jew, a mere immigrant.

With an enrollment of 826, the class of 1925 was the largest in the college's history—some referred to it as a "mammoth class." While the class size caused some panic among school administrators, they were even more concerned that the class included a record number of Jewish students. The administra-

tors circulated memo upon memo to guard against this worrisome trend. In January 1922, Russell H. Chittenden, the director of Yale's Sheffield Scientific School, wrote to President James Angell to deplore the increasing "number of Hebrews" enrolled in the science departments. In April of the same year, Alfred K. Merritt, the college registrar, alerted Angell to the fact that representation of "the chosen race" had grown excessively: from 2 percent in the class of 1901, Jewish students rose to 7.5 percent of the class of 1921, and now to an all-time high of 13 percent of the class of 1925.[5] Frederick S. Jones, the college dean, summarized for President Angell the impact of Jewish students' academic talents on their predominantly WASP classmates in these terms: "While many of these Hebrew boys are fine students, I think the general effect on the scholastic standing is bad. Some men say that they are not disposed to compete with Jews for first honors; they do not care to be a minority in a group of men of higher scholarship record, most of whom are Jews."[6]

In short, Marcus R. realized from the start that he was stigmatized *precisely because* he was bright. He had been raised in accordance with a strong model that, with his years of Talmudic education, had become his true identity: the all-powerful nature of study. As Dan Oren aptly describes it, "The Jews' desire for college was tied to their traditional education values and to the growth of social mobility as a function of degree of formal education."[7] By denying him entry into its exclusive society, Yale, that pseudotemple of learning, hampered the development of the identity of the young prodigy from Dvinsk. After conducting a detailed assessment of the Jewish students on the campus, Dean Jones found that while the majority of them belonged to humanistic organizations like the Society for the Study of Socialism, the classical music club, and the debate club, they hadn't joined any athletic teams at a time when sports had become a powerful vehicle for social inclusion and

advancement.[8] Marcus R. remained almost entirely absorbed in politics, classical music, and debating, avoiding athletics because of his clumsiness and lack of physical coordination. Yet sports could have helped him. In fact, Russian Jews eager to conform favored basketball as the most effective means of assimilation. The case of Joseph Weiner (BA 1916) had already made a lasting impression at the time: Joseph belonged to the Atlas Club, the club for young Jews at New Haven High School, and became the first Jewish student to play on Yale's varsity basketball team. Soon after, Weiner stated that he "felt he was shattering the stereotype of the nebbish Jew," asserting that "no longer, would people have to pity the helpless Jew."[9]

Marcus R.'s situation at Yale, in contrast, deteriorated in stages. During his freshman year, he had to rent a bedroom in New Haven because his status as scholarship recipient denied him the right to live in a campus dormitory. So, with his friend Max Naimark[10] he moved into a third-floor bedroom in the home of Dr. Herman Grodzinsky, on 840 Howard Street. Situated in the city's Jewish ghetto, he felt like an outcast once again. Then, in his sophomore year, following the departure of Naimark, who had dropped out, Marcus R.'s scholarship was converted into a loan, which enabled him to get a room on campus, in Lawrence Hall. At this point, however, as a direct consequence of the quota, or *numerus clausus*, that the university had just established, he was compelled to work in order to pay for his studies, which left him disadvantaged in comparison with other students. Once again he took on menial jobs, working in the laundry room and cleaning tables as a busboy in the dining hall. When he wasn't busy working or rushing to or from his aunt Esther Weinstein's, where he ate both lunch and dinner, Marcus R. buried his nose in books of English literature, French literature, European history, history of philosophy, psychology, economics, math, and physics. But it was already too late. Although "brilliant and scholarly," according

to his classmates, he received mediocre grades—slightly above average (C-plus at the time). First marginalized by the other students because of his origins, then handicapped by the loss of his scholarship, and ultimately disappointed by the whole experience, Marcus R. lost interest in what Yale could offer him and left.

From the outset, the young Rothkowitz was destined to be excluded from this "inaccessible club of young WASPs." As a townie, he belonged to the 39 percent of students who, for lack of space in the dormitories, had to live off-campus. As a former public school student, he did not belong to the exclusive East Coast prep school coterie. And finally, as the son of European immigrants, he lacked the refinement of the upper class.[11] On Yale's campus in the fall of 1921, therefore, Marcus R. bore all the wrong credentials. How could he not feel powerless? Despite his efforts, it was as if social determinism doomed him to failure.

Of course, some claimed that if the campus's Jews were not tolerated by the elite, it was the result of their clannish behavior, their own practice of self-seclusion, their refusal to subscribe to the WASP ethos, and their display of poor civic and ethical qualities. Of course, some rationalized that discrimination had its origins in a circular process, exclusion causing seclusion and seclusion causing, in turn, exclusion: "the more desperately the Jews wanted to climb the social ladder, the more panic-stricken the others became at the idea of becoming invaded."[12] There were some counterexamples, like Theodore Zunder (BA 1923), born into an eminent German Jewish family of New Haven, who was elected to a fraternity in 1921. There was also John M. Schiff (BA 1925), one of Marcus R.'s classmates at Yale and the grandson of Jacob Schiff, one of the country's most powerful bankers, businessmen, and philanthropists.[13] When John M. Schiff arrived on campus, preceded by his family's reputation, he was in a position to rub shoulders for four years with

his WASP comrades from Taft High School, which accounted for the majority of Yale's young graduates. Climbing the rungs of power to the top, Schiff managed the campus magazine (the *Record*), became captain of the varsity swimming team, and was admitted to the Beta Theta Pi fraternity—an extremely rare exception for a Jew.[14]

The fraternities upheld the logic of social castes, and they traditionally excluded Jews. With their old and hermetic rituals, they opened up infinite possibilities at a time when the campus was underequipped, providing meals, organizing evening parties, and creating social networks—the privileged helping the privileged. While Marcus R. was no Weinstein, he was even less of a Schiff, and in addition to the ethnic discrimination of the WASPs, the social division of the Jews worked against him. Caustic and rebellious, he created with Aaron Director—in an ironic and desperate attempt to assert himself—a polemic journal, the *Yale Saturday Evening Pest*, which disappeared when he exited the school.

In one of his early journalistic enterprises, he taunted Yale students who "instead of talking about art and literature . . . spend their evenings in basketball discussion, bridge playing and dancing" and declared outright that "the whole institution is a lie and serves as a cloak of respectability for a social and athletic club."[15] He condemned the social conventions that, at the expense of academic values, ruled that "house of the dead," the university. "The undergraduate cringes before fancies that were born in his own mind," he wrote, implicitly referring to the golden calf of the Bible. He stressed the fact that Yale students worshiped an idol they had themselves built and that dictated their behavior, diverting them from essential values (work, truth, and friendship). "False gods! Idols of clay!" he exclaimed. "There is only one way to smash them, and that is a revolution in mind and spirit in the student body at Yale University. Let us doubt. Let us think . . ." Describing this

adoration of the golden calf, Marcus R. blacklisted five deceitful "false gods": athletics, extracurricular activities, social success (by way of the fraternities), the opinion of the majority, and grades. He also criticized the superficial and fake behaviors—flattery and hero worship—that all too often ruled campus relationships. But he reserved his most vehement criticism for fraternities, athletes, pompous academics, and the submissive majority.

Candidly wishing that fraternities would one day be "at the service of friendship," Marcus R. valiantly expounded his vision of education—but did he really believe in it? "We shall see what is as plain as daylight—that blind conformity to the custom of the majority, to the average, brings mediocrity, and crushes genius." In the future, he wrote, "the individual and his individualism will be respected. The atmosphere of a well-drilled army will change to one of varied interests and modes of self-expression. . . . The university will provide a home for romantic genius. It will aim at preparing students not to make a living but to live. . . . Yale will become an educational institution, with the library at its core. It will breed a race of students whose visits to the instructors will be for the purpose of discussing intellectual problems, never to find out marks. They will make their search for truth their chief aim as long as they are at the university."[16] These statements, echoing his previous essays published in the *Cardinal* and the *Neighborhood*, could be considered as Mark Rothko's early manifesto.

Marcus R.'s failure at Yale is indeed ironic. When he joined the school during President Angell's tenure, "one thousand flowers were blooming in one thousand places across the university." And, in a place "where tradition had always governed . . . , now acting, singing, writing, painting took on a new dignity and excitement."[17] But this new progressive policy developed by Yale's president did not actually benefit the young immigrant. He would find "dignity and excitement" only in the arts and a few years later, in another context. Did these dark years sig-

nal the end to his age of innocence? At twenty, Marcus R. left Yale for New York, where he found a room with relatives in Harlem, but he kept moving from one address to the next (c/o Mrs Goreff, 19 West 102nd Street, New York; c/o Harold Weinstein, New Haven; c/o Kate Rothkowitz, Portland), working one menial job after another, living on a tiny income (three dollars a week), pushing himself to the limit, taking advantage of his extended family's support, becoming a pattern cutter in the New York garment district, then accountant for Samuel Nichtberger, a relative of the Weinsteins from New Haven. Shuttling between New Haven, New York, and Portland, most often by hitchhiking, he skipped from encounter to encounter, passion to passion, brooding over society and growing bitter toward his older brother for not supporting him enough during these years of chaos.

According to the legend, Marcus Rothkowitz discovered his calling by chance or, rather, by epiphany. One day in October 1923 he visited a friend who studied figure drawing at the Art Students League. "It is the life for me," he said on the spot, embarking immediately on two months of lessons there.[18] He returned to Portland in April 1924 to take a stab at theater for a few months, working with Josephine Dillon, the wife of Clark Gable. His fluctuations between cities and institutions lasted for a few years. Finally, in January 1925, Marcus R. returned to New York and to painting. He first studied at the New School of Design in the graphic arts workshop of Arshile Gorky before selecting, at the Art Students League, the life drawing classes of George Bridgman, and then the still life classes of Max Weber, and finally attending an illustration workshop at the Educational Alliance Art School.[19]

The Educational Alliance had been founded in 1889 in New York's Lower East Side, a few years after a new wave of immigration. In 1891, a fund-raising campaign brought in $125,000 and enabled the opening of its main building at 197 East Broadway. The executive council historically included strong person-

alities, all of them German Jews: Isidor Straus, then the co-owner of Macy's department store, who perished on the *Titanic* in 1912; Samuel Greenbaum, who served two fourteen-year terms as a New York State Supreme Court Justice; the lawyer Myer S. Isaacs, a leader in the New York Jewish community who in 1864 wrote to President Lincoln to caution him against the specter of a "Jewish vote"; Morris Loeb, who was admitted to Harvard University at the age of sixteen and became the first chair in physical chemistry in the United States; Edwin R. A. Seligman, a professor of economics at Columbia University, who had particularly conservative views on taxation; and Jacob H. Schiff, the grandfather of John M. Schiff, Marcus's classmate at Yale (the two were never close) who had been admitted to a fraternity. Soon after its creation, the Education Alliance Art School organized its first visual art courses, with the intention to "morally support the students, while developing their aesthetic values." Among the first generation of students were Peter Blume, Ben Shahn, Phillip Evergood, Chaim Gross, and the Soyer brothers; the second one included Barnett Newman, Adolph Gottlieb, and Mark Rothko.

With the support of his own family and the Jewish community network, Marcus Rothkowitz managed to overcome the pain of his college years. After a quick return to Portland, he found someone who was to become his first real mentor: the painter Milton Avery, whom he met in New York during the fall of 1928. But this period ended on a bitter note, with a regrettable incident involving Lewis Browne, a cousin of his friend Aaron Director. It reinforced his feeling of exclusion and exposed him to an episode of so-called Jewish anti-semitism.

After undertaking rabbinical studies, Browne became successful in writing popular books about the Old Testament. At some point he hired Marcus R. as an illustrator for his new project, *The Illustrated Bible*, signing him to a $600 contract.

However, the relations between the two men ultimately soured, and Marcus R. started legal proceedings against Browne and his publisher, Macmillan, to recover the laughable amount of $50 they still owed him. Any remotely realistic analysis of the power dynamics could have predicted the outcome. In January 1928, after a distressing misadventure, the young illustrator was left with a sense of failure, betrayal, and ridicule—as well as $900 in lawyer fees. But this conflict was far more complex than it seemed, for it involved the cruel confrontation between two individuals from the same minority.

Ten years earlier, Browne had published his article "The Jew Is Not a Slacker" in the *North American Review*,[20] and it described the stereotypes facing Eastern European Jews who had recently immigrated to the United States. "The un-Americanized Jew," he wrote, "is one who lives in this country but is not yet essentially a part of it." Foreign-born, "usually from Russia," the new immigrant, "who has lived here for a decade, perhaps two," was described by Browne as an "alien slacker," an artifact of the Old World from which he came, "almost crushed beneath centuries of servility and oppression." This "un-Americanized Jew" had a "constitutional" antipathy toward "physical violence" and so couldn't understand "the dashing heroism we Occidentals so greatly admire."[21] Under the guise of a critical analysis of antisemitism, Browne exhorted Jewish immigrants to assimilate as quickly as possible and to transform themselves by adopting the dominant ethos. However, between the lines, some read what could be described as Jewish self-hatred. According to the historian Paul Reitter, this is "a complex and possibly redemptive way of being Jewish, [the] only way for them to apprehend the world."[22] In this painful professional relationship, Browne, the archetype of the "shameful Jew," had indeed *abused* Rothkowitz by acting haughtily, dishonestly, and even sadistically.

During the legal proceedings, Browne accused Rothkowitz

of "littering [his] apartment with his clothing" and leaving "finger stains on the maps." This allegation seemed tantamount to reducing Marcus R. to the "Jewish slacker" type stigmatized in his article. Rothkowitz, in Browne's view, epitomized the "un-Americanized Jew" he so looked down upon with mistrust—a Russian immigrant who, dependent and hence completely inassimilable into the New World, bore a hard-to-pronounce name, spoke English with a Russian accent, felt nostalgia for the shtetl, and maintained archaic attitudes, as evidenced by the way he dressed, ate, and worshiped God. Those newcomers were seen as a burden by Browne, who felt socially superior because he was rich, secular, dynamic, and integrated. For shameful Jews, those needy cousins, whom they nevertheless financially supported, quickly became hateful doubles, and even embarrassing inconveniences. In abusing Rothkowitz, Browne sent him back to an inescapable place of failure.

This latest unpleasant episode further derailed the young man's process of integration in the United States. At Yale, Marcus R. had realized he was neither a Weinstein nor a Schiff. Now he was made aware that he wasn't a Browne either. In his first attempt to play his part in the world, Marcus R. had sailed troubled waters, navigating between the kindness of his cousins, the philanthropy of the German Jews, the discrimination of the young WASPs, and the sadism of a man like Browne. The 1920s were a particularly conservative period in the United States, and the young immigrant had arrived under dramatic circumstances, along with many—perhaps *too* many—others. Despite such conditions, the twenty-four-year-old wounded man who emerged from these chaotic years had definitely achieved a sort of miracle: in 1928 he was included in his first group exhibition, at the Opportunity Gallery. A year later, he was appointed drawing instructor at the Brooklyn Jewish Center's Academy, a position that he would keep until 1952 and that would provide him undeniable stability.

4

<hr>

The Metamorphosis of Marcus Rothkowitz:
1928–1940

This perhaps passing conjunction of the modern in art and
the Jewish has, I suggest, certain aptness . . . which
possibly explains why many young Jews find it easy
to become modern painters.
—Leo Steinberg

FOLLOWING HIS breakthrough into the art world, Marcus
Rothkowitz seemed to build momentum, steadily lining up se-
rious and interesting projects; however, as a New York artist,
he still needed to establish a foothold. Despite his late start, by
age thirty he could already boast about having his first solo ex-
hibition, held at the Portland Museum of Art, followed within
the next two years by shows in New York and Paris. In spite
of these achievements, his public recognition remained elu-
sive. All the same, these were years of critical importance to
the artist's emerging identity. Having gleaned the rudiments of

the craft from various teachers in different institutions for four years, he joined the circle of Milton Avery, finding his place in this informal community that was reminiscent of the artists' colonies of Pont-Aven and Giverny. For the next eight years, between vacations in Lake George, New York, and Gloucester, Massachusetts, complemented in New York by poetry reading nights and weekly figure painting workshops organized by Avery, Marcus R. would work alongside this group of fellow artists, benefiting from the master's advice and the viewpoints of his peers.

Between 1928 and 1939, one exhibition followed the next: at the Opportunity Gallery, Contemporary Arts Gallery, Uptown Gallery, Gallery Secession, Municipal Art Gallery, and Bonestell Gallery in New York, as well as at the Galerie Bonaparte in Paris.[1] But his works—oils, watercolors, and paintings on paper—sold poorly. After a misunderstanding with Robert Godsoe, one of his dealers, Marcus R. and his colleagues decided to leave his gallery and establish themselves as an artists' collective. In November 1935, The Ten was born; in addition to exhibiting the art of its members, it started exchanging ideas about the revered masters of the time and developed into a discussion group. Soon after, Rothkowitz began working as an artist for the Works Progress Administration, the New Deal agency created by President Roosevelt to administer public works projects. Then he joined the Artists' Union and participated in the first American Artists' Congress. Finally, on February 21, 1938, Marcus Rothkowitz became an American citizen and, two years later, sloughed off his original name—from then on, he was Mark Rothko. It was as if, in a spectacular act of reinvention, Mark had left behind Marcus's painful past along with his former identity. That year he also divorced his first wife, after eight years of an apparently unsatisfactory marriage.

The years 1928–1940 signal in many ways a remarkable period: Marcus R. was coming of age as an artist while the city

of New York was evolving into a dynamic capital of modern art—two completely contemporaneous transformations, each of which was preceded by years of turbulence (1913–1928). For the New York art world, the exhibition known as the Armory Show epitomized a new era and saw the mass arrival and display of nearly four hundred works by European Modernist artists (a third of all the works exhibited) in the heart of Manhattan on February 17, 1913. It preceded, by six months, the arrival at Ellis Island on August 17, 1913, of Marcus, his mother, and his sister—the last three members of the Rothkowitz family to reach the shores of the New World. The Armory Show was the first time Americans were exposed to avant-garde artists who had been flourishing throughout Europe, and the public was dumbfounded. The abrupt and disorderly introduction of Duchamp, Brancusi, Braque, Gauguin, Kandinsky, Seurat, van Gogh, and Rouault, among others,[2] in a country lagging behind Europe artistically, produced a cataclysmic effect. The headline in the *New York Times* read, "Cubists Migrate: Thousands Mourn."[3]

While Marcus R. was adjusting to American life at Neighborhood House and Lincoln High School in Portland, helped in part by the generosity of Oregon's German Jews, American artistic circles, many of German-Jewish origin, were paving the way for the European Modernists in America. Among them were the collectors Gertrude and Leo Stein, who, upon arriving in Paris, amassed in their Montparnasse home on Rue de Fleurus masterpieces by a pioneer named Cézanne and by up-and-coming young artists, including Picasso and Matisse, whose talents they identified early on. Over time, their salon became the meeting place for American artists in Paris, to whom they transmitted their passion for the avant-garde. "For hours, they stood around a large table . . . examining portfolios full of drawings by Matisse, Picasso and others, and folios well stocked with superb Japanese prints. [Progressively this place

grew into] a sort of international clearing-house of ideas and matters of art, for the young and aspiring artists from all over the world. Lengthy and involved discussions . . . took place, with Leo Stein as moderator and pontiff. Here one felt free to throw artistic atom bombs and many cerebral explosions did take place."[4] On the other side of the Atlantic, since 1908, Alfred Stieglitz had been exhibiting in his small New York gallery at 291 Fifth Avenue—commonly called "291"—works by Rodin, Matisse, Cézanne, and Picasso, which the photographer Edward Steichen, then residing in Paris, selected and transported in small batches to this elite European enclave in the city.[5]

The Armory Show elicited mixed reactions, to put it mildly, in the American art world and among the general public. It bewildered some artists but was met with utter enthusiasm among those who loved the art of their time. The former viewed the Armory Show as a dire event, a "chilly wind from the East" that, according to artist Jerome Myers, "had blown on our artists" and "left our critics in a daze. Reputations began to tumble, incomes to dwindle. Galleries began to bloom with foreign flowers. The era of modern had set in. . . . While the French dealers had the world as their market, here in New York we had only what the French left over for us."[6] The exhibition took place at a time of intense debate in American society, a period that was marked by the resurgence of conservatism and a return to moral order. But on the opposite side, American Modernist painters were thrilled to discover such marvels. Among them was William J. Glackens, who eagerly declared, "Everything worthwhile in our art is due to the influence of French art. We have not yet arrived at a national art. . . . I am afraid that the American section of this exhibition will seem very tame beside the foreign section. But there is promise of a renaissance in American art, the sign of it everywhere. This show coming at the psychological moment is going to do us an enormous amount of good. . . . It may be

that the country, going through the process of building, has not had time for art. It may be that the money-god has been a preponderant influence. . . . It may be that our most energetic men have not had time for art, but inoculate the energy shown elsewhere into our art and I should not be surprised if we led the world."[7]

Glackens was correct in asserting that the United States had "not had time for art," and when Marcus R. set out on this path in 1923, several generations of American artists had already complained about the lack of enlightenment in their country, whose culture had long been dominated by pioneers and businessmen. Throughout the colonial period, the artist's work was regarded as "no more than any other useful trade . . . like that of a carpenter, tailor, or shoe maker, not as one of the most noble arts in the world."[8] Their purpose was to document reality, with their talents being used simply to immortalize a scene, a face, a place. Their artistic technique was just a means to an end. Only with the creation of the first school of American landscape painting, the Hudson River School, around the mid-nineteenth century, did U.S. artists become aware of their identity and start clamoring for recognition. After the Civil War, many of them traveled to Paris to receive training at the École des Beaux-Arts and in the artist colonies—and, especially, to seek recognition in a country where artists were looked upon as heroes.

In the following decades, thanks to painters with combative personalities and political acumen like Thomas Eakins and Robert Henri, the standing of American artists began to improve. Upholding their newly found social status, however, was a permanent struggle. Was it any wonder that Marcus Rothkowitz chose to become a painter? Socially, he was a rebel who, after enduring a series of setbacks, had developed a precocious political awareness as well as a desire for revenge. To pursue a career in art meant, for him, joining a professional group of

outcasts with which he could identify. Culturally, as had been pointed out to him all too many times, he was still very much influenced by Europe, but the handicap of being a Russian immigrant would eventually turn into an asset in the art world. Under the dual tutelage of Max Weber, a Russian Jew who had integrated the lessons of Paris better than anyone else, and Milton Avery, a pure-blooded American who singlehandedly led the way for Modernism in 1930s New York, Marcus Rothkowitz soon got his bearings.

Weber had arrived in Paris in September 1905 at the age of eighteen. At that time, the French capital appeared, in his words, as "a veritable melting-pot in the history of art. They were years of renewal that took on the nature of a spiritual and aesthetic revival. . . . Cézanne's spirit and concept reigned supreme. Young aspiring painters from all over the world sat for hours at a time, analyzing Cézanne's color construction and design; his alluring archaic type of beauty and austerity, which rehabilitated and enriched the art and the intrinsic meaning of painting then, and for all time."[9] And while little Marcus was studying the Talmud in Dvinsk, Weber, who was born in Bialystok in the Pale of Settlement sixteen years earlier, frequented the Steins' salon in Paris. Of all the American students in the French capital in those years, Weber was the one closest to the young Picasso, sharing his passion for African art and the works of Henri Rousseau. Max Weber personally transported sixty-four drawings by Picasso from Paris to New York, where Alfred Stieglitz exhibited them at Gallery 291—the Spanish master's first exhibition in the United States. Weber and Rothkowitz immediately connected, each having experienced both Jewish orthodoxy and the pogroms under the Russian Empire. Weber was an excellent teacher, and his still-life classes attracted more than forty students, while those of his fellow teachers had only eight or ten. His artistic advice was wide ranging, and Marcus R. heeded it. He suggested referencing Cézanne's compo-

sitions and Matisse's colors and, asserting that art went far be-
yond a simple representation of reality, believed that the artist
was a prophet.[10]

As for Milton Avery, he was a self-taught painter, well con-
nected to Brooklyn's Jewish community through his wife. There
he had become the mentor to various young artists, includ-
ing Adolph Gottlieb, Barnett Newman, Joseph Solman, and
Louis Schanker—the same collective Marcus R. joined. With
his attraction to stylized forms and primary colors, Avery was
clearly embracing the lessons of Matisse and Cézanne. Under
his influence, Marcus R. profoundly altered the way he painted,
and he would subsequently refer to Avery as a mentor: "It was
true for many of us who were younger, questioning and look-
ing for an anchor. This conviction has never faltered. It has
persisted, and has been reinforced through the passing decades
and the passing fashions."[11]

Avery, who unreservedly embraced the lessons of the Eu-
ropean Modernists, exemplified the effects of the Armory
Show. This legendary exhibition which, according to art histo-
rian Meyer Schapiro, marked a "point of acceleration," deeply
transformed the ecology of the art world, and, consequently,
according to Schapiro, "the advancing historical present was
forced upon the spectator by the art of Spaniards, Frenchmen,
Russians, Germans, Englishmen and Americans, of whom
many were working in Paris." Finally, Schapiro commented,
"The moment belonged to the whole world. Europe and Amer-
ica were now united in a common cultural destiny, and people
here and abroad were experiencing the same modern art that
surmounted local traditions."[12] Thwarted by the often narrow-
minded Puritan views of the early settlers, the art world was
then slowly developing in the United States. In the end, the
essential elements—a "point of acceleration," the "awareness
of modernity," the "universal notion of time," the "lesson in
internationalism"—so astutely described by Schapiro would

reach the heart of the country partly thanks to a specific group
of artists: the Jewish immigrants who, shaped by European
values and at odds with Regionalists' preoccupations, had no
other choice but to abide by them. No wonder Marcus Roth-
kowitz was among them.

Without a doubt the 1930s constituted the most significant
decade in American visual arts. In November 1929, when the
Museum of Modern Art opened, its young director, Alfred H.
Barr, Jr., who had scoured Europe and scrutinized its muse-
ums, launched a brand new experimental space in the heart of
Manhattan. Sowing the seeds of European Modernism in his
own country, he did not favor American artists, nor did he give
special treatment to artists from any particular country. But
his resolutely Modernist vision and his plan for a permanent
collection within an institution representing "a transnational
order of cultural forms" accelerated the acceptance of Ameri-
can artists into the broader art world.[13] Nonetheless, local crit-
ics and artists, who felt ignored by him, looked harshly upon
Barr's artistic choices. In 1936, after the *Cubism and Abstract Art*
exhibition, members of the American Abstract Artists picketed
in front of MoMA. "How Modern Is the Museum of Mod-
ern Art?" one of their leaflets asked. "Let's look at the facts.
The museum is supposed to exhibit the art of our era. Art of
whose era? Sargent, Homer, Lafarge and Harnett? Picasso,
Braque, Léger, and Mondrian? What era? If it's that of the de-
scendants of Sargent and Homer, then where are the descen-
dants of Picasso and Mondrian? Where is American Abstract
Art? Shouldn't the concept of Modernity include the Avant-
Garde?"[14] Marcus Rothkowitz's artistic education was built on
the encyclopedia of Modernism Alfred H. Barr assembled at
MoMA, including first-class historical exhibitions like *Cubism
and Abstract Art* in 1936 and *Fantastic Art, Dada, Surrealism* in
1938, and he benefited from New York's accelerated transfor-
mation into a world capital of Modernism in just a decade. In

1939, Hilla Rebay widened the field even more by opening the Museum of Non-Objective Art on 54th Street at Fifth Avenue, with works by Kandinsky, Mondrian, and Klee from the Solomon R. Guggenheim collection.

Around the same time, a national movement initiated by President Roosevelt, and spurred on by the Great Depression, started promulgating a purely local art culture in America's heartland. In contrast to MoMA's European-influenced Modernist style, a more American-based nostalgic style was in the making—two antagonistic yet complementary dynamics simultaneously at work on American soil. On September 5, 1938, in an unprecedented initiative, the Works Progress Administration opened more than one hundred and fifty cultural centers throughout the United States, introducing various art programs to an audience of more than four million people— as many as the combined number of visitors to MoMA and the Metropolitan Museum of Art that same decade. More than 1,150 frescoes and 42,406 paintings were produced to decorate 13,458 public buildings all over the country. As anticipated by presidential adviser George Biddle, these frescoes, which emphatically represented the "democracy in art" Roosevelt had envisioned, became the favorite creations of the American people. Under this program, Marcus Rothkowitz earned a monthly salary ranging from $91.10 to $103.40 between June 1936 and August 1939, in exchange for the easel paintings he created in about sixty hours of work per week. Around this time, Jackson Pollock assisted Thomas Hart Benton in the execution of large, realistic frescoes; Willem de Kooning helped Fernand Léger in a similar project; and Orson Welles taught Shakespeare to children in Harlem, contributing to the heroic decade during which the country's post offices, train stations, airports, schools, universities, and federal buildings were covered in glorious representations of American history. As a consequence of this unprecedented project, artists in the United

States were at last perceived as useful citizens, and during a period of economic crisis, no less.

In the same vein, another institution was created in New York during the month of November 1931: the Whitney Museum, devoted to contemporary American art. This collection had been amassed entirely by Gertrude Vanderbilt Whitney, an artist and a patron who had studied sculpture in Europe with Rodin. "I have collected during these years the work of American artists because I believe them worthwhile and because I have believed in our national creative talent. Now I am making this collection the nucleus of a Museum devoted exclusively to American art—a Museum which will grow and increase in importance as we ourselves grow."[15] As for Marcus R., his breakthrough as an artist benefited from this propitious time—from the combined effects of internal factors specific to American society (the dynamics of civil society as well as educational, philanthropic, and fiscal projects), and external ones in connection with the political and demographic changes that were taking place at the same time in most European countries.

"How many galleries were there in town?" Joseph Solman wondered about New York in the 1930s. "Sixteen galleries in the whole town? Most of them handled Old Masters. So we got to drinking coffee, visiting each other's houses and so forth and so on."[16] Despite these ongoing changes, local artists remained desperately isolated. And so, The Ten was formed, a group of actually nine artists who, according to Solman, had "in a way the mark of the damned on them and were homeless in the art arena. . . . The term 'expressionist' was subversive at the time."[17] In fact, they were united more by a social project than by a single aesthetic allegiance, for in 1936, Ilya Bolotowsky and Louis Schanker, two of The Ten, founded a parallel group, the American Abstract Artists, to broaden the visibility of abstract art at a time dominated by Social Realism and Regionalism. More than anything, The Ten were bent on establishing

their identity in opposition to artists whom traditional galleries had chosen to promote. "It started because galleries were showing too many artists that we didn't like—too many dark, romantic pictures," Solman said. "We felt our drawings were more honest . . . and that we were doing better work."[18]

It is hard to capture the essence of this group of nine artists—all men, all first- or second-generation Eastern European immigrants, all politically committed and involved in teaching or writing—which included Marcus Rothkowitz, Ben-Zion Weinman, Ilya Bolotowsky, Adolph Gottlieb, Louis Harris, Yankel Kufeld, Louis Schanker, Joseph Solman, and Nahum Tschacbasov. They came together to talk about Matisse, Cézanne, Soutine, and Picasso before deciding to join forces, in spite of their incredible range of styles and projects, to contend with art dealers and museums. This group of rebels, hostile to established institutions and brought together by social affinity, disconcerted the newspaper critics, who failed to understand them, and some found it easier to bluntly dismiss their work. "Perhaps they can be loosely grouped as 'expressionists,'" a *New York Times* critic wrote. "The pictures are mostly such as to give any one with the slightest academic sympathies apoplexy. While wishing them full measure of success in their efforts to be individual, I personally feel that there is much needless obscurity and reasonless distortion in most of the work."[19] Others attempted irony. "Expressionism is relaunched by The Ten (who are nine, but looking for a tenth hand) in their first show as a group at the Montross Gallery," reported the *New York Post*. "Most of these artists are really not ready to show yet. Louis Schanker and Louis Harris are probably the most developed. Bolotowsky, Tschabasov and Solman look as though they may soon score some direct hits. Rothkowitz still swings pretty wildly."[20]

After taking on the galleries, The Ten turned against the Whitney Museum, exhibiting at the Mercury Galleries three

days before the opening of the Whitney's Biennial in 1938. With Regionalist art as their target, they lamented the situation of a "public which has had 'contemporary American art' dogmatically defined for it by museums as a representational art preoccupied with local color [and with] a conception of an art only provincially American and contemporary only in the strictly chronological sense."[21] Having sidelined their enemies, The Ten tried to define their own identity: "For four years, THE TEN have been exhibiting as an articulate entity," they wrote. "They have been called expressionist, radical, cubist and experimentalist. Actually, they are experimenters by the very nature of their approach, and, consequently, strongly individualistic."[22]

Subsequently, The Ten descended on the New York art scene with a series of systematic blitzes; they ultimately found themselves embroiled in a new conflict with their latest gallery, the Mercury Galleries, which they decided to leave, sending the directors a curt letter, apparently written by Rothko and Gottlieb. "Gentlemen: I am sorry to inform you that The Ten will not be able to exhibit in your gallery during the rest of the season. Since our exhibition in your gallery, certain problems of reorganization have arisen which have made it necessary to abandon all exhibition activities for the present season. We hope that you will have no difficulty in rearranging the exhibitions for whatever time you had intended to allot us."[23] The directors, Sidney Paul Schectman and Bernard B. Braddon, responded philosophically and dismissed the artists' feeling of rejection: according to the gallerists, The Ten especially resented the Whitney Museum with its "glittering shows going on," its "famous people coming in," and its "fine openings," but "where they remained out in the cold somewhere, unrecognized, hoping to be recognized."[24] The group trudged along, making a last stop at the Bonestell Gallery, before finally breaking up in 1940. In retrospect, the irony of the situation is inescapable.

Despite their boisterous demonstrations, meant to shake the conservative and backward-looking art institutions that mainly focused on Europe, The Ten remained a voice crying in the wilderness. What if its virulence had been triggered by decades of indifference and passivity toward art, in a country marked for too long by philistinism?

During that period (from 1928 to 1939), Rothkowitz produced landscape watercolors, gouaches, as well as oil paintings representing enigmatic phantom figures; they started as massive, elephantine, shapeless patches of color jostling together in strange scenes but became more spindly over the years, still keeping their isolated and distorted twist, as in the works of Soutine and the German Expressionists. According to the general consensus, Marcus Rothkowitz never stood out as a great draftsman and could even at times appear clumsy in the execution of his oil paintings. "Although he paints the figure chiefly," the *New York Sun*'s art critic noted laconically at the time, "his peculiarly suggestive style, with its dependence on masses and comparative indifference to establishing any markedly definite form, seems better adapted to landscape, and watercolors."[25] Among his works from this period, let's now consider the most elaborate ones: *Street Scene*, 1936, and *Entrance to Subway (Subway Station/Subway Scene)*, 1938 (Plate 2)—two monochromes, the first in beige, the second heightened with blue verticals; two silenced and mastered "snapshots"—in which the artist, struggling to transcend the banality of the scene, excels at guiding his ghostly characters into a controlled interaction with their surroundings, and effectively avoids all chaotic proceedings from the street or the subway.

A few days after Franklin Roosevelt won his first presidential election in November 1932, the artist married Edith Sachar, a young woman of Jewish-Russian origin whom he had met at the Hearthstone Point camping site. But this union did not last and they divorced eight years later. In the meantime,

though, Marcus Rothkowitz had gained both financial stability and intellectual maturity thanks to his teaching job at the Brooklyn Jewish Center's School Academy, a position he would hold from 1929 until 1952. In this progressive school that subscribed to the theories of the philosopher John Dewey, Rothkowitz came to master his very own political thoughts. The aesthetic experience, which, according to Dewey, remained "the effect of unity and totality," because it "freed from the forces that impede and confuse its development as experience,"[26] became the focus of Marcus Rothkowitz's interests at the Center, where he worked with children of all ages. "Painting is just as natural a language as singing or speaking," he wrote in the Center's *Review*, expounding at length on his teaching approach, which he conceived of as a fundamentally political activity. "It is a method of making a visible record of our experience, visual or imaginative, colored by our own feelings and reactions and indicated with the same simplicity and directness as singing or speaking. . . . The function of the instructor is to stimulate and maintain [the children's] emotional excitement . . . and above all to inspire self-confidence on their part, always, however, taking the utmost care not to impose laws which might induce imaginative stagnation and repetition."[27]

In fact, as he brought to light the talent of his students, the art teacher would draw striking parallels—"an analogy exists between the art of children and these works which have occurred in the history of the world and which society has accepted as art"—or else raise thorny questions—"Is the child mad, the madman childish, and does Picasso try to be a little of both?"—before finally concluding that "all of them employ the basic elements of speech."[28] His remarks echoed those of Alfred Stieglitz, who since 1908 had exhibited in his gallery works of arts done by children and mental patients, as well as Auguste Rodin's erotic drawings. During this first artistic phase, the

painter Marcus Rothkowitz was undertaking a complex social project in which art became the vehicle of a new system of political values and in which the transmission of knowledge was akin to the ethical principles of a Jewish education.

It seems fitting to raise a question relevant throughout Marcus R.'s career: Why, when during the previous centuries Jews had generally been absent from the visual arts, did the dawn of abstraction coincide with their entrance into the world of art, with Jewish collectors, critics, artists, and dealers detecting, supporting, and following the lessons of the first Modernists? Leo Steinberg put forward an explanation whereby "like modern painting, Jewish religious practices are remarkably free of representational content," which "possibly explains why many young Jews find it easy to become modern painters."[29] It is undeniable that they strongly contributed to spread Modernism in the United States. According to Yuri Slezkine, who describes these Jewish artists as supremely fruitful in all of their modern initiatives, the epithet "mercurial" certainly applies to them in the context of American art.[30]

Among the collectors was the Stein family, which included Leo and Gertrude as well as their brother Michael and his wife, Sarah—a friend of Matisse's who developed a school around the French master. Then came Alfred Stieglitz, whose family, just like the Steins, had immigrated from Germany to the United States in 1849. In a sense, the Steins were exact counterparts of the Stieglitzes. They belonged to the same generation and had made their fortune in the United States during the Civil War, raising their children in Europe (the Stieglitzes in Berlin, the Steins in Vienna). They all experienced the same pressure for higher education, and had the same cultural depth, an amalgam of admiration for Old Europe and a devotion to the United States. Then there were the Guggenheims, whose Museum for Non-Objective Painting would become the Guggenheim Museum in 1953. There were also the Warburgs, whose son

Eddie became a trustee of MoMA and offered his private home on Fifth Avenue to house the Jewish Museum. There was, finally, Paul Sachs, a descendant of bankers and the founder of Harvard's renowned Museums Studies program, which trained successive generations of museum directors, beginning with Alfred Barr. "It was designed to implant scholarly standards in future museum workers; to educate their eyes so that they might be helped to see."[31] His ambition was no less than to create a new profession and train what he called "connoisseur-scholars."[32] He intended the role of this new American, this new guide, to be "first and foremost a broad, well-trained scholar and a linguist, and then in due course, a specialist."[33] In the same way, the new museums of twentieth-century America would no longer stagnate as a kind of "Ali Baba's cave," but begin to transmit an "educational system."[34] In this respect, the German Jews' powerful network played a pivotal role in the American museum world.

There were the critics as well, among them the art historian Meyer Schapiro, a professor at Columbia University. Like Steinberg, Greenberg, Rosenberg, Hess, Rosenblum, and others, Schapiro would follow Rothko's career in the years to come. And finally were the artists. Rejecting the local artists' Regionalist perspectives, they were unable to define themselves as mere U.S. citizens. Instead, they presented themselves as cosmopolitan internationalists, freer and more open to incorporate the intercultural lessons of the European Modernist avant-gardes. When the Fascist regimes began to decapitate these new art movements (with the closing of the Bauhaus in 1933 and the mounting of the exhibition *Entartete Kunst* [Degenerate Art] in Munich in 1937), great masters like Josef Albers and Piet Mondrian made their way to the United States, and American Jewish artists welcomed them with open arms. Halfway between the European Modernists and their fellow American artists, they served as exemplary "agents."

As for Mark Rothko, by shrewdly inserting himself in Jewish community organizations and identifying the trends of his day, he became a major player in the social struggle of American artists, and his own metamorphosis benefited from the unique transformation of the art world in the United States during this time.

5

In Search of a New Golden Age: 1940–1944

Why did Rothko write the book?
And why did he never finish it?
—Christopher Rothko

Art is not only a form of action, it is a form of *social* action.
—Mark Rothko

THE 1940s were crucial years for Rothko. In less than a decade, the painter expressed himself through a remarkable variety of stylistic phases, before the majestic power of his pictorial rhetoric was revealed once and for all. At a pace unprecedented in art history, his painting shifted from figurative to Mythological in 1940, then Surrealist in 1944, Multiform in 1946, and, ultimately, colorist abstract in 1949. Yet, this critical period began with a "painter's block" that lasted over a year. Rothko was thirty-six years old at the time, with a receding hairline and

a burning, intense gaze softened by his thick eyeglass lenses. A tall and imposing man, he was by all accounts unathletic (in 1941 he was declared 4F by the Selective Service System: "registrant not acceptable for military service"). Even while working in his studio, he typically wore a shirt and a tie. Destabilized by the mediocrity of New York art circles, the gradual disintegration of The Ten, his rejection from the army, his faltering marriage, and the political events in Europe that would inexorably lead to World War II, he found himself struggling. After the German-Soviet Pact was signed and the USSR invaded Poland in September 1939, he resigned from the American Artists' Congress for siding with the Soviet Union and took part in the founding of the Federation of Modern Painters.

Through this organization Rothko continued to express himself politically and joined its most influential bodies: the exhibition committee, the membership committee, and the cultural committee, whose chairman was his friend Adolph Gottlieb. At the New York World's Fair, which ran from May 1939 to late October 1940 in Flushing Meadows Park in Queens, Rothko showed some of his work as part of the exhibition *American Art Today*. Held in the twenty-three galleries of the American Art Building's elegant rotunda, built by architects Frederick Ackerman, Joshua Lowenfish, and John Van Pelt, the show offered ideal space to showcase paintings. Its brochure pompously proclaimed, "Here are the materials, ideas, and forces at work in our world. These are the tools with which the World of Tomorrow must be made. They are all interesting and much effort has been expended to lay them before you in an interesting way. Familiarity with today is the best preparation for the future."[1]

But this fanfare heralding a radiant future could not save a man in crisis. How did Rothko eventually work his way out of this hole? In yet another display of self-reinvention, he decided to stop painting and, as he told friends, set out to "write

a book." Unpublished, the manuscript sank into oblivion and remained hidden for more than sixty years, until his son, Christopher, rediscovered it in 2004. "Why did Rothko write the book?" Christopher wonders. "My father was first and last a painter. . . . It was therefore a very radical move for him to put down the brush after nearly twenty years and devote himself to writing. . . . His painting was, and would remain, about ideas. The writing of the book was simply a different way to get them out into the world."[2] In transcribing, introducing, and publishing these abandoned pages under the title *The Artist's Reality*, Christopher not only unearthed the book, but also resuscitated Rothko's voice from six decades earlier, giving his father new life.[3]

"What is the popular conception of the artist? Gather a thousand descriptions, and the resulting composite is the portrait of a moron: he is held to be childish, irresponsible, and ignorant or stupid in everyday affairs," declares an irate Mark Rothko at the outset of his 1940 manuscript.[4] While his diatribe on the social status of the artist begins with a reference to his own historical context, the analysis progressively expands to a wide range of periods and cultures, encompassing reflections by such predecessors as Leonardo da Vinci and Giotto. At the time he was writing the manuscript, Rothko read and worked frenetically. Weaving together historical periods and geographical areas in his manuscript, he aimed to draw a geopolitics of the art before his time (in Byzantium, Egypt, Holland, Renaissance Florence). Following the disappointing and traumatic experiences he had suffered in Portland and at Yale, after opposing not only the Regionalist painters, but also New York galleries and museums, Rothko was unleashing his passions in writing. His manuscript took the form of imaginary expeditions in space and time, as if he was trying to escape the present deadlock in which he felt trapped. Posing as both the dramatist and the great redeemer of the artistic cause, Rothko brought to center stage fellow painters who, in his eyes, were

constrained by their dogmatic and authoritarian societies, fraught with oppressive rules and mores. "Most societies of the past have insisted that their own particular evaluations of truth and morality be depicted by the artist. . . . Authority formulated rules, and the artist complied."[5] But, he continues, "The history of art is the history of men who, for the most part, have preferred hunger to compliance."[6] "And we find Ingres, David, Corot, Manet, Courbet, and Delacroix battling against the excoriating indifference or hostility of the populace."[7] In the passages addressing contemporary society, Rothko advocates for the artist as a citizen who has acquired a sense of responsibility and commitment, who voices his own demands, refusing to submit. "Today, instead of one voice, we have dozens issuing demands. . . . For the artist, now, there can be neither compliance nor circumvention."[8]

In 1940, therefore, Rothko's first intellectual discovery amounted to good news: the days of the passive, submissive artist were over. His second discovery, however, was not nearly as good: the collectors and patrons who had fostered generations of artists during art history's mythic golden ages were desperately lacking in American society, which eagerly praised businessmen and pioneers, but rarely artists. And what hurt Rothko most in his professional life was undoubtedly the indifference of his fellow citizens toward the arts. In this regard, his text sometimes gives way to nostalgia: "Fortunate indeed have been those artists living in the golden age of Pericles, or patronized by the cultured merchants of the Renaissance or by the iconoclastic soldier-poets of the Trecento."[9] "Obviously," he writes, "we cannot but look with envy at those societies where, within the span of a century or less, a series of geniuses appeared who contributed endless pleasure to the world and made the locations within which they worked synonymous with the greatest cultural achievements . . . the Greece of Pericles, or the Florence of Giotto, or the France of the cathedral. . . . These all

constitute golden ages for us, and our desire for one is no less strong for all our doubts to its possibilities."[10]

In a singular exercise of spatial-temporal decentering, from his gigantic and solitary work area, Rothko sets out to revisit the experience of his artistic predecessors and peers while examining the basis of Western culture from a universal perspective. A radical but disciplined scholar, using the rhetorical tools of the Talmud and its tradition of study, he engages in a series of challenging one-on-one conversations with an imposing list of great names of the past: Plato and Nietzsche, Shakespeare and Michelangelo, Freud and Jung. Such initiatives prompted Christopher Rothko to emphasize that his father belongs to "the artistic tradition but sets himself apart—he is an intellectual and to be taken quite seriously." While Mark Rothko's stance reflects a certain confidence in his own ideas, it also reveals an insecurity that stemmed from "his lack of recognition" at the time.[11] What motivated him to maintain fictitious conversations with renowned Western thinkers of the past precisely during these years of world war? Was he perhaps seeking to reassure himself of the continuity of this intellectual tradition at a time when it was threatened? Or was he rather positioning himself as an artist and an intellectual in this great European lineage? As his son perceptively points out, Rothko sees himself on the side of continuity and not innovation, as one might have presumed: "It is striking that this artist who by appearances broke so dramatically with prior tradition, sees himself not in the vanguard of the new, but as someone carrying forth the torch of the great Western artistic tradition."[12]

Further along in the text, using botanical metaphors and references to a pioneering model of transnational history, Rothko performs an analysis of the complex interacting factors that create an "ecology of the art world": "For the history of many artists is more often a defiance of the prescriptions and the proscriptions of the environment than it is a resignation

to them. . . . And like a plant there are a million factors which daily would lead to the artist's destruction. The plant, as well as the artist, must overcome these environmental demands if they are to survive."[13]

As a result of his Talmudic education in Europe and his intellectual training in the United States, throughout his various conflicts with local institutions Rothko always addressed his adversaries in written form (philosophical essays, poems, articles, plays), in the proper fashion of a Jewish intellectual respectful of the Book. After he decided to leave Yale in 1921, disappointed by an institution that failed to respect its educational contract, he deliberately chose a career in art for reasons that could be interpreted as social and political. He did not embrace the visual arts as a result of any traditional education in them, which might have led him to discover his talent (as was the case of John Singer Sargent, for example), but because he had become convinced that the social role of the artist best supported all of his projects. In addition, the status of an artist would at last enable him to create a true identity for himself in the United States' social landscape and, making his own Sartre's wager before its day, to build a persona that would not be bound by either ethnic or religious affiliations. "Therefore, the fact that a man was rich or poor," he writes of the Artist with a capital A, "that he lived in a flat or hilly country, that he was shy or forward with women, or that his parents had inherited traits that are associated with temperate or torrid climates or with what are considered the attributes of the Anglo-Saxon or Latin race—these circumstances may explain why the artist's part in the plastic continuity showed this or that peculiarity. Yet in spite of any peculiarity, he nevertheless functions definitely and inexorably within the plastic process—nothing else is possible here."[14]

Rothko's vision of art history draws comparisons with Hegel's: art lives through the artist in accordance with a final

purpose, evolving with each new generation, for, the painter insists, "art, like thought, has its own life and laws."[15] The artist performs "a dual function": first, he furthers "the integrity of the process of self-expression in the language of art" and protects "the organic continuity of art in relation to its own laws."[16] According to Rothko, the artist's mission *immunizes* him against the prejudices of a materialistic society, and, beyond fulfilling the "biological necessity for self-expression," art "is not only a form of action, but of *social* action," he asserts.[17] Hence, the artist's capacity to transcend cultural and geographical boundaries has less to do with the internationalization of the art market and the arrival of European painters in the United States than with his own role as a vector of Modernity. In looking at the time horizon, Rothko also manages to escape the weight of his own suffocating social reality. Could this explain why, opting, like so many other Jewish immigrants, to Americanize his family name, he chose "Rothko," a more opaque and less ethnically identifiable patronymic than "Roth," the one picked by his brothers?

Just when Europe was entering the most horrific catastrophe in its history, Rothko expresses, for the first time, his passionate attachment to the old continent. The list of the major events for 1940 speaks for itself. On April 9, Nazi Germany invaded Denmark and Norway. By May 10, the Netherlands, Belgium, and Luxembourg were occupied. The Reich's armies then marched toward France and, on June 14, occupied Paris. Obsessed with Europe, Rothko developed his concept of the artist's intellectual dimension as if he were creating a talisman. "My father wrote the book because he could not, at that point, express the ideas it contained to his satisfaction in his own painting," Christopher Rothko explains. "And he abandoned the project because of a reawakening in his painting that allowed him to express those ideas more effectively through art than he could on paper."[18] And so, at the conclusion of

this Promethean intellectual journey, a year after setting his brushes aside for the pen, fortified and inspired by the "great torch of European tradition," Rothko went back to painting.

No wonder, then, that the new paintings Rothko began producing in late 1940 all explicitly referred to European tradition. However, it wasn't the real Europe of his contemporaries, but the Europe of his birth—Mother Europe, the cradle of civilization. Indeed, the titles he gave his works at that time were inspired by Greek, Egyptian, and Mesopotamian mythology and, to a lesser extent, as in his 1941 paintings *Antigone* and *Crucifix*, by Christianity. Should we question the choice of the title *Crucifix* by a former *heder* student and an intellectual who never repudiated his Jewish background? Influenced by the reading of *Birth of Tragedy* by Nietzsche and *The Golden Bough* by the Scottish anthropologist Sir James Frazer—one of the first studies in comparative religion, which held that there is no clean break between pagan myths and the "myths" of the new monotheistic religions—Rothko returned to painting in a completely different frame of mind, creating a far more inclusive cultural space for his new works than he had done before, and embracing both Greek mythology and Christian references.

Although inspired by ancient myths, Rothko's works endeavored to question the future as much as to recall the past. He increasingly reflected on themes such as destiny, transcendence, and what Walter Benjamin, who had died tragically in September 1940, described as "one single catastrophe," the "storm" that is the "liberation of history."[19] "The theme is derived from Agamemnon's Trilogy of Aeschylus," Rothko wrote about his 1942 painting *The Omen of the Eagle*, before developing his intention: "The picture deals not with the particular anecdote, but rather with the spirit of myth, which is generic to all myths of all times. It involves a pantheism in which man,

bird, beast and tree, the known as well as the knowable, merge into a single tragic idea."[20]

Let us pause for a moment over *The Omen of the Eagle*. The painting is a construction of superimposed friezes: a row of five frizzy-haired heads resting upon another row of two stylized eagles sitting on colonnades, which stands on a conglomeration of clogs and feet. Let us recall the specific episode from the *Iliad* serving as its inspiration: the Greek army, waiting to sail for Troy, catches sight of two eagles swooping down on a pregnant hare, presaging the victory of the two "eagle kings," Agamemnon and Menelaus. Following this sign, Agamemnon consents to his daughter Iphigenia's sacrifice, convinced that it will allow his ships to set sail, but it does not prevent his own final assassination by his wife, Clytemnestra. While drawing inspiration from this dramatic myth, Rothko decided not to illustrate it literally, but instead to allude to its overall meaning. In 1942, undeniably aware that the eagle was Nazi Germany's national emblem, the public could not have failed to understand the painting's poisonous omen. In fact, during those years, Rothko was not the only one who turned to the myths of antiquity to allude to World War II. In Nazi-occupied Paris, Jean-Paul Sartre used the myth of Orestes in his play *The Flies* to expose "the complacency of repentance and shame" promoted by Marshal Pétain under the Vichy government.[21] Orestes appears as a free and solitary hero who, in an act of self-realization, manages to free himself from his "bad faith" toward the political situation of his time. Just like Sartre in France, Rothko was misunderstood by the public at the time, as evidenced by the sharp reaction of *New York Times* art critic Edward Alden Jewell, who rejected Rothko's Mythological stand as a superficial one: "Mark Rothko stylizes decoratively, though not often exhilaratingly."[22]

Writing his manuscript not only led Mark Rothko to initiate his Mythological phase, but also allowed him to begin his

"search for unity," in his son Christopher's words. Demanding dignity for the human being, whom History had made captive, was the painter's only solution to transcend the "catastrophe" announced by Walter Benjamin. According to Rothko's vision, by introducing into his work the supernatural elements cast aside by the Enlightenment and scientific progress, the artist could fill the void left by the disappearance of the prophets and oracles. "Yet the absence of the myth," the painter insisted, "cannot deprive man of the desire for heroic deeds . . . as men could not live long without gods."[23]

Rothko's fervent pursuit of unity is reminiscent of one of Judaism's key concepts: that of the *tikkun olam*, or the "repairing of the world." "Rothko has little patience with the Europeans' quest to dissect, when, for him, the role of art is to synthesize," his son writes, stressing that his father's goal was "mending, not dismembering."[24] Prophecy, another core concept of Judaism, allowed him to fix not just the world as it was but also the world as it had always been through the ages. In prophecy, Rothko found a way of giving meaning to History by imparting a clear direction to it, a *telos*. It may not be a coincidence that, at the same time Rothko was seeking to give pictorial form to Oedipus (Plate 3), Antigone, and Tiresias,[25] the German historian Heinrich Zimmer was offering a seminar at Columbia University on the role of myth in an increasingly complex world, and the author Joseph Campbell was publishing *The Hero with a Thousand Faces*, a study that traced Jungian archetypes throughout Western literature. Four decades later, when interviewed about Rothko for the Archives of American Art, Elaine de Kooning would simply describe him as "hypnotized by his own role," adding, "and there was just one. The role was that of the Messiah."[26]

Rothko did not remain politically inactive for long, and the buzz of activity at the Federation of Modern Painters, which

organized a series of annual exhibitions at the Riverside Museum in March 1941, facilitated his return to painting.[27] "I have been peddling my pictures again," he wrote to a friend at the time. "I think you will be surprised by my new pictures, there has been another transition with some excellent results."[28] Two specific events in the year 1942, while particularly irritating to Rothko and his friends, also provided them with an opportunity to define their aesthetic perspective more acutely and determine their position on New York's various art institutions and artistic groups. When, in February 1942, MoMA presented its sweeping exhibition *Americans 1942: 18 Artists from 9 States*, the Federation of Modern Painters vigorously opposed what amounted, in their view, to "reducing American art to a demonstration of geography."[29] Similarly, when on December 7, on the first anniversary of Pearl Harbor, the Metropolitan Museum of Art organized the catch-all exhibition *Artists for Victory*, consisting of 1,418 works by contemporary artists—John Steuart Curry took first prize—the Federation vehemently criticized the works, calling them realist and isolationist.

A few weeks later, the Modernist group responded with the exhibition *American Modern Artists* at the Riverside Museum. In the show's catalogue, Barnett Newman cautioned the public against "isolationist art [that] still dominates the American scene." Newman also predicted that America would soon "become the cultural center of the world" and that Regionalist nationalism was about to be replaced by a higher Modernist nationalism.[30] In this merciless struggle, fought on the front line of the still-depressed New York art scene, Rothko's friendship with Newman and Gottlieb proved helpful. Newman was going through a difficult time: he, too, had stopped painting in 1940, but his period of inactivity would last much longer than Rothko's, until 1944, contributing to his isolation from the art world. "We felt the moral crisis of a world in shambles, a world devastated by a great depression and a fierce World War,"

Newman declared unyieldingly. "It was impossible at that time to paint the kind of painting that we were doing—flowers, reclining nudes, and people playing the cello. . . . Painting is finished, and we should give it up."[31] As for Gottlieb, he was in a better place. With him, Rothko embarked on his Mythological artistic phase, as an alternative response to the challenges of history.

While writing his manuscript throughout 1940, Rothko had Europe on his mind as he also rubbed shoulders with European émigrés daily in New York. In fact, the Europeanization of the city's art world during World War II strongly influenced his own artistic evolution. For the European visitors of the time, however, the New York gallery scene seemed hopelessly provincial. Compared with Paris, "it was a desert," Ileana Castelli reminisces, and the local artists still remained largely unseen.[32] "In 1940," Newman later admitted, "some of us woke up to find ourselves without hope—to find that painting did not really exist."[33] In the same vein, Gottlieb remarked that "a few painters were painting with a feeling of absolute desperation. The situation was so bad that I know I felt free to try anything no matter how absurd it seemed."[34]

So it was in a state of dreary isolation that New York artists witnessed the comings and goings of thousands of Europeans between 1936 and 1948. The European community of painters forced into exile by the war formed a very warm group in which "a climate of intellectual exaltation held sway."[35] Interestingly, these tragic circumstances brought about many chance encounters between the European émigrés and those Europeans who were passing through New York. André Masson and Claude Lévi-Strauss scoured the antiques dealers on Third Avenue, looking for artifacts from the Pacific Northwest, objects that, Lévi-Strauss recalls, "made you think that the entire substance of human heritage was present in New

York in the form of hatched and rehatched samples."[36] "New York," he went on, "was decidedly not the ultra-modern metropolis I had expected but an immense horizontal and vertical disorder."[37] A new map of the city of New York was being drawn in those years:[38] new territories, new forces, new educational institutions, new exhibition spaces, new magazines, new cafes, new habits. In this changing environment, foreign dealers, collectors, critics, and artists gleefully mingled with domestic ones.[39] Galleries opened by Europeans accelerated this artistic fusion, including one of Pierre Matisse, the renowned painter's son, which attracted a growing clientele in the Fuller Building on Fifty-Seventh Street. Pierre started selling Aristide Maillol's bronze sculptures and some of his father's finest paintings, before shrewdly exhibiting works by other European artists, including Joan Miró, Alberto Giacometti, and Raoul Dufy, who subsequently influenced their young American counterparts. Such spaces served as a crucible for the education of the European and American avant-gardes, allowing an American taste for Modernism to develop.[40] The number of European refugees grew so markedly that in March 1942 Pierre dedicated an exhibition to them, *Artists in Exile*. Already, changes were taking place. "Fortunately," James Thrall Soby wrote in his preface to the catalogue of the exhibition, "numbers of American artists and interested laymen are aware that a sympathetic relationship with refugee painters and sculptors can have a broadening effect on native tradition, while helping to preserve the cultural impetus of Europe. These Americans reject the isolationist viewpoint which ten years ago sought refuge, and an excuse, in Regionalism and the American scene movement. They know that art transcends geography."[41]

Peggy Guggenheim offered yet another opportunity for Europeans and Americans to cross paths. She came to New York in 1941 with her husband, Max Ernst. One year later, assisted by the Romanian architect Fred Kiesler, who had spent

much of his life in Vienna, she founded the Art of This Century gallery.[42] With its walls made of pliant, undulating fabric, Art of This Century consisted of a Cubist and abstract gallery, a realist gallery, and a film gallery. Guggenheim asked André Breton to help complete her art collection.[43] In 1942, he and Marcel Duchamp organized a memorable show, *First Papers of Surrealism*, which, along with Pierre Matisse's show *Artists in Exile* the following year, and James Johnson Sweeney's exhibition *Eleven Europeans in America* at MoMA three years later, solidified Europe's influence on the New York art scene. According to Alfred H. Barr, Guggenheim's influence grew rapidly and "Art of This Century immediately became the centre of the vanguard. Under the influence of Duchamp, Ernst and Breton, the Surrealist tradition was strong but never exclusive. The great abstract painter, Piet Mondrian, was also welcome and took an active part as a member of the juries which chose the recurrent group shows of young American artists."[44]

Through Howard Putzel, her assistant, Guggenheim soon heard about Mark Rothko. A stocky, moonfaced man with small, round glasses, Putzel had grown up in San Francisco, where, in 1935, he had opened a gallery before moving it to Hollywood Boulevard in Los Angeles and showing Surrealist artists such as Yves Tanguy and Joan Miró. He began corresponding with Guggenheim, eventually sending some Tanguys to her London gallery. In 1938, his gallery failing, Putzel left for Europe, where he and Peggy became close friends. Back in New York, Putzel started acting as Peggy's artistic adviser. Mark Rothko, who never missed an occasion to remind people of his Slavic atavism, rejoiced in Putzel's interest in his work and readily agreed to include his painting *Entombment* in the inaugural exhibition of Peggy Guggenheim's gallery, in the company of Picasso, Braque, Léger, Mondrian, Miró, as well as Jackson Pollock and Robert Motherwell. It was there that, in April 1944, while hanging *Entombment* for this *First Exhi-*

bition in America of Twenty Paintings, he met Robert Mother-well. They would become close friends for many years, bond-ing over their penchant for European tradition. "Some of [us] wanted to shatter Europe and . . . others wanted to continue Europe," Motherwell would later observe.[45]

Art historians consider 1943 a pivotal year: it was then that the U.S. artists who felt they didn't fit in with the American Abstract artists movement transitioned to abstraction.[46] That year, Jackson Pollock produced his *Mural* in a single night at Peggy Guggenheim's New York apartment, and Clyfford Still's constantly evolving style took a decisive turn in San Francisco. It was during the summer of 1943, following the Federation of Modern Painters' third annual exhibition, *Modern Painters and Sculptors Scene,*[47] that Mark Rothko, faithful to his personal ritual of public protest—as he had done in Portland in 1920, at Yale in 1923, in New York in 1938—sent Edward Alden Jewell, the *New York Times* art critic, an open letter in the form of a manifesto, cosigned by Adolph Gottlieb. To this day, it remains one of his most legendary texts. This letter, which involved at least six rough drafts, has become a primary source of specula-tions surrounding the origins of one of the most interesting ab-stract art movements in the United States. Does it really con-tain the secret key to Rothko's shift to abstraction, which he enacted in his art seven years later?

In examining the drafts, one immediately perceives Roth-ko's passionate need for recognition from Jewell, the leading art critic of the day. Some of the text in the drafts he even-tually omitted from the final version, presumably because he considered them too naive, speak for themselves: "I was glad to observe that your remarks concerning my painting [*Syrian Bull*] in the exhibition of Modern Painters & Sculptors seemed couched in the form of a question rather than with the hos-tility which has usually attended your reviews of my work."[48]

Rothko also self-censored the passages that betrayed his excessive expectations of critics' reactions: "We liked the violence of the reaction, whether in praise or disdain, because to us it was a proof that the picture struck home."[49] The final text, which reads like a very straightforward, square, and sound manifesto, does not reflect what for him must have been an extremely daunting writing process.

"We assert that the subject is crucial," Gottlieb and Rothko wrote in the published version, "and only that subject matter is valid which is tragic and timeless."[50] Further on, they attempted to define their own aesthetic position, both distinct from European research and opposed to the academicism of the local American Abstract Artists:

1. To us art is an adventure into the unknown world, which can be explored only by those willing to take the risks.

2. This world of the imagination is fancy free and violently opposed to common sense.

3. It is our function as artists to make the spectator see the world our way—not his way.

4. We favor simple expression of the complex thought. We are for the large shape because it has the impact of the unequivocal. We wish to reassert the picture plane. We are for flat forms because they destroy illusion and reveal truth.

5. It is a widely accepted notion among painters that it does not matter what one paints as long as it is well painted. This is the essence of academicism. There is no such thing as good painting about nothing. We assert that the subject is crucial and that only subject-matter is valid which is tragic and timeless. That is why we profess spiritual kinship with primitive and archaic art.[51]

In addition to asserting the subject's critical importance, their allegiance to "tragic and timeless" themes, their filiation to "primitive and archaic art," and their commitment to truth,

risk, and freedom, Rothko and Gottlieb, both of whom had left The Ten by this time, stressed the necessity of establishing an efficient communication with the public through large-format paintings. On October 13, they had the opportunity to hammer home their point on the WNYC radio broadcast "The Portrait and the Modern Artist." "Neither Mr. Gottlieb's paintings nor mine should be considered abstract paintings," Rothko asserted. "If our titles recall the known myths of antiquity, we have used them again because they are the eternal symbols upon which we must fall back to express basic psychological ideas. They are the symbols of man's primitive fears and motivations, no matter in which land or what time."[52] The two artists were insisting on the necessity of resorting to myth, which in time of war or repression may well be the only outlet for speaking, the only possible way to depict the present. "Those who think that the world of today is more gentle and graceful than the primeval and predatory passions from which these myths spring," Rothko stated firmly, "are either not aware of reality or do not wish to see it in art."[53]

Toward the end of 1941, Rothko sold his painting *A Last Supper*, 1941, to one of his friends, the writer H. R. Hays, who, welcoming what he perceived as a "radical change" in the painter's style,[54] invited him to a New Year's Eve gala dinner at the lavish Stork Club, followed by a party at the Pierre Hotel. However, this period of increasing artistic activity for Rothko also had its setbacks. During the summer of 1943, he separated from his wife and shared an apartment with Jack Kufeld, a former member of The Ten. "I had taken an apartment in a little hotel on 74th Street next to the Berkeley," Kufeld recalls. "Mark moved in with me. He was very unhappy and very disturbed. In a previous time we used to spend the night talking about art and what his aims were, and we sort of continued in that vein. And, as far as he was concerned, it was always the

same thing—that he was looking for the essence of the essential. That was his whole aim."[55] In trading his brushes for a pen during all of 1940, Rothko had embarked on a quest, searching out a new age for the artist. He succeeded in this intellectual tour de force by turning this initial artistic impasse, caused by nostalgia, into a far more dynamic quest for unity that would take various forms in the development of his style and thinking.

During his Mythological phase, Rothko sought this unity in the mythological archetypes of Western culture (outside the human being). In the following "Surrealist phase," he looked within his subconscious (inside the human being). During his "Multiform" period, he sought it in his sensory experience (midway between the two). All in all, his path took him in a very different direction from the conflicts that had hampered The Ten. "We have come together as American modern artists," his friend Barnett Newman stated with confidence, "because we feel the need to present to the public a body of art that will adequately reflect the new America that is taking place today and the kind of America that will, it is hoped, become the cultural center of the world."[56]

Plate 1. *Self Portrait*, 1936, oil on canvas,
81.9 × 65.4 cm. Christopher Rothko.

Plate 2. *Entrance to Subway* (*Subway Station/Subway Scene*),
1938, oil on canvas, 86.4 × 117.5 cm. Kate Rothko Prizel.

Plate 3. *Oedipus* (*Untitled*), 1940, oil on canvas, 91.4 × 61 cm. Private Collection.

Plate 4. *Hierophant* (*Untitled*), 1945, oil on canvas, 95.6 × 69.9 cm. Private Collection.

Plate 5. *Untitled*, 1948, oil on canvas,
127.6 × 109.9 cm. Private Collection.

Plate 6. *Untitled (Multiform)*, 1948, oil on canvas,
226.1 × 165.1 cm. Private Collection.

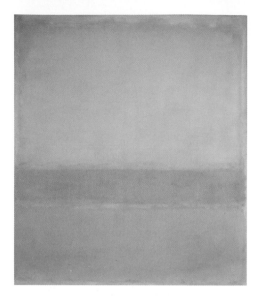

Plate 7. *Untitled (Yellow, Pink, Yellow on Light Pink)*,
1955, oil on canvas, 202.6 × 172.1 cm. Private Collection.

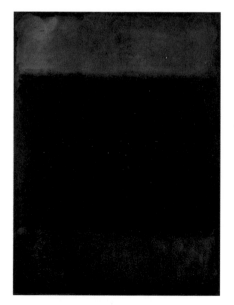

Plate 8. *Untitled*, 1955, oil on canvas, 207 ×
151.5 cm. Private Collection.

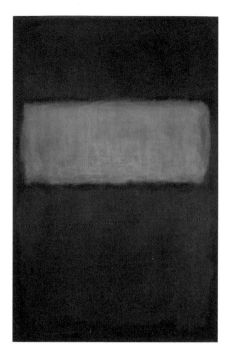

Plate 9. *No. 7[?] (Orange and Chocolate)*, 1957, oil on canvas, 176.9 × 110.5 cm. Private Collection.

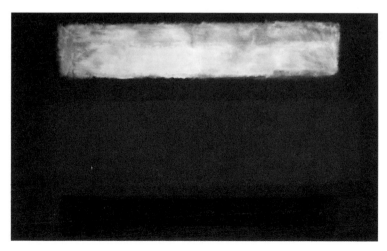

Plate 10. *No. 9 (White and Black on Wine) (Black, Maroons, and White)*, 1958, oil on canvas, 266.7 × 421.6 cm. Glenstone, Potomac, Maryland.

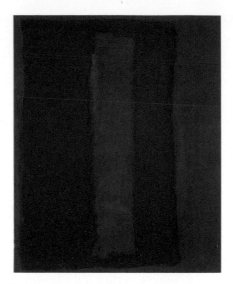

Plate 11. *Untitled (Seagram Mural Sketch)*, 1959[?], oil on canvas, 266.1 × 215.9 cm. Private Collection.

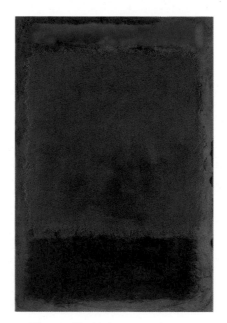

Plate 12. *Untitled*, 1959, tempera on paper, 96.75 × 63.5 cm. Private Collection.

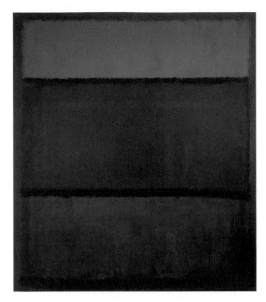

Plate 13. *Untitled (Orange, Dark Ruby, Brown on Maroon)*,
1961, oil on canvas, 266.1 × 235 cm. Private Collection.

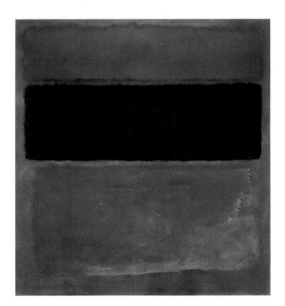

Plate 14. *No. 10/Brown, Black, Sienna on Dark Wine (Untitled)*,
1963, oil on canvas, 175.3 × 162.6 cm. Christopher Rothko.

Plate 15. *Untitled (Brown on Red)*, 1964 or 1960, oil on canvas, 228.6 × 175.3 cm. Private Collection.

Plate 16. *Untitled*, 1969, acrylic on canvas, 233.7 × 200.3 cm. Private Collection.

6

·◆·◆·◆·

Between Surrealism and Abstraction: 1944–1947

I quarrel with surrealist and abstract art only as one quarrels
with his father and mother. . . . The surrealist has uncovered
the glossary of the myth and has established a congruity be-
tween the phantasmagoria of the unconscious and the objects
of everyday life. This congruity constitutes the exhilarated
tragic experience which for me is the only source book for art.
—Mark Rothko

IN 1941, the art dealer Sam Kootz encouraged American
artists to take up the challenge posed by the war: "Under pres-
ent circumstances the probability is that the future of painting
lies in America. Now is the time to experiment. You've com-
plained for years about the Frenchmen's stealing the American
market—well things are on the up and up. Galleries need fresh
talent, new ideas. Money can be heard crinkling throughout
the land. And all you have to do, boys and girls, is get a new ap-

Mark and Mell Rothko sitting in his Fifty-Third Street studio, c. 1953
(Photograph by Henry Elkan. Copyright © 2013 Kate Rothko Prizel and
Christopher Rothko)

proach, do some delving for a change—God knows you've had
time to rest."[1] What Kootz did not mention, and what Roth-
ko's fellow New York artists kept trying to figure out, was the
form a truly American art would take. Should they break with
the tradition of the Europeans who had settled in New York
and turn to something radically new or, to the contrary, pick
up the torch of Western tradition and raise it to new heights at
a time when it was under threat more than ever?

This debate, which went beyond the mere artistic sphere in
those years of World War II, brought back some painful mem-
ories, especially for European-born Jewish artists. For instance,
Barnett Newman took a clear stand against local American
artists, outlining his position in particularly dramatic terms:
"Isolationist painting, which they [the New York institutions]
named the American Renaissance, is founded on politics and
on an even worse aesthetic. Using the traditional chauvinistic,

isolationist brand of patriotism, and playing on the natural desire of American artists to have their own art, they succeeded in pushing across a false aesthetic that is inhibiting the production of any true art in this country. . . . Isolationism, we have learned by now, is Hitlerism."[2]

Rothko's respect for tradition, be it Jewish or European, prompted him to follow the European model for a few more years. In 1943, far from answering Kootz's call to arms, Rothko kept ignoring the siren song of some local dealers. Under the combined influence of European artists living in New York and his recent reading of Jung, he launched a new phase that art historians call his "Surrealist phase." From then on, a sometimes deceptive dual aesthetic allegiance, both Mythological and Surrealist, would characterize his work. Paintings such as *Aubade*, 1944, and *Archaic Idol*, 1945, provide perfect examples of this hybrid influence. While the subject still refers to antiquity, the line becomes freer, with a greater confidence in the execution of the forms, and the canvas seems to breathe more under much thinner layers of paint. This new development in his art occurred at the same time that Rothko met Mary Alice ("Mell") Beistle, an illustrator nineteen years his junior, at the studio of the photographer Aaron Siskind. On March 31, 1945, a year after his divorce from his first wife, they married.[3]

From that moment on, Rothko (almost) never left the company of this lovely and exotic young woman with a classical face, sensual lips, and long brown hair, and in his letters to friends it was no longer "I" but "we"; from that moment on, the inherently tormented Rothko mellowed, and his professional career entered a more prosperous period. Born in Cleveland to a middle-class American family, Mary Alice Beistle had always enjoyed a strong relationship with her mother, who was a driving force in her life; together they had written and published children's books since she was sixteen. She attended Skidmore College in upstate New York, a prestigious school

that brought her into contact with women from New York's upper middle class. She blossomed there, becoming president of her class and editor of the college literary magazine *Profile*. When she graduated at age twenty-two, finishing third in her class, she earned a living by writing for the magazines of Macfadden Publications, which also enabled her to support her hero—her husband, Mark Rothko. "My world has become infinitely enlarged," the artist admitted somewhat reservedly in a letter of November 15, 1944, to his sister Sonia.[4]

In considering the forward march of intellectuals and artists in the United States at the time, one must also take into account a few notable European voices between the years 1944 and 1948. This key period, much like an airplane's black box, still contains today the archaeological evidence of the European fin de siècle, marked by the eclipse of the Old World in a geopolitical shift. On the other side of the Atlantic, Jean-Paul Sartre, then emerging as a hegemonic intellectual, predicted in September 1945, "It isn't Peace. Peace is a beginning. We are living through death throes. . . . Peace seemed to us like a *return*. . . . The [peace] that is vaguely in the air now . . . is an enormous world peace, in which France has only a very small place. The little gun that was coughing the other afternoon confirmed France's slide—and that of Europe."[5]

At the end of World War II, American artists and intellectuals initiated a complex period of redefinition of the Western cultural boundaries, well aware that their country's new dominant position on the world political arena would inevitably be followed by a cultural makeover. Great European figures were disappearing: Mondrian died in New York on February 11, 1944, and Kandinsky in Neuilly, France, a few months later. The chaotic careers of these two giants of art, whose constant geographical movements (Amsterdam, Paris, Amsterdam, Paris, London, New York for Mondrian; Moscow, Odessa,

Munich, Moscow, Berlin, Neuilly for Kandinsky) profoundly influenced their work, were emblematic of Europe's devastation. In the United States, local artists, still seeking their way, were torn between Regionalism and internationalism, while galleries and museums were trying their best to make room for both trends. "America's more important artists are consistently shying away from Regionalism and exploring the virtues of internationalism," the gallery owner Sam Kootz commented at the time. "This is the painting equivalent of our newly found political and social internationalism."[6]

The Museum of Modern Art, whose initial project since 1929 had been the incorporation of the European Modernists into an inclusive and dynamic permanent collection, was criticized many times over for its neglect of U.S. painters. Despite the efforts of some of the museum's curators, including Dorothy Miller and James Thrall Soby, to acknowledge the demands of the American Abstract Artists and the press for more local artists, MoMA's policy regarding American art remained confused and somewhat awkward in those years. While the excellence of the museum's historical exhibitions of the great European masters (Léger, Picasso, Rouault, van Gogh) was beyond dispute, it was glaringly obvious that those devoted to American art emphasized only its heterogeneous nature and, what was worse, did not measure up in terms of quality, a disparity that persisted until the mid-1950s.[7] Consequently, in New York, European artists kept taking precedence over Americans like Rothko.

Meanwhile, with the stability that married life had brought him, the artist continued painting. The Surrealist influence in his work was palpable: organic forms and curved lines were a direct tribute to Miró's drawing *The Family* (1924),[8] which was Rothko's favorite.[9] Overall, the paintings he produced in 1945 depicted fragments reminiscent of insects, human beings, and plants, and were composed of lines as mysterious as they

were elegant, while arabesques in primary colors—red, yellow, blue—were drawn on a typically neutral beige or gray background. The drawings in the pictures were distributed in an automatic manner, inspired by the method of André Masson and guided by the unconscious rather than by some preplanned order. With a free linearity, in *Slow Swirl at the Edge of the Sea*, 1945, Rothko abandoned the frieze or layered construction typical of his Mythological works in favor of biomorphic forms borrowed from the Surrealists. Dancing toward us are two abstract figures, made up of a succession of organic forms resembling amoebas emerging from the water (the "edge of the sea," represented by the darker band at the bottom of the canvas, is the only identifiable division in the space).

Slow Swirl at the Edge of the Sea, a work created when he was falling in love with Mell, was among the first Surrealist paintings exhibited in Peggy Guggenheim's gallery during a solo show in January 1945 (all of the artist's fifteen other works in the exhibition were in the Mythological vein). It is also the painting that the gallerist, who always purchased one work per exhibition, acquired for her personal collection. Preparations for this show had plunged Rothko into intense activity. "My exhibition opens on January 9th, and I am painting feverishly not because I need the pictures but because I hope by miracles to outdo myself (as if one can). In addition, I am framing my own pictures, seeing loads of people, going miserably into debt, because it takes money to put up a show right," he wrote to his sister Sonia on November 15, 1944.[10] Yet, despite the artist's enthusiasm and the show's positive reviews, the exhibition did not outdo Pollock's show two years earlier, and only three works were sold.

Why did Rothko take such perverse pleasure in preserving the mystery of his artistic evolution? Although in 1945 he had already begun following the Surrealist aesthetic, he obstinately exhibited Mythological works almost entirely—that is, paint-

ings from his previous artistic period—at Peggy Guggenheim's gallery. It was disorienting, as expressed at the time by *New York Times* critic Edward Alden Jewell, who was doing his best to follow the creative meanderings of such a mercurial artist: "Mark Rothko is still beyond my grasp," he candidly admitted in January 1946, further confessing: "The unsigned text in the catalogue issued by Art of This Century, where Rothko's work is now to be seen, may or may not help. I read it and then went back to the walls. Life seemed to have come to a standstill. It is a year or two since I first saw 'The Syrian Bull.' There it was again, more charming in color than I had remembered it, but just as eluding. Or if we repeat often enough the words 'archaic' and 'hierarchical' and 'omen' may our quest be speeded?"[11] Regardless of the irony emanating from these lines, one can't help marveling at the critic's professionalism in seeking to decipher the artist.

Less than six months later, in May 1945, Jewell was given the ideal opportunity to solve the conundrum of Rothko's evolution, when Howard Putzel presented an exhibition titled *A Problem for Critics* at his new 67 Gallery. This pivotal event, which included both Europeans and Americans,[12] explored new trends, circumscribing their position in the modern tradition as a way to unify them and identify their common goals. Strangely the show played the role of a projective test: one after the other, critics and artists all brandished their personal references to celebrate what everyone sensed was a cohesive and original American group. Putzel had "come right out with *A Problem for Critics* posed on the walls of his 67 Gallery," acknowledged Jewell.[13] But, he went on, "Modernism is a continuing phenomenon, not to be conveniently ticketed and laid on the reference shelf. There are still problems unsolved (some of them, perhaps, insoluble)." In his response to Jewell, Rothko stated that "to make this discussion hinge upon whether we are moving closer to or further away from natural appearances is

somewhat misleading." And, with a keen pedagogical sense, he analyzed the various branches of abstraction, including Cubism and Purism, to contrast them with the projects of his own group. "I do not believe that the paintings under discussion are concerned with that problem . . . but we are in a sense mythmakers and as such have no prejudices either for or against reality."[14]

In both his writings and his paintings Rothko firmly maintained his attachment to "mythmaking," even as he had moved on to Surrealism. How to explain this duality? It is as if the Mythological reference shielded him from being associated with more legible aesthetic trends, allowing him to embark on an alternative path. "Our paintings, like all myths," he concluded, "do not hesitate to combine shreds of reality with what is considered 'unreal' and insist upon the validity of the merger."[15] Some weeks earlier, Clement Greenberg had anticipated Rothko's point: "For one thing, I disagree with Mr. Putzel that the inspiration of this new tendency came from Arp and Miró," he had asserted. "No, that owes its impulse to surrealist 'biomorphism' [which, by] restoring the third dimension, gave the elements of abstract painting the look of organic substances."[16]

And so, little by little, the name of Mark Rothko, as an artist and as an intellectual, inevitably infiltrated the network of those who, from June 1945 on, were inventing the new aesthetic paradigms of the years to come. He asserted himself with intensity, seriousness, and humor in the company of artists like Gottlieb and Newman, critics like Rosenberg and Greenberg, and dealers like Putzel, Kootz, and Sidney Janis. This circle of upwardly mobile men and women would gradually leave its mark on the cultural and social life in the United States, which, in many respects, still remained closed to them. "I have produce [sic] a number of things since I've returned [from Provincetown]," Rothko exulted in a letter to Barnett New-

man. "I have assumed for myself the problem of further concretizing my symbols, which give me many headaches but make work rather exhilarating. Unfortunately we can't think these things out with finality, but must endure a series of stumblings toward a clearer issue," he added, before teasing his old comrade, who, as previously mentioned, did not produce a painting for the first four years of the decade. "I hope that you are jealous and will be spurred to greater labors."[17] In September 1945, Jewell made up his mind to isolate the work of Rothko and Gottlieb from the rest of the artists of the Federation of Modern Painters. While mocking the paintings coming from "left-wing academism . . . misty obscurantism . . . geometric non-objectivists," he admitted that "others paint what cannot be called anything short of abstraction, though it is not in the 'geometry' class. I refer to typical thematic enigmas by Mark Rothko and Adolph Gottlieb."[18]

For his part, Barnett Newman, after having identified the importance of the subject as the quintessential lesson of Surrealism, tried to fathom in "The Plasmic Image" (1945) how subjects could be represented abstractly on a canvas. He believed that this was the only way to avoid one of the major pitfalls of abstract art in the United States: the fact that it had "to a large extent been the preoccupation of the dull, who by ignoring subject matter, remove themselves from life to engage in a pastime of decorative art." According to Newman, "the artist working outside the rim of the three movements of journalistic realism, Freudian realism, and puristic design should find their place in expressionism." Should it come as a surprise that a former member of The Ten pointed out the necessity of the context? In fact, if Rothko's friend was showing his faithful commitment to the Expressionist aesthetic, it was for this precise reason. "Expressionism," he insisted, gave artists "their opportunity for personal commentary on the world around them."[19]

For the visionary intellectual, "the good American artists in

this movement" were "able to project some deeply felt emotion that approached the profound." And, in his effort "to define the essence of this new [American] movement," Newman defined it as "an attempt to achieve feeling through intellectual content," before further declaring that "in handling philosophic concepts which *per se* are of an abstract nature, it was inevitable that the painters' form should be abstract. In the sense that these pictures try to say something—that is, that they have a subject—it was equally inevitable that the abstract form should have surrealist overtones." Barnett Newman called this new current "subjective abstraction" and decided that Rothko and Gottlieb were its obvious leaders. "Essentially," he explained, "the new painters were dissatisfied with realism, yet they could not enter into the reactions against realism typified by the abstract and surrealist artists." From his perspective, "the artistic problem was not whether they should or should not have subject matter; the problem was, what kind of subject matter." It was inevitable, in this view, that "the surrealist's world of the imagination should reach a cul-de-sac of invention." Decisively promoting the idea of a uniquely American art, Newman proclaimed it loud and clear: "In New York it is now admitted that Surrealism is dead."[20]

The year 1946 would confirm the definitive breakthrough of Rothko and Gottlieb. American galleries and museums increasingly exhibited their work apart from the group with which they had previously been identified. In May 1946, when Betty Parsons showed his watercolors at the Mortimer Brandt gallery, Rothko exulted, "One person invested more than $1,000 in the stuff. So maybe there is hope."[21] At this precise moment, Jewell became inescapably drawn to Rothko's work. "Mark Rothko, at the Mortimer Brandt, phrases his abstract brush speech with a new muted subtlety. Color seems less sonorously lyrical yet it can create, as in 'Gethsemane,' telling accents," he wrote with an empathy implying that he was now

firmly won over.[22] This propitious situation was reinforced in 1947, when Betty Parsons offered him an official contract that guaranteed a one-man show every year. And some time later, Rothko's growing sales would enable him to stop teaching at the Center Academy in Brooklyn and devote himself entirely to painting.

Spending the summer months in East Hampton with Mell, he joined another group, which considerably differed from The Ten, and exhorted Barnett and Annalee Newman to meet them at Louse Point, this "heaven" a few hours from New York, near the village of Springs, where Jackson Pollock lived with Lee Krasner. As if intoxicated by these new relationships, Rothko wrote his friends Gottlieb and Newman in great detail, granting himself the right to praise and criticize his new acquaintances. "Bob" Motherwell was "extraordinary kind" and "a gracious and interesting guy." Similarly, William Baziotes was "a swell and vivid person." However, Rothko was unsurprisingly more reserved about Pollock, whom he described as "a self contained" man with a "sustained advertising concern." And of Harold Rosenberg, the artist called him "one of the best brains that you are likely to encounter, full of wit, humaneness and a genius for getting things impeccably expressed. But I doubt that he will be of much use to us." With the growing confidence of someone convinced he belonged to the elite, Rothko insisted, "If you recall that we chose our present location to avoid the intrigues of the winter, rest assured that there is plenty here too! I guess our clamor is no longer escapable . . . as to work, I am at it and stuff is accumulating. . . . The few folks around seem to like it, and before our return the situation may even better itself."[23]

In spending time with Motherwell and Rosenberg, Rothko joined a more intellectual society of writers, architects, and musicians who, beginning in September 1947, produced *Possibilities*, an avant-garde magazine that styled itself as "An Oc-

casional Review" and a "magazine of artists and writers." In the end, it published only one issue. Its editorial committee included not only Motherwell and Rosenberg but also Pierre Chareau and John Cage. The texts, with an existentialist flavor and an obvious infatuation with Europe (poetry by Paul Valéry and a musical score by Edgard Varèse) and South America (a photograph of Oscar Niemeyer's concrete church), were clearly elitist. In the "Documents of Modern Art" series appended to the magazine, Motherwell gave an introduction to the great pioneers of European abstraction in all realms: Apollinaire, Moholy-Nagy, Kandinsky, Arp, Picabia, Miró, Mondrian, Van-tongerloo, Tzara, and Ernst. This new lineage, with a position vis-à-vis abstraction far different from that advocated by the Federation of Modern Artists, would deeply influence Rothko's work, as would his new group of friends. "Political commitment in our times means logically—no art, no literature," asserted the magazine's editorial, co-signed by Motherwell and Rosenberg. "A great many people, however, find it possible to hang around in the space between art and political action."[24]

For the American artists who wanted to stand apart from the Regionalist or realist tendencies of the local painters, the presence of Europeans in New York represented a tremendous asset. Yet it was sometimes a mixed blessing. "The refugees were around during the war. They were 'the artists'; we all looked up to them . . . with that started the nucleus. Then the refugees slowly disappeared," Philip Pavia explained. "They went back to Europe. Then we were on our own."[25] In Rothko's case, this transition was certainly also rooted in his own history, in his own geographical displacements. And the Surrealist period, one of the shortest aesthetic phases in his career, stopped cold. At this point, the artist began his annual westward migration and started detaching himself from Europe, responding to Sam Kootz's 1941 injunction that these "boys and girls" should "get a new approach."

7

————◆◆◆————

Toward Absolute Abstraction: 1947–1949

We are freeing ourselves of the impediments of memory, as-
sociation, nostalgia, legend, myth, or what have you, that have
been the devices of European painting. Instead of making
cathedrals out of Christ, man or "life" we are making them
out of ourselves, out of our own feelings.
—Barnett Newman

DID ROTHKO's friendship with Clyfford Still, whom he
first met in San Francisco in July 1943, contribute to the disso-
lution of his figurative style? Born in 1904 in Grandin, North
Dakota, far from any European influence, Still was working in
San Francisco during the early years of the war. His canvases,
characterized by fields and patches of color "in strips," evinced
no national character, but they had something raw and brash
about them, two qualities generally associated with American
culture. In the summer of 1945, Still left San Francisco for New

Mark Rothko in his studio with *Tiresias*, 1944 (in far room), and *Untitled*, 1945 (Unknown photographer. Copyright © 2013 Kate Rothko Prizel and Christopher Rothko)

York and settled in Greenwich Village. The friendship that developed between the two men remained mostly intellectual, born from the encounter of two vigorous minds endlessly exchanging ideas. "We were complete opposites," Still explained later. "He was a big man. He would sit like a Buddha, chain-smoking. We came from different sides of the world. He was thoroughly immersed in Jewish culture. But we had grown up only a few hundred miles apart. We had read many of the same things. And we could walk through the park together and talk about anything."[1]

Of course, their face-to-face conversations tended to focus on the conflicts between the New York artists and the city's artistic institutions as well as the need to create a truly "American" art. Around that time, as Rothko was transitioning from his Surrealist to his "Multiform" phase, his paintings started

losing all their representational dimensions and no longer depicted any identifiable elements. In *Aquatic Drama*, 1946, for instance, a vertical axis of symmetry in the center of the painting suggests the presence of two bodies facing each other, each consisting of two light-colored oval forms. It's a striking contrast to the vertical mass displayed in *Personage Two*, another of Rothko's paintings that year. What exactly is this "personage" to which the title refers—an animal, a human being, a god? In masses of primary colors with rounded contours, which randomly float on the surface of the canvas, some of them swirling and blending into one another, the "Multiforms" appear to break away from the painter's aesthetic.

The conversations between Rothko—the European émigré who had tried his hand at Surrealism—and Still—the North Dakota native who had recently approached abstraction—contributed to their ongoing aesthetic search, taking the form of a fascinating intercultural joust. Still had begun as a figurative artist and gradually evolved toward abstraction, applying thick layers of bright color to immense canvases that recalled the monumental, heroic, transcendental landscapes of the first true American school in the nineteenth century, the Hudson River School. More and more, he was considered as an authentically American artist, whose individual brushstrokes on the canvas shaped in turn the image of the modern American artist in the mind of critics.[2] "I continued postponing an invitation for [Rothko] to visit me," Still explained. "One evening he came to my studio uninvited. After seeing some of the canvases I had stretched, he became visibly excited and asked permission to tell Peggy Guggenheim about them."[3] Carried away by his admiration for Still's daring, Rothko decided to mobilize his considerably broadened professional connections to help Still's career. Late in 1945, Rothko managed to persuade Guggenheim to organize a solo exhibition for his friend, going so far as to offer to write the catalogue himself. Ever mistrustful

of the art world, however, Still proved reluctant but eventually yielded to Rothko's arguments. The exhibition opened in early 1946. In its catalogue, Rothko described Still's works as "of the earth, the damned and of the recreated," while making a heated case for their "unprecedented forms and completely personal methods."[4]

"Clyff had been a tremendous influence in [Rothko's] thinking and in giving him courage," wrote Katharine Kuh, a curator and close friend of Mark Rothko. Still "gave Mark the freedom to be himself or to be something even better than himself."[5] Indeed, Still's presence in New York encouraged Rothko to resume his artistic experiments and to free himself from the European Surrealists, as well as to further distance himself from official institutions through ironic criticism. It was Still, in turn, who negotiated Rothko's first solo show in a major institution, a critical milestone in his career. Opening on August 13, 1946, at the San Francisco Museum of Modern Art, the exhibition included nineteen oil paintings on canvas and ten watercolors. "It was without question the best show I have ever seen in the gallery for years," Still wrote to Betty Parsons, "and it commanded the highest respect from those out here who know good work when they see it."[6] As a sign of admiration, the museum even bought a painting, *Tentacles of Memory*, 1945–1946, the first official acquisition of Rothko's work by an American institution. Encouraged by the San Francisco museum's show of confidence in Rothko, the Whitney and the Brooklyn Museum each acquired a work from the exhibition as well: *Entombment I*, 1946, and *Vessels of Magic*, 1946, respectively.

Rothko's painting career gained considerable exposure in March 1947, when he started to exhibit his works at Betty Parsons's gallery. Born at the turn of the century in New York to a conservative upper-middle-class family, Betty Pierson (who became Parsons in 1919) began her career as an artist, living

for ten years in Europe, where she worked with the sculptor Antoine Bourdelle, before returning to New York in 1940. She opened a gallery in 1946, but it was two years later when she made her breakthrough, thanks to Peggy Guggenheim, who, returning to Europe, asked her to look after her stable of painters. The Betty Parsons Gallery then "became a meeting place for artists. The big four were Newman, Rothko, Still and Pollock, or, as she called them 'The Four Men of the Apocalypse.' In the beginning, they were tremendously supportive of each other and would help hang each other's pictures for shows. As she used to say 'I give them walls. They do the rest.'"[7]

Yet some remained skeptical about Rothko's works. For instance, his first exhibition at Parsons's gallery failed to convince *New York Times* critic Howard Devree, who wrote of the occasion: "Mark Rothko, at the Betty Parsons gallery, invokes the spirits of antiquity and even inorganic pre-history. At best, he is individually suggestive, though titles such as *Phalanx of the Mind* and *Orison* seem hardly to the point. And when he essays such overblown examples as *Rites of Lilith*, the size makes for emptiness."[8] The effects of this chilly reception, however, were short-lived. That summer, Rothko started the first of his western tours, as a guest instructor at the California School of Fine Arts in San Francisco, together with his friend Clyfford Still, fellow painter Clay Spohn, and the school's director, Douglas MacAgy. Immersed in the school's studious work environment and its distinctively warm and sharing atmosphere, Rothko experienced one of the most intense moments in his career. Ernest Briggs, one of his students there, described Rothko's first appearance in his class, escorted by Still:

> I first met Rothko—Still brought him into the class and introduced him. And there was of course a total difference in terms of personalities. Rothko was the epitome of the New York Jewish intellectual artist/painter and exuded an entirely different kind of energy [than Still]; urbane, deep intent,

quintessential New Yorker. . . . The big thing with Rothko's presence there in the program was that he gave a lecture once a week which was in a separate room and people who were not even in the painting class came to listen to the lectures. Which again, was not a lecture. It was more like a conversational thing, responding to a few questions and then going on. . . . I can remember when he was in the earlier period, the so-called Surrealist period, he mentioned that he and his particular group, Gottlieb and Baziotes, were influenced by and very close to classical studies, classical mythology, and he would be quoting Herodotus or something at some of these lectures or repeating an antidotal [sic] story of Herodotus in answer to some inquiry on the part of a student.[9]

"What was there about last summer which seems now to have been so magical?" Rothko wrote to Spohn, back in New York. "You, Clyff, Doug, etc. set up tensions which made us exist, I believe, on a very desirable plane, and I miss it."[10] The magic of those months spent in San Francisco with Mell considerably affected the painter's identity, to the point that he wished for the city to become "the art center of the world": "The city is *unspeakably* beautiful & the weather perfect. . . . The weather is now (and I am told always) benignly autumnal, combining a slight briskness with melancholy—nourishing my Slavic predilections. (We live, in fact, on Russian Hill). . . . There is no doubt that . . . this city has earned the right to be the art center of the world, and that we must do something to bring this about. I suggest that we defame European art and expose Oriental art—thereby causing the commercial & ideological lanes to shift automatically to the Pacific."[11]

The change of scenery, the "hectic life" of his new network of friends, the excitement of teaching in an institution of international reputation where, he explained to Newman, he had "perhaps conveyed many of our mutual ideas" in this "tiring but vivid experience out here"[12]—it all contributed to this

magic. However, his work suffered there: "My canvas is dry and my paper stretched. Now if only an idea made its way into my head," he complained at times.[13] But it was not until he was back in New York that Rothko started to sense the benefits of his San Francisco interlude, especially as Still's aesthetic—huge dark backgrounds lacerated with bright colors—was beginning to take shape. That summer, Rothko borrowed *1949-9-W,* a painting by Still he would hang in his New York studio for a few years. "I have already received and stretched the canvases I did in San Francisco. Having been unable to judge them there, I have decided that in that respect all was not lost," he wrote to Clay Spohn upon his return to New York. "The picture I own of Clyff's also arrived and it looks even better than I remembered. I think I am beginning to think of Frisco as the classical golden age with the beautiful court and patio and the clear crisp afternoons and our conversations there."[14]

It was really in New York, on September 24, 1947, that Rothko realized the impact of his first stay in California on his aesthetic evolution. "Elements occurred there," he wrote, "which I shall develop, and which are new in my work and that at least for the moment stimulate me—which gives me the illusion—at least—of not spending the coming year regurgitating last year's feelings."[15] In fact, his first Multiform canvases were painted in San Francisco during the summer of 1947. The following autumn, Rothko returned to writing, completing the now unstoppable dynamic that would define his work. When approached by the magazine *Tiger's Eye,* he eloquently described the relationship between the artist, his art, and his fellow citizens: "A picture lives by companionship and quickening in the eyes of the sensitive observer. It dies by the same token. It is therefore a risky and unfeeling act to send it out into the world." This was prophetic of his future career.[16]

Meanwhile, critics were attempting to understand the new period that was taking shape before them. In October 1947,

Clement Greenberg reiterated his resentment toward his country's relationship with art: "Artists are as isolated in the United States as if they were living in Paleolithic Europe. . . . The isolation is unconceivable, crushing, unbroken, damning. . . . What can fifty do against a hundred and forty million?"[17] Barely two months later, he started to acknowledge that a "new indigenous school of symbolism" was dawning, which included, "among others, Mark Rothko, Clifford [sic] Still and Barnett Benedict Newman [sic]," with Gottlieb as "perhaps the leading exponent." While disapproving of "the importance this school attributes to the symbolical or 'metaphysical' content of its art," Greenberg conceded that "as long as [it] serves to stimulate ambitious and serious painting, differences of 'ideology' may be left aside for the time being. The test is in the art, not in the program."[18] In January 1948, in the midst of a transition period that saw the establishment of a new balance of power between Europe and the United States, brought on by the announcement of the Marshall Plan six months earlier, Greenberg did not conceal his optimism, despite the darkness of the postwar years: "American painting in its most advanced aspects—that is, American abstract painting—has in the last several years shown here and there a capacity for fresh content that does not seem to be matched either in France or Great Britain."[19] It was Greenberg again who identified and defined what he perceived then as a turning point in American art history: "For some reason, 47–48, there was a swing."[20] The painter Philip Pavia admitted for his part that "no other moment contained so many surprises and changes, and so much shifting. . . . 1948 was a key year. . . . Gorky's suicide came as a blow to the Eighth Street gang."[21] At that same time, Jackson Pollock began producing his first drip paintings by dancing around the canvas, while Barnett Newman was starting to conceive his own "zip" paintings.

In his second exhibition at the Betty Parsons Gallery (in March 1948), as he had done in the past, Rothko decided to reveal himself only partially: he would show earlier paintings, disconnected from his latest work. He exhibited fourteen oils created between 1944 and 1946, all in a Surrealist style. This new exhibition did not keep him from continuing to fume about the most conservative New York galleries and critics. "Fifty Seventh Street is a stinking mess," he wrote to Clay Spohn in California. "There has been what is apparently an organized attack on 'unintelligible' art in the N.Y. Times, Telegram, Art News, etc. . . . Personally I think that the attack is the greatest signal honor, which we have received here in 10 years. To be intelligible to them is dishonorable and suspect."[22] How could such a rebel tolerate the New York art world now that it, at last, accepted him? Would he, with a career headed for success, suddenly become conciliatory? Certainly not, judging from his correspondence with Spohn. "I am beginning to hate the life of a painter. One begins by sparring with his insides with one leg still in the normal world. Then you are caught up in a frenzy that brings you to the edge of madness, as far you can go without ever coming back. The return is a series of dazed weeks during which you are only half alive. That is a history of my year since I've seen you. I am beginning to feel that one must break this Cycle somewhere." San Francisco remained a nurturing utopia in Rothko's mind, in stark contrast to New York, where, he complained, "you spend your strength resisting the suction of the shop-keeping mentalities for whom, ostensibly, one goes through this hell. I wish we could relive, in a new day, our last summer, for as often as I think of it, I recall it as a momentous time. Perhaps you can plan a visit to N.Y. in the near future. Please write to us again."[23] San Francisco, New York, San Francisco, New York—the geographical tensions between the West Coast and the East Coast, between "Frisco as the

classical golden age" and the city of "shop-keeping mentalities," seemed to enrich the work and life of Mark Rothko.

On more than one occasion, he protested against the acquisition policies of the Whitney and the Metropolitan. And though he echoed critics of MoMA who complained that the museum did not show enough American artists, he was more ambivalent toward that museum itself, maintaining affection for the institution whose permanent collection included the best Modernist European artists. In fact, the last stage of his uncanny aesthetic evolution during those years took place there. Just as in 1940, while writing his book Rothko had immersed himself for months in a long, patient, and astonishing study of art history from which he returned transformed, four years later, in MoMA's galleries, he plunged into a long, patient, and breathtaking study of an artwork produced in Paris in 1911 that had just been acquired by the museum: Matisse's *The Red Studio*.

Standing before a canvas whose sweeping rust color drowns the forms and erases all breaks between vertical and horizontal lines, viewers enter a studio abandoned by the artist to find themselves faced with paintings, sculptures, and objects—figures frozen in motion. In this space, at once deserted and populated, they interact directly with an incongruous, random assembly of nudes, children, and models that nurtured the artist's imagination. There, seven abandoned works in progress await, in the ponderousness of their incompletion, the creator who will give them life forever. Through this metaphorical scene, the blinding omnipotence of the demiurge-artist transpires, as if, without him, those lifeless dolls, poor withered Pinocchios, were to face the dreadful challenge of being extinguished forever or becoming immortal works of art. Had Rothko come across MoMA's press release of April 5, 1949, introducing the work to the public? Regardless, after diving into

the French master's canvas for weeks, Rothko plunged once and for all into abstraction.

"Matisse was 42 in 1911, the year he painted *The Red Studio;* he had been painting for 20 years. Three or four years before he had emerged from fauvism, inconclusive style with contradictory influences. . . . The most striking feature of *The Red Studio* is, of course, the great uniform background of rust red. This background color is completely arbitrary, for in a similar painting of an adjacent view of the same studio, Matisse used pink and lavender tones for floor and walls. After the daring color and boldly scattered composition of *The Red Studio,* Matisse turned in the following years to a somewhat more austere and classic style," read the museum's press release about its acquisition.[24] It was "the most important work by this master to enter the Museum Collection," Alfred Barr further explained, proud of the masterpiece he had just acquired.[25] An earlier illustration of Matisse's studio at Clamart, in tones of pink and lavender, had been sold almost immediately after its completion to the great Russian collector Sergei Shchukin of Moscow. As for *The Red Studio,* with its far more daring style (and imposing dimensions: 71 × 86 inches), it was first lent by the artist to the 1913 Armory Show in New York, Boston, and Chicago. After the painting was returned to him in France, an English collector purchased it, before its next public reappearance at the Philadelphia Museum of Art's Henri Matisse retrospective in 1918.

Let us assume that in 1949, Rothko, whose aesthetic search had entered into a new phase, was also interested in other European works acquired by MoMA around the same time, including Boccioni's *Unique Forms of Continuity in Space;* Mondrian's *Composition C* (1920); Vlaminck's *Mont Valérien;* Zadkin's *Torso;* and a drawing from the prodigious series by Theo van Doesburg, *Composition VII (The Cow).* Van Doesburg's various rough sketches of the animal are gradually transfigured into abstraction, in an almost magical glide, as the drawings turn

into gouache paintings, ending in geometrical cubes of color.[26] Along with other local artists who no longer needed to travel abroad to complete their training, Rothko was introduced to these works thanks to the efforts of Alfred Barr;[27] since 1929, he had regularly enriched MoMA's permanent collection, turning it into what Leo Castelli would later call an "encyclopedia of European art that no European museum could offer at the time."[28] How fascinated Rothko must have been, at this crucial juncture in his career, to read Barr's public announcement: "*Composition (The Cow)*, 1916, constitutes a lucid and valuable documentation of De Stijl methods during the formative period of 1916–1917. The three drawings exhibited show the process of geometrical abstraction proceeding from a naturalistic sketch of a cow to a construction of vertical, horizontal and diagonal lines. . . . In the final canvas, the lines are eliminated, leaving free-standing, colored rectangles asymmetrically composed against a white background. After 1920, the paintings of van Doesburg and Mondrian were no longer based directly upon specific forms in nature."[29]

For his third show at the Betty Parsons Gallery, in March 1949, Rothko chose, at last, to exhibit his most recent works—the now famous "Multiforms" he had begun in San Francisco. Among them, *No. 1 (Untitled)*, 1948, particularly stood out for conveying the combined influence of Still and Matisse. Using a palette for the background restricted to the same orange, red, yellow, and off-white as in *The Red Studio*, Rothko added only a darker blue form in the center. And, on the painting's surface, other forms seemed to float side by side, with no hierarchy, in a matte medium thinly spread on the canvas while its texture remained perceptible. At the *New York Times*, it was no longer Jewell but Stuart Preston who presided as the art critic, and Preston noticed the exhibition's "single-minded experimentation." He noticed the "abstracts which proclaim the desertion

of his former calligraphic manner." He noticed the "conjuring with patches of luminous color that float softly up or impetuously punctuate the thinly coated surfaces of his canvases." He noticed everything, including the "design [that] is casual and uncertain." He even noticed the "'philosophic' overtones that . . . are . . . no more than the involuntary reactions set up in his eyes by gazing at the color harmonies for a given length of time."[30] This fine tribute was later cited by the artist himself in conversations with William Seitz. His evolution toward the Multiform, Rothko explained, resulted not so much from the fact that "the figures had been *removed*" from the canvas, but that they had been replaced, first by "the symbols for the figures" (during his Mythological and Surrealist phases), and then by forms that evolved into "new *substitutes* for the figures."[31]

As Rothko was making his way toward total abstraction during a stay in San Francisco in the summer of 1949, Clement Greenberg prophesied, "It is possible that national pride will overcome ingrained philistinism and induce our journalists to boast of what they neither understand nor enjoy."[32] Greenberg's article appeared in the *Nation* on June 11, and barely two months later *Life* magazine plastered on page 43 the provocative question: "Jackson Pollock: Is he the greatest living painter in the United States?"[33] In an accompanying photo, standing in front of *Summertime: Number 9A*, one of his first drip paintings, the artist, arms across his chest, a cigarette dangling from his lips, and dressed in black, insolently regards the spectator. Indeed, some time earlier, Greenberg himself had spoken of Pollock as "a fine candidate to become the greatest American painter of the 20th Century."[34] In her article, *Life* journalist Dorothy Seiberling explained: "Recently a formidably highbrow New York critic hailed the brooding, puzzled-looking man shown above as a major artist of our time. . . . Others believe that Jackson Pollock produces nothing more than interesting, if inexplicable, decorations. Still others condemn his

pictures as degenerate and find them as unpalatable as yesterday's macaroni. Even so, Pollock, at the age of 37, has burst forth as the shining new phenomenon of American art." This article, published in a magazine with a circulation of five million, began to reverse the perception of the U.S. artist in his own society.[35]

In this context, the New York art world ineluctably gained momentum. When, in the fall, Sam Kootz inaugurated his new gallery, he asked Harold Rosenberg to select the artists for the opening show, *The Intrasubjectives*, which he named after a concept put forth by the Spanish philosopher Ortega y Gasset in the August 1949 issue of the *Partisan Review*. "The guiding law of the great variations in painting is one of disturbing simplicity. First things were painted; then, sensations; finally ideas. This means that in the beginning the artist's attention was fixed on external reality; then, on the subjective; finally, on the intrasubjective."[36] It was, in the wake of Putzel's efforts, another attempt to define and embrace the new American painting as a whole. "Space or nothingness . . . that is what the modern painter begins by copying," Rosenberg wrote. "Instead of mountains, corpses, nudes, etc., it is his space that speaks to him, quivers, turns green or yellow with bile, gives him a sense of sport, of sign language, of the absolute."[37] All of a sudden Baziotes, de Kooning, Gorky, Gottlieb, Hofmann, Motherwell, Pollock, Reinhardt, Rothko, Tobey, and Tomlin appeared in a single bloc. What a wellspring of talent!

A few weeks later, the opening of Pollock's solo exhibition at the Betty Parsons Gallery on November 21, 1949, indicated that the era of isolation for American artists was over. Let us consider the following scene: "The crowd filled both rooms of Parsons' little gallery and spilled out into the hallway. Gossamer clouds of cigarette smoke filled the upper reaches of the windowless space. Glasses glinted and clinked and the babble of conversation seemed especially dense and breathless.

It wasn't the usual crowd. These were not the friends and fel-
low artists who normally drifted from one opening to the next
in a show of solidarity. These were distinguished-looking men
and women—most of them strangers—in tailored suits and de-
signer-label dresses. Milton Resnick, who came with Willem
de Kooning, remembered the odd, new feelings that permeated
the Parsons gallery that night. 'The first thing I noticed when
I came in the door was that people all around me were shak-
ing hands,' Resnick remembers. 'Most of the time you went to
an opening, all you saw were other people that you knew, but
there were a lot of people there I'd never seen before. I said to
Bill, 'What's all this shaking about?' 'Look around, de Kooning
answered, these are the big shots. Jackson has finally broken
the ice.'"[38]

On June 11, 1949, Clement Greenberg confirmed the new-
found popularity of American art by arguing that the enemies
of contemporary art, with their constant criticism and denial,
were precisely the ones who had brought about the new state of
affairs: "The importance of modern art had become such that
it is no longer sufficient to oppose it by ignoring its presence;
its enemies have to fight it actively, and in doing so they have
made painting and sculpture a crucial issue of cultural life—
which is to assign them more relative importance than they
ever enjoyed before in this country."[39] Alongside critics, the art-
ists themselves reflected on their influences and intentions, in-
cluding the creation of alternative art studies. In October 1948,
in a loft at 35 East Eighth Street in the East Village, Rothko
founded the Subjects of the Artist School with William Ba-
ziotes, David Hare, Barnett Newman, and Robert Motherwell.
In addition to offering classes during the week, the program in-
cluded lectures on Friday evenings. Each teacher was assigned
a day of the week and left free to choose how to organize his
teaching. According to Motherwell, the artists were "very anx-
ious that the school not be doctrinaire, that those of us who

were teaching be regarded as individuals, and that the students be regarded as individuals."[40]

The school quickly became known for its Friday lectures. During the three eight- to twelve-week sessions, from fall 1948 to spring 1949, one could run into Joseph Cornell, John Cage, Richard Huelsenbeck, and Hans Arp, who had joined the founding members and their inner circle (Gottlieb, de Kooning, Reinhardt).[41] During this time all sorts of personalities interested in contemporary art in the United States met there to exchange ideas and discuss topics, in keeping with the school's name, like the "subjects of the artist"—an intriguing choice considering that their work was becoming more abstract. Robert Goodnough solved the mystery: "The term 'subject matter' can be misleading when referring to abstract painting but it was then used to convey the meaning that the artist may have a subject even if it does not refer directly to recognizable objects or incidents; that his attempts to deal with more subjective feelings and ideas constitute subjects."[42] These new interactions between artists and writers, a legacy of European tradition, enabled the artists to clarify their ideas, discuss their influences, and construct a movement consisting of strong individuals.

And even if Philip Pavia, one of the "downtown artists" who gathered around Hans Hofmann, described this experience somewhat ironically—"There were five professors and five students. . . . The Subject of the Artist School hardly made any kind of dent in Hofmann's school or his popularity"—he could not have helped but acknowledge its relevance. "At last," he said, "the New York Surrealists were recognized as a separate entity."[43] Rothko and his friends, the "uptown" artists who lived in better neighborhoods or were identified with the uptown galleries that represented them, were the target of the bohemian "downtown" artists' sarcasm. "Our downtown group was apprehensive," Pavia wrote, then alluding to the American Revolution: "The powerful uptown Surrealist army are sending

down a contingent of redcoats[44] to take over Eighth Street. . . .
These redcoats were not the menace that we imagined them to
be. . . . In this skirmish with the redcoats, we were nicknamed
the coonskins, meaning the American frontiersmen—the Wal-
dorf cafeteria crowd, the Hofmann School and the Eighth
Street bunch. . . . In 1948 we coonskins got organized and de-
cided to rent a club room."[45]

Beyond the mere skirmishes among fellow artists, some-
thing vital was occurring. Education, just as it is a critical com-
ponent of Jewish tradition, became a decisive factor in Mark
Rothko's career. It was indeed his position as a drawing teacher
at Brooklyn Jewish Center that provided him with the stabil-
ity he needed to launch his career. And, after participating in
the Subjects of the Artist School, he became a major player in
the new art culture that was being built in the country where
he had arrived thirty-six years earlier. In parallel, his art also
kept evolving. With *No. 9*, 1948, he composed a space of float-
ing forms, entirely inhabited by variations of red and orange,
pink and purple, from pastel to wine red, with a white trickle of
six random stripes in the upper right corner. Less than a year
later, he painted *No. 8*, 1949: an orange square at the bottom,
a yellow rectangle at the top, a pink longitudinal space along
the left side, and, again, random stripes inside a red square, the
colors screeching at each other, beckoning the viewer's atten-
tion. And again, later that year, with *No. 11/No. 20 (Untitled)*,
1949, which showed blocks of yellow, green, and white color
veined with red, a new phase emerged. Mark Rothko had com-
pleted the aesthetic voyage he had begun ten years earlier.
While he would continue to evolve, he had definitively found
his language.

8

With the Rebel Painters, a Pioneer: 1949–1953

One would have to be blind indeed to deny that Rothko is
a subtle and sensitive colorist. He has a partiality for sono-
rous chords that flush and fade with the rich, rigid solemnity
of strongly held organ chords. Visually, these paintings are
impressive and, to a certain point, they provide the emotional
release that is furnished by all genuine works of art . . .
Salutations to a pioneer
who is adding to the formal vocabulary of painting.
—Stuart Preston

ADDRESSING CONGRESS on August 12, 1949, Republican
Senator George A. Dondero, in an example of philistine men-
tality, launched a particularly virulent attack against contem-
porary artists: "The art of the isms, the weapon of the Russian
Revolution, is the art which has been transplanted to America,

and today, having infiltrated and saturated many of our art cen-
ters," he declared,

> threatens to overawe, override and overpower the fine art
> of our tradition and inheritance. So-called modern or con-
> temporary art in our own beloved country contains all the
> isms of depravity, decadence and destruction. . . . As I have
> previously stated, art is considered a weapon of communism,
> and the Communist doctrinaire names the artist as a soldier
> of the revolution. . . . What are these isms that are the very
> foundation of so-called modern art? . . . I call the roll of
> infamy without claim that my list is all-inclusive: Dadaism,
> Futurism, Constructionism, Suprematism, Cubism, Expres-
> sionism, Surrealism, and Abstractionism. All these isms are
> of foreign origin, and truly should have no place in Ameri-
> can art . . . all are instruments and weapons of destruction.
> . . . Cubism aims to destroy by designed disorder. Futurism
> aims to destroy by the machine myth. . . . Dadaism aims to
> destroy by ridicule. Expressionism aims to destroy by aping
> the primitive and insane. . . . Abstractionism aims to destroy
> by the creation of brainstorms. Surrealism aims to destroy
> by denial of reason.[1]

That summer, Mark Rothko once again spent several in-
vigorating months with Mell in San Francisco, an idyllic trip,
during which he had time to teach alongside his friends Still,
MacAgy, and Spohn, followed by a spectacular journey to
New Mexico, before heading home to New York. "Same [re-
gards] from Mell and we will see you before you know it,"[2] he
wrote Barnett Newman, so full of optimism that one wonders
whether he had heard about Dondero's vehement speech. Still,
it seemed that the artist's status in the United States was im-
proving and the hardest times were behind. That was now the
opinion of Clement Greenberg, who acted as an intellectual
barometer in the world of art. Yet Greenberg had been rather
pessimistic on the subject in the first half of the decade. In 1943,

before the annual exhibition at the Whitney, he noted that "for the tenth time the Whitney Annual gives us a chance to see how competently and yet how badly most of our accepted artists paint, draw, and carve."[3] A year later, he renewed his warnings: "This year's Whitney Annual . . . is more disheartening than ever" and "American art, like American literature, seems to be in retreat at this moment."[4] However, four years later, he began to change his tune. "If artists as great as Picasso, Braque, and Léger have declined so grievously," he wrote in a 1948 issue of *Partisan Review*, "it can only be because the general social premises that used to guarantee their functioning have disappeared in Europe. And when one sees, on the other hand, how much the level of American Art has risen in the last five years, with the emergence of new talents so full of energy and content as Arshile Gorky, Jackson Pollock, David Smith—and also when one realizes how consistently John Marin has maintained a high standard, whatever the narrowness of his art—then the conclusion forces itself, much to our own surprise, that the main premises of Western art have at last migrated to the United States, along with the center of gravity of industrial production and political power."[5] Following Greenberg's acute intuitions, as was the case during the opening of the Pollock exhibition at the Betty Parsons Gallery on November 21, 1949, observers were now forced to admit that American artists were shifting toward the forefront of the contemporary art world scene.

Gallery owners were not short of initiatives, either. After the dealer Sam Kootz solicited Harold Rosenberg and Ortega y Gasset for *The Intrasubjectives* exhibition, he asked two eminent intellectuals of the time, Clement Greenberg and Meyer Schapiro, to visit the insalubrious, dilapidated East Village artist studios and scout out new talents. "The results of this Sabbath trek—a selection of twenty-three pictures by as many artists —have just been hung in the Kootz Gallery. . . . About two thirds of the artists represented happen to be under thirty,"

Tom Hess wrote enthusiastically, "and it all adds up to one of the most successful and provocative exhibitions of younger artists I have ever seen."[6] As another example, in 1950, the Trieste-born collector Leo Castelli, who had briefly run a gallery in Paris before immigrating to New York in 1941, took up Pierre Matisse's old concept. He suggested to his friend the gallery owner Sidney Janis the idea for the exhibition *Young Painters in the United States and France,* which paired artists from both countries in an attempt to append the legitimacy of the French to the energy Castelli sensed among the young Americans. A painting of a woman by de Kooning hung next to one by Dubuffet; a Kline paired with a Soulages; a Gorky faced a Matta; a Pollock echoed a Lanskoy; David Smith neighbored Léger; Coulon matched up with Cavallon; and, in what was perhaps the most telling of these associations, a vertical abstraction by Mark Rothko was beside a horizontal abstraction by Nicolas de Staël. "This exhibition was first shown at the Galerie de France in Paris," Castelli explained, "where it was exposed to a great deal of hostility from a small circle of chauvinistic artists who insisted that, with very few exceptions, there was no comparison possible between American painting and French painting."[7]

"We decided that Leo would select the Americans and I would select the French," said Janis. "Leo was helpful. He was a great champion of the work of Jackson Pollock and Rothko and people like that."[8] According to Castelli, "The comparisons were rather curious and amusing, but well founded nonetheless . . . I was roundly criticized for this approach. Charles Egan, a very chauvinistic man, was especially incensed. The night of the opening, he told me it was an absurd idea, that there was no possible comparison between the Americans and the French. As for Barr, who didn't really buy American painters and was content to watch from the sidelines, he wasn't very enthusiastic!"[9] "So I felt that in my first show I wanted to stress this idea

that American painting was just as good as the European, the great Europeans."[10]

What the artists, critics, and dealers felt from the inside in New York was also noticed by occasional visitors from across the Atlantic, including the Belgian critic Michel Seuphor, who reported from New York: "Why has Fifty-seventh Street always looked so sunny to me, even when it's snowing? Was it Sidney Janis' smile, Wittenborn's singsong voice, Egan's veiled humor, or, just around the corner on Madison Avenue, Kootz's cordial welcome? This street of art dealers has very wide sidewalks: room for everyone."[11] Seuphor's exploration of the New York art scene led him of course also to Castelli's work at the Sidney Janis Gallery. Impressed by this comparison of twelve American and twelve French painters, he not only praised the exhibition, but also devoted a compelling series of photographs to it. In one of them, a painting of a woman by Dubuffet, hung high on the wall at the left side of the gallery, seems to disappear beside a larger *Woman* by de Kooning. On the other side of the door, it is Rothko who, at the left, vibrates more intensely than Nicolas de Staël, and while Kline's furious lines contrast with the calm of Soulages, Pollock's drip painting almost obliterates Lanskoy's forms. Beginning with its title, "Paris–New York 1951," Seuphor's report on the exhibition leaves no doubt as to the confrontational nature of the comparison between the two art capitals, the one in decline, the other on the rise.

Such successful initiatives as Castelli's, at that critical moment, allowed New Yorkers to hold their heads high. On both sides, in these postwar years, the French and the Americans were observing and gauging each other, trying to reconfigure themselves within new cultural spaces, according to a new distribution of roles. Invited to Yale University, Sartre had astonished more than one listener by welcoming the salutary effect of the young American novelists on French literature.

The Occupation intensified the fascination that American life exerted on French intellectuals—its violence, its profusion, its mobility. The American novel's influence lay in its revolutionary narrative techniques. . . . Without tradition and without help, American novelists have forged tools of inestimable value with barbarous brutality. . . . Soon the first French novels written under the Occupation will be published in the United States. We are going to return these techniques to you that you have lent us. We are giving them back to you digested, intellectualized, less effective and less brutal, consciously adapted to French taste. Because of the incessant exchange that seems to lead nations to rediscover in others what they have invented and then rejected, you will perhaps rediscover, in these foreign books, "old" Faulkner's eternal youth.[12]

Nevertheless, it would take years for those early symptoms to mature and for true, deep changes to take place in the heart of U.S. institutions. The Metropolitan Museum of Art, for instance, had long ignored the art of its own country and was legendary for rejecting, in 1929, Gertrude Vanderbilt Whitney's outstanding collection of contemporary American art, with a new wing attached to house it. Irritated by this refusal but determined to assume her role as a great patron of art, Whitney immediately founded the Whitney Museum of American Art. When, in 1950, the Met made the announcement of its exhibition *American Painting Today*, most contemporary artists received it poorly. On April 21, 1950, Adolph Gottlieb, assisted by Barnett Newman and Ad Reinhardt, began collecting his friends' signatures and, in a bold open letter to the director of the Metropolitan Museum of Art (published in the *New York Times* on May 22), opposed "the monster national exhibition," lashing out at the curator for being hostile to "advanced art," accusing the director of "contempt for modern painting," and regretting that "a just proportion of advanced art" had not

been included in the upcoming exhibition. "We draw to the attention of these gentlemen the historical fact that, for roughly a hundred years, only advanced art has made any consequential contribution to civilization," they wrote.

Six months later, in a small studio on 125th Street, the photographer Nina Leen went to great lengths to bring together the group of fifteen angry artists who had signed the letter. Their spokesman, Adolph Gottlieb, suggested this location to the editor of *Life* magazine as a place for them to speak their minds about the exhibition. They considered it desperately conservative, of course, but their criticism extended well beyond this one show. It included, foremost, a century's worth of artists' struggle for public recognition in the United States. In this battle, the Met had always been considered an impregnable fortress, accepting only French artists and barring the door to contemporary American artists. Nearly two months after this photo was taken, the group portrait by Nina Leen was published on page thirty-four of the January 15, 1951, issue of *Life*, with a caption that read, "Irascible Group of Advanced Artists Led Fight Against Show."

From then on, these fifteen artists became known as "the Irascibles." They were pioneers, whose outcry connected them to the tradition of dissident European art movements—the Salon des Refusés in 1863 Paris, the Secession in 1897 Vienna, Der Blaue Reiter in 1911 Munich. Furthermore, while the standard image of personalities in the United States was all smiles, the photo published in *Life* showed a group of hostile artists dressed like businesspeople, with expressions of unaccustomed seriousness.

These fifteen American rebels posing before the camera, unabashedly glowering and contemptuous, clearly challenged the established order. They form a pyramid of seated men (Rothko, Newman, Theodoros Stamos, Ernst, Brooks, Pollock) surrounded by eight standing men (Tomlin, Moth-

erwell, Still, Baziotes, Poussette-Dart, Reinhardt, Gottlieb, de Kooning), above whom stands a single and elegant woman (Hedda Sterne). Among these Irascibles, Newman, in the center, Pollock, just above him, and de Kooning, in the upper left, perfectly capture this new form of cold revolt. But it is Mark Rothko, with his mustache, intellectual glasses for his nearsightedness, oversized jacket, and a cigarette in his right hand, who appears, incontestably, to be the most aggressive of the lot. Seated in the foreground, in the lower right corner of the photo, with his left shoulder turned toward the camera, he takes on a posture that indicates he will not compromise—to the extent that he scarcely deigns to look at the camera. In New York city of the early 1950s, Rothko belonged to an artistic minority. Within this group of fifteen Irascibles, he also belonged to two other minorities: a European one (with Ernst, de Kooning, Stamos, and Sterne) and a Jewish one (with Gottlieb, Newman, and Sterne).

The year 1950 was an auspicious one for Rothko. It began with a rare compliment in the *New York Times* of January 8 regarding his abstract paintings at the Betty Parsons Gallery. "What we think beautiful may be scorned in another generation and what we despise raised to honor," the critic Howard Devree wrote, alluding to Somerset Maugham's memoirs, *The Summing Up*. "'The only conclusion is that beauty is relative to the needs of a particular generation.' One of the cases in point is Mark Rothko who is definitely in a period of transition." His big canvases, the critic states, "are vibrant, even strident, with color and without what we usually call subject matter. He seems to be trying to achieve a kind of fluid Mondrian effect, abandoning sharp edges and lines but keeping more or less such areas as Mondrian used more geometrically. How far such a procedure can go and what goal it may reach is not yet clear."[13]

His good fortune that year continued with Rothko and

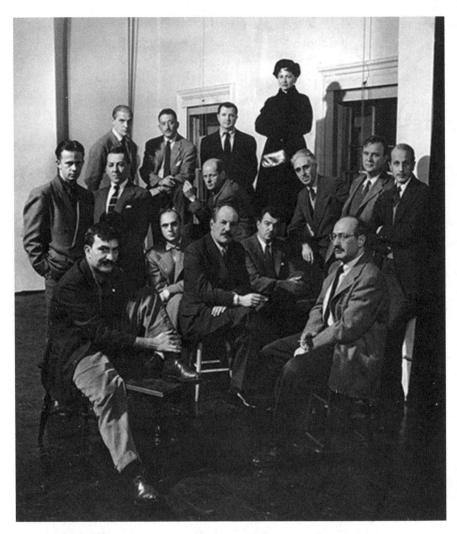

The Irascibles, November 24, 1950. Front row, left to right: Theodore Sta-
mos, Jimmy Ernst, Barnett Newman, James Brooks, Mark Rothko. Middle
row, left to right: Richard Poussette-Dart, William Baziotes, Jackson Pol-
lock, Clyfford Still, Robert Motherwell, Bradley Walker Tomlin. Back row,
left to right: Willem de Kooning, Adolph Gottlieb, Ad Reinhardt, Hedda
Sterne. (Photographer: Nina Leen—Time & Life Pictures/Getty Images)

Mell's five-month trip to Europe—Paris, Chartres, Nice, Cannes-sur-Mer, Venice, Florence, Arezzo, Siena, Rome, then back to Paris, and on to London—which deeply transformed the painter on a personal level. Far away from the conflicts of the New York art scene, he was at last enjoying some peaceful moments and, on June 30, 1950, exultantly announced to Barnett Newman: "Mell is pregnant—the child having begun his fourth mensis of wombal life. We are happy about it, so happy, that we are leaving the practical considerations until we reach home."[14] During this European sojourn, Rothko was also able to adjust his mental image of the legendary Old World, magnified by childhood memories, to the reality of a land heavily altered by the world's recent geopolitical changes. France proved especially disorienting for Rothko, who had great trouble adapting to it. "I did just want to tell you that from my slight impressions," he wrote to Newman, "not all the differences that we had postulated between our own state of minds and that of Paris ever approached even a fraction of the actuality. Never did I ever conceive that the civilization here would seem as alien and as unapproachable as the actuality as it appears to me. Therefore, for Betty's information at least, our reluctance to send pictures over here seems to me to have been correct."[15] How to interpret such a negative stand? And how could one understand the significance of his harsh words if not as evidence of Rothko, then fully American, feeling so alien to the depressed world of European galleries that he was even reluctant to send his paintings there?

Such a reaction echoed that of Leo Castelli, who emigrated from Europe in 1941 and soon felt intoxicated by the bustling American economy: "As soon as I arrived [in New York], I saw that America was a dreamland, and it seemed to me that Europe was going down the drain. After the war's transfer of culture, America restored Europe's confidence. . . . Without the U.S., I don't know whether Europe would have got back on its

feet."[16] On one occasion, Castelli even planned to include his old Paris colleagues in a New York project but soon gave up the idea. "I never managed to convince either [René] Drouin or [Michel] Tapié to work with the United States," he stated the following year. "In fact, the poverty was too great and the economic situation too desperate. Drouin was so poor he had to give up his apartment and live in the basement of the gallery!"[17] Stanley Kunitz recalled precisely Rothko's vehemence upon his return to New York and "his flat rejection" of the "whole tradition of European painting beginning with the Renaissance." "We have wiped the slate clean. We start new. A new land. We've got to forget what the Old Masters did," the boy from Dvinsk bluntly told him.[18] In fact, Rothko's works at the time, as in the case of *Untitled*, 1949, were growing into a purer form than ever before.

Rothko's daughter, Kathy Lynn, was born in December 1950. She was named after Rothko's mother, who had died in Portland a few months earlier. Naturally, this little girl transformed the couple's daily existence drastically, bringing them closer to friends who had a more stable life, like the Motherwells. In a letter to his friend Herbert Ferber, for instance, Rothko enthusiastically announced, "Kate in contrast insists on doing everything, which produces the opposite of the well being that you are experiencing. I went off with Bob for the weekend, leaving Mell alas with Kate in the country, to Woodstock, where the perfect weather plus copious drinks and food did much to drown the banal words."[19]

This first return to Europe had taken Rothko away from the New York scene right as the situation with the Metropolitan Museum of Art was about to resolve itself. While sightseeing in Paris with Mell, he had given his signature to Gottlieb and Newman for the instantly famous "Irascibles" letter of April 1950. But Rothko returned to New York well disposed, with an unprecedented ardor for the United States and new

resolutions, including the decision to devote himself to his personal success. "Obviously, now that we are coming home and that we have read your report of the end of the season, we must find a way of living and working without the involvements that seem to have been destroying us one after another," he assured Newman. "I doubt whether any of us can hear much more of that kind of strain. I think that this must be a problem of our delayed maturity that we must solve immediately without fail. Perhaps my ranting against the 'club' was no more than a cry of despairing self-protection against this very danger."[20] How should one interpret what he described euphemistically as his "ranting against the 'club'"? Why this "cry of despairing self-protection"? And what was exactly the "danger" he wanted to protect himself from? Could the onset of unavoidable tensions within any up-and-coming new group lurk behind the terms "destroying" and "strain"?

The "Club" had begun its activities in the fall of 1949. It was a small group of artists and intellectuals who, like the Impressionists gathering at the Café Guerbois in the 1890s, were trying to bolster their identity in a society deaf to their concerns. They organized meetings and discussions; they fostered intellectual exchange. The New York visual art scene was finally starting to answer their plea, with the opening of new galleries uptown and, more important, the growing endorsement of key players like the critics, museum curators, and gallery owners. In the cafes of the East Village, New York artists were starting to create an atmosphere resembling that of Saint-Germain-des-Prés.

There, visual artists (Pavia, de Kooning, Kline, Lassaw) mingled with musicians (Cage, Varèse, Margulis), critics (Greenberg, Rosenberg, Schapiro, Hess), writers (Hannah Arendt, Frank O'Hara), museum curators (Barr, Sweeney), gallery owners (Egan), and collectors (Leo and Ileana Castelli). In the loft they rented at 39 East Eighth Street, Wednesday evenings were devoted to meetings of the Club's founding members, while

Friday evenings were open for friends and featured readings, concerts, panel discussions, and lectures. Thus New York's first true community of artists was founded, and its power dynamics inevitably were structured around its geographical tensions (uptown versus downtown) and its symbolic ones (established artists versus emerging artists).

Abstract and Expressionist painters sought to define themselves in endless debates. There were artists on the verge of fame (such as Franz Kline, Willem de Kooning, Ad Reinhardt, Jack Tworkov, and Robert Rauschenberg) and others not quite on the cusp (such as Lewin Alcopley, George Cavallon, Ibram Lassaw, Landes Lewitin, Conrad Marca-Relli, Philip Pavia, Milton Resnick, and Ludwig Sander). "Downtown, below Thirty-fourth Street," Clement Greenberg had written a few years earlier, "the fate of American art is being decided by young people, few of them over forty, who live in cold-water flats and exist from hand to mouth. Their art is abstract, they rarely show it on 57th Street, and their reputations do not extend beyond a small circle of fanatics, . . . of misfits obsessed by art and isolated in the United States as if they were living in Paleolithic Europe."[21]

The Club also served as an arena in which all the latent conflicts of the art world were being played out over and over again, with the various existing clans giving free rein to their tensions. Pollock, who lived mainly in Springs, outside New York, seldom came to the meetings, nor did his champion Clement Greenberg. At any rate, Pollock was badly received by the club, and intellectual debates irritated him. During one of his rare appearances he became "an instant target" and left muttering, "I don't need a club!"[22] In everyone's opinion, the club was committed to the cause of the adverse party—the de Kooning camp—of which Tom Hess, the new editor of *Art News*, was the official champion. "Hess was playing a power game," recalls Conrad Marca-Relli, "pushing de Kooning and

trying to get rid of Jackson in the number one spot."[23] And then, another faction came into the picture, the one of Motherwell and his friends Rothko, Gottlieb, and Newman, regarded by "Bowery bums" like Marca-Relli as "the first of another kind of artist." In Marca-Relli's view, "They were the uptown boys, people who had already made a name, already had a gallery uptown before they joined. With their arrival came the panel discussions and guest speakers, and everything become more public, more formal."[24] Motherwell, especially, was criticized for the intellectual veneer he had developed with the Surrealists, his frustrated ambitions, and his disdainful envy of Pollock. Rothko, who belonged to Betty Parsons's stable of artists, was branded by the younger artists who had not yet broken through and who thought he acted like an "arrogant master." "We were supporting each other," Marca-Relli recalled. "There were the older artists, some of them such as Pollock who had already succeeded and others such as de Kooning, who was about to succeed and who exhibited in the uptown galleries, and there were the younger ones who had never shown anything."[25]

In the spring of 1951 the idea of mounting a group exhibition in an abandoned antique shop was suggested. According to legend, Castelli played an active, even central, role in this exhibition.[26] Despite the chaotic atmosphere during the show's preparation and the tensions that persisted up to the very last minute, and despite Pollock's canvas *Number 1, 1949* being hung horizontally instead of vertically, the first day of the exhibition, on May 21, 1951, remained a landmark date in everyone's memory. "All the stars!" recalled Sander. "And the jam of taxis pulling up, five or six at a time. People getting out in evening clothes. Whoever they were in those days. I didn't know too many. . . . Really it was amazing the number of people that came to that. It gave us enthusiasm about ourselves I think. It did us more good in our own eyes than it did in any other way. I think there was only one thing sold."[27]

That evening, from their flea-ridden hangouts at the bottom of Manhattan, the artists of the East Village infiltrated the city like a Trojan horse—they managed to attract an audience from the tonier neighborhoods who had never before come down to the Village, and to wipe out the boundary between uptown and downtown, between the upper middle class and bohemia. At some point, Alfred Barr, who attended the opening in the company of Dorothy Miller, approached Castelli. "With tremendous enthusiasm," recalled the collector, "he took me aside and said, 'Let's go somewhere quiet so you can tell me how your friends put all this together.' . . . So we went to the Cedar Bar and I showed him the photos. He wrote the artist's name on the back of each photo. He was not familiar with the majority of them. Of course, he knew the work of Pollock, Kline and de Kooning, but to my knowledge, only Pollock had a work in a museum collection at that time."[28]

Strangely enough, neither Newman, Still, nor Rothko took part in this legendary event that over the years came to be known as the "Ninth Street Show"—a notable absence that raises a number of questions. Why, in the first place, did some of the uptown art dealers, including Sam Kootz, who found the invitation insulting, refuse to exhibit their artists there? And why did Gottlieb and Baziotes decide to comply with such a dictate, while Motherwell transgressed it, to the great delight of his friends from the Club, who praised his resolution? Conversely, in some instances, the uptown dealers allowed their painters to be included in the show, but the artists themselves refused. Such was the case of Betty Parsons, who came up against firm opposition from Rothko, Still, and Newman. What should one make of this attitude? Certainly, Rothko's absence from the Ninth Street Show was a missed opportunity of his own making. At a time when he felt that his popularity was on the rise in the New York art world, did he fear that his participation in the show might jeopardize his ascent? Was he

already convinced that he belonged to another class of artists?[29] Ernest Briggs offered his impressions dating from his arrival in New York in 1953, when "the Club was dominated by Franz [Kline] and Bill [de Kooning] and Pavia who were sort of the manager and kept it going." Meanwhile Still, Rothko, Pollock, and Newman, he went on, "represented . . . another 'gang' you know. And there was a definite separation in their manner essentially. Certainly not in their ambition or their aspirations, but the mere fact that Still and Rothko were in the Betty Parsons Gallery . . . separated them from the 10th Street milieu and that whole excitement that was very genuine and very real and characteristic of New York's intellectual life. But they more or less had withdrawn."[30]

Probably Rothko's absence from the Ninth Street Show can be attributed to his own exhibition at the Betty Parsons Gallery, which had taken place just a month earlier, from April 2 to 22. Of all his solo shows, it was, by far, the most warmly received by the press. "Visually, these paintings are impressive and, to a certain point, they provide the emotional release that is furnished by all genuine works of art," a delighted Stuart Preston wrote on April 8, 1951, in the *New York Times*.[31] Among Rothko's canvases, now simply identified by numbers, the one which stood out was *No. 21 (Red, Black and Orange)*, 1951, in which two rectangular masses with blurry outlines (one pinkish orange, toward the top; the other orangish pink, toward the bottom), with brown in the background, seem to float in space, dialoguing with each other and drawing the viewer into an endless spiral. Let us also mention *No. 10*, 1950, an immense work, more than seven and a half feet tall, in which translucent masses of orange and white rest on the bright blue surface like impalpable clouds—a random arrangement that fascinates and disconcerts at the same time.

"It is the work of a very great man and I do not use the term with abandon," Clyfford Still wrote to Betty Parsons

after visiting the show. "I consider myself one of the specially favored to know . . . this power and to have . . . understood its genesis and development. That is, as far as an outsider can comprehend it. For it is unique and I know is completely misunderstood in its essence by some of Mark's more vocal admirers."[32] Later, Irving Sandler recalled the essential elements of this new phase: "In 1950 Rothko began to paint abstractions, each composed of a few softly painted and edged horizontal rectangles of luminous color placed symmetrically one above the other on a somewhat more opaque vertical ground. . . . It is the field of resonant, atmospheric colors rather than the design that arouses the primary visual and emotional response. . . . He also started to paint on a more monumental scale. In these abstractions, Rothko achieved the clarity, immediacy, and drama that he desired, to the extent that he repeated this general format in all of his subsequent pictures."[33]

Rothko reached new heights when his paintings were included in one of the contemporary shows organized by MoMA, which were among the best recurring exhibitions during those years. Their creator was the beautiful and elegant Dorothy Miller, who was widely admired by the artists of that generation quite simply because she respected them. She began her career in the orbit of the man who introduced European Modernism to New York, Alfred Barr, and married Holger Cahill, a key supporter of the opposite movement, American Realism. Cahill contributed to the creation of art centers throughout the United States and initiated the Works Progress Administration (WPA), the program launched by President Roosevelt in 1933 and which lasted until 1943. Dorothy Miller had become as acutely aware of the different art trends of the time as anyone could be.

Scarcely a year after his dazzling exhibition at the Betty Parsons Gallery, Mark Rothko took part in MoMA's *Fifteen*

Americans show (April 10–July 6, 1952). With a hundred paint-
ings and sculptures, all assembled by Miller, it was intended to
be the museum's response to critics who resented the all too
strictly European policy it had pursued since its creation. Ac-
cording to MoMA's records, half of the selected works were ab-
stract (Rothko, Still, Pollock, Tomlin, Corbett, Wilfred, Lip-
pold), while the other half included realist artists who strongly
opposed the former. Pleasantly surprised that Still, who fa-
mously disdained (or ignored) large institutions, had agreed to
show his work at MoMA, Miller designed his and Rothko's ad-
joined galleries as the culminating "crescendo" of the abstract
section, and offered all artists the opportunity to be involved in
the hanging of their works. Most of them declined, but Rothko
advised her and Still spent an entire evening taking part in the
installation with her. According to Miller, Rothko grew un-
happy that Still's works could be seen from his gallery, and de-
manded "an absolute blaze of light in order to outshine Still's
gallery which would be normal light . . . He wanted twice as
many lights in all the light pans that we have around the ceil-
ing which threw the light on the walls. Plus he wanted central
lights put in."[34]

Rothko's paintings struck viewers with their monumental
dimensions, especially *No. 2/No. 7/No. 20*, 1951, whose surface
of white and pale green masses was horizontally striped in the
lower third by an assertively contrasting red line and which
measured nearly ten feet by more than eight feet (almost three
by two and a half meters). "I paint very large pictures," the art-
ist explained in an interview with the magazine *Interiors*, as if
to fend off criticism. "I realize that historically the function of
painting large pictures is something very grandiose and pomp-
ous. The reason I paint them however—I think it applies to
other painters I know—is precisely because I want to be inti-
mate and human. To paint a small picture is to place yourself

outside your experience, to look upon an experience as a stereopticon view or with a reducing glass. However you paint the larger picture, you are in it. It isn't something you command."[35]

In the *New York Times*, Howard Devree gave a particularly detailed report on the event, explaining that "Dorothy Miller has assembled as highly diverse a group of artists as the series of these shows has yet produced," before going on to describe the impressive range of the works on display, "from the romantic and sometimes stereoscopic realism of Herman Rose's Manhattan rooftops to the completely nonobjective swirls of Jackson Pollock's intricacies." The exhibition, he concluded, "unfolds pretty much the full tale of contemporary art." Next to the figurative works by Herman Rose, the daring paintings of Jackson Pollock and Mark Rothko stood out. That being said, MoMA, with its quasi-exclusive European Modernist focus since 1929, had ignored innovative American artists for so long that to some critics, Dorothy Miller's *American* shows seemed almost infeasible in the context of the institution. This could explain why Devree seemed to refer to the great American artists of his time with some degree of reluctance. While he referred to Pollock, Rothko, and Still as true "pioneers," he also admitted that "one extreme is reached in the present show" and could not refrain from writing silly observations, such as "Rothko's simplifications of color areas might well lead the untutored to think them at first glance to be the flags of unknown nations." Was he trying to reach out to a philistine audience? Furthermore, what was he attempting to achieve with his comment that "Still's color forms suggest cloudscapes or unfinished relief maps"?[36]

According to Dorothy Miller, Still and Rothko refused to let her send the *Fifteen Americans* show abroad for fear that they wouldn't be able to supervise the installation, ultimately thwarting her plans for a traveling exhibition. "I didn't travel that show because Still refused and Rothko refused," she bluntly

stated. "And I don't remember if there was anyone else that re-
fused. But with them out, it just ruined the show."[37] She even
alerted Alfred Barr about her "endless nerve-shattering diffi-
culties with Rothko and Still over circulating the show," before
admitting that she was "finally losing out."[38] All things con-
sidered, Miller persisted in her dedication to contemporary
American artists, even as she had little room to negotiate the
tensions with the press, on the one hand, and the oversensitiv-
ity of the artists on the other. Hence her explicit note to Barr:
"I sent you clippings so you know my show got a foul press
which fortunately the artists and I choose to take as proof that
the show is a success. Actually I have never had such good com-
ments on any show I've done."[39]

After *Fifteen Americans* closed, Rothko continued to visit
the MoMA gallery where his paintings had been shown, which
now displayed works by Georgia O'Keeffe and John Marin:
"Ran up to the Museum show," he wrote Ferber, in a somewhat
hypersensitive mood. "My room is now inhabited by Marins
and O'Keefe [*sic*]. I must admit that the after-show remaining
from my own stuff made those quite invisible for me at least.
. . . I met and had a long talk with Walkowitz, whose glocoma
[*sic*] has made him almost blind. Still he haunts the museum
daily. I have always had the highest respect for him. And so it
goes. Barney [Newman] has remained invisible."[40] Indeed, a
lot was disclosed in this short letter to Ferber: Rothko's heart-
felt admiration for an aging Walkowitz (he had been a regular
at the Steins' salon in Paris and a friend of his mentor Max
Weber); Rothko's explicit resistance to Marin's and O'Keeffe's
art; Rothko's observation about the new phase of his (some-
what strained) relationship with Barnett Newman. But these
were still in the future!

A few months after this show, Rothko's particular mistrust
toward established institutions—as a true idiosyncratic pattern
—resurfaced. This time, he targeted the Whitney Museum by

addressing a remarkable letter to one of the directors after he had been informed that the museum intended to purchase some of his works. The following letter that Mark Rothko wrote to the associate director of the Whitney demonstrates the artist's newfound confidence—as both a pioneer and a rebel.

Dear Mr. Goodrich,

Betty Parsons has informed me that you have asked for two of my pictures to be sent before the holidays to be viewed by your purchasing committee. In view of the fact that I must decline the invitation, I hasten to get these remarks to you due in time. I am addressing these remarks to you personally because we have already talked about related matters in regard to your present annual; and I feel therefore that there is some basis of understanding. My reluctance to participate, then, was based, on the conviction that the real and specific meaning of the pictures was lost and distorted in these exhibitions. It would be an act of self-deception for me to try to convince myself that the situation would be sufficiently different, in view of a possible purchase, if these pictures appeared in your permanent collection. Since I have a deep sense of responsibility for the life my pictures will lead out in the world, I will with gratitude accept any form of their exposition in which their life and meaning can be maintained, and avoid all occasions where I think that this cannot be done. I know the likelihood of this being viewed as arrogance. But I assure you that nothing could be further from my mood which is one of great sadness about this situation: for, unfortunately there are few existing alternatives for the kind of activity which your museum represents. Nevertheless, in my life at least, there must be some congruity between convictions and actions if I am to continue to function and work.[41]

9

---◆I◆I◆---

The Avant-Garde Jewish Painter and His Journey of Dispersion: 1954–1958

To become an avant-garde painter meant to become an avant-garde Jew: a figure apart, perhaps torn away, undertaking a journey of dispersion more radical than that of other Jews.
—Irving Howe

IN 1954, Mark Rothko turned fifty: He had become a recognized artist, an avant-garde painter, and a responsible father. But how easily could he embrace success, after so many ordeals and so much hostility against official institutions? How easily would he undertake, as Irving Howe so aptly put it, his own "journey of dispersion," between assimilation and fragmentation?[1] During one of the most conservative periods of recent U.S. history—Senator McCarthy's witch hunt against "card-carrying members" of the Communist Party, confrontation with the Soviet Union during the Cold War, the condemnation of leftist intellectuals after the Rosenbergs' trial, and

the Korean War—how would this psychological dilemma play out? And how would Rothko benefit from the country's dazzling economic prosperity of the time, wherein new fortunes emerged along with new opportunities?

During this phase of professional success, two eminent personalities of the art world, each with an unusual trajectory, would foster Rothko's ascent in two of the country's major cities: in Chicago, the curator of the Art Institute, Katharine Kuh; and in New York, the art dealer Sidney Janis. Of all the "dynamic players"[2] instrumental to anchoring Rothko's position as artist in American society, how not to mention that these two, in particular, were "assimilated" Jews?

"Your letters are invaluable. . . . They help sharpen issues and my ideas about them. And above all, they make of you a concrete audience to whom I am addressing thoughts, whose warmth and understanding make me want to be truthful and clear."[3] This genuine confession, addressed to Katharine Kuh on July 28, 1954, betrayed Rothko's affection for the curator—something of an oddity in the course of the artist's life. A subsequent undated letter confirmed the artist's undeniable gratitude to Kuh: "I did want to tell you that you did start a process of speculation about ideas and work, in which I have not engaged for some years, and which I find valuable and enlivening, and for this reason I want to thank you."[4]

Born Katharine Woolf in St. Louis, Missouri, to a well-to-do Jewish family who had emigrated from London four decades earlier and had since prospered in the garment industry, she courageously overcame polio as a teenager and was Rothko's exact contemporary. At Vassar College, she attended a class taught by Alfred Barr, who convinced her to pursue an art history degree at the University of Chicago and, later, at New York University. After becoming Kuh by marriage, she opened Chicago's first avant-garde gallery in November 1935, exhibiting

a selection of modern Europeans and Americans, African and Pre-Columbian art, and photography along the lines of what Alfred Stieglitz had done in New York at his Gallery 291 thirty years earlier—in other words, it was a financially unsustainable enterprise. After six years as a gallery owner, Kuh took a position at the Art Institute of Chicago in 1943, where she managed the Gallery of Art Interpretation, a flexible space designed by Mies van der Rohe, whose collection she went on to enrich and expand. Kuh carried on with the educational tradition of the American museum exemplified by Alfred Barr, who had created an Education Department at MoMA, with its catalogues, radio broadcasts, and traveling exhibitions. She even surpassed her former mentor, pioneering new interactive experiences for visitors, including exhibitions that prompted them to wonder about art history: "How did Constable's and Turner's work lead to Impressionism?" she asked in one leaflet. The questions were as diverse as "How does the artist transform nature?" and "How might we evaluate the state of American art and French art in the nineteenth century?" These techniques, along with the minimal written explanations that accompanied each work, quickly immersed visitors in art issues, transforming them from passive observers into active participants.

As soon as she became a curator of the Art Institute's painting department in 1954, Kuh started to enrich the museum's collection, and she also proposed the idea of a solo show of Mark Rothko, a first in the artist's career. "Dear Miss Kuh: I am very glad that you were able to arrange the exhibition," a delighted Rothko wrote her on May 1. "And I think that you are inaugurating something very worth while, and the date you have arranged seems very good, too. I will be in New York on July first and will expect you."[5] The curatorial process began on July 1, 1954, when Kuh visited the artist's studio in New York; there, he showed her some of his work. In mid-September, he sent her the canvases for the show, all painted between 1950

and 1954, including even new ones. "I sent nine pictures, seven of which you chose and two which were painted since your visit here whose inclusion, I felt, significantly added to the scope of the group. I hope that the group seems as right to you as it did to me in the studio."[6]

Drawing on her unique creativity, she then decided to innovate once again and publish a book of interviews with the artist, based on their personal correspondence, which consisted of a dozen or so letters, all warm, detailed, and lengthy, each around ten pages long. Without question, this would have been a first in American art as well as for Rothko! Fully committed to this project, the artist immersed himself again in their epistolary relationship with a precision that conveyed the depth of their bond: "I sent off a letter to you yesterday and remembered that you had asked for the return of yours. It occurs to me that it would be well for both of us to have copies of the full correspondence. Therefore I have made a copy of yours and have retained one of my own. I think it would be easier if we both retain copies of our own before we mail them. In that we shall both be able to contribute suggestions, at the end, which may prove welcome." Contrary to the suspicion and hostility Rothko often directed toward the Metropolitan Museum of Art, the Whitney, and other art institutions, he showed Katharine Kuh the utmost elegance and refined politeness. His closing remarks conveyed the same sense of consideration: "In the agonies of writing, I have failed to wish you a most delightful and restful vacation, and I hope that there will be some way that we can meet before your return to Chicago to discuss both the correspondence and the pictures for the exhibition. Sincerely, Mark Rothko."[7]

Built on these premises, Rothko's friendship with Kuh began around the time of the 1954 exhibition and intensified when the curator moved to New York in 1959, ending only with the artist's death eleven years later. According to Christo-

pher Rothko, Katharine Kuh was "one of the few scholars with [whom] my father became friendly. The Chicago exhibition was my father's first major exhibition and I think he felt she really understood his work. . . . My father was notoriously difficult and controlling in the context of exhibitions and the display of his artwork. Socially, however, he was much-loved and much more jovial (even if a bit of a provocateur)."[8] Kuh herself later referred to the painter as "a warm, articulate companion . . . both loyal and affectionate, his personality, like his paintings, enveloping you in its amplitude." She also found him to be "an iconoclast, exuberantly immersed in his painting and also in his various biases . . . an inveterate crusader."[9]

"Thanks for your letter," promptly replied the artist in another of his letters to the curator. "It has had the effect of starting me in the attempt to collect my thoughts and setting them down. . . . You write that what you would really like to know is what I am after, how I work and why I have chosen the particular form which I use. I hope that some kind of answer to these questions will be implicit in our correspondence before it is completed."[10] In fact, from the very beginning of their correspondence, Rothko emphasized his reluctance to provide an interpretation of his own work, while insisting on the premises of their original agreement. "May I suggest, however, that at this time we abandon any preconceived notions of what ought to be said and printed. For unless we do, it will bind us to a course which will inevitably lead to the meaningless banality of forewords and interviews." Far from the traditional exhibition catalogues, with their familiar critical comments, Rothko had something much more ambitious in mind: "I would like to find a way of indicating the real involvements in my life out of which my pictures flow and into which they must return. If I can do that, the pictures will slip into their rightful place: for I think that I can say with some degree of truth that in the presence of the pictures, my preoccupations are primarily moral

and that there is nothing in which they seem involved less in than aesthetics, history or technology."[11]

Correspondence and paintings, paintings and correspondence. Ultimately, the idea of an accompanying text, written by the painter, was abandoned, putting an end to their initially engaging experiment. Nevertheless, in the process of preparing the exhibition, Rothko revealed many bits of valuable information about his work, as when describing the hanging to his new friend: "Since my pictures are large, colorful and unframed, and since museum walls are usually immense and formidable, there is the danger that the pictures relate themselves as decorative areas to the walls. This would be a distortion of their meaning, since the pictures are intimate and intense, and are the opposite of what is decorative; and have been painted in a scale of normal living rather than an institutional scale." In the following pages, I will discuss at length Rothko's fear of appearing "decorative"—a concern he raised on numerous occasions. I will also come back to his meticulousness and the obsessive attention he gave to presentation and lighting—in other words, the "general ideas" he arrived at in the course of his own "experience in hanging the pictures," in an attempt to fully master the effect of his works on the audience. "I have on occasion successfully dealt with this problem by tending to crowd the show rather than making it spare. By saturating the room with the feeling of the work, the walls are defeated and the poignancy of each single work had for me become more visible."[12] In claiming full control over the presentation of his works, Rothko meant to take on the role of curator as well and to produce paintings not as isolated works of art but rather as a genuine and holistic interactive *experience* for the public. Hence the program he described to Kuh: "I also hang the largest pictures so that they must be first encountered at close quarters, so that the first experience is to be within the picture. This may well give the key to the observer of the ideal relationship

between himself and the rest of the pictures. . . . I hope that you feel as warmly about the pictures when they arrive as you seemed in the studio, and that the feeling continues through-out the exhibition."[13]

In September 1954, with Petronel Lukens—she was Kuh's assistant—Rothko carefully organized the transportation of his works to Chicago. "I have consulted with Budworth [the ship-ping company] and have arranged for the paintings to be col-lected on Sept. 17th," he wrote her. "There are nine paintings as requested by Miss Kuh in her letter in June. Budworth has as-sured me that these should reach you by Oct. 1st. . . . As soon as the pictures have gone I will write in detail about sizes and other pertinent matters to Miss Kuh so that she may have the information before the arrival of the pictures."[14] With equal tact and determination, the artist organized the hanging of his works: "It would be best if all nine could be hung for I have thought of them as a group. I realize that this may be impos-sible. Would you send me the numbers if any are omitted. It would help me to visualize the show. I, of course, would like to see it. You mentioned the possibility of my being brought out on the basis of a lecture. I would like to entertain the idea if one can be arranged."[15]

Surprisingly, Rothko traveled to Chicago neither for the hanging nor for the opening, nor to visit the show even once. Yet, the tremendous and flamboyant *No. 10*, 1952 (over 9 × 12 feet), in which a golden yellow contrasts with an orangish red and a bright yellow, hanging like a sunset from the ceiling in the exact center of the gallery, made an unforgettable impres-sion, as did the eight other works shown on three walls of a sin-gle room, isolated from the rest of the museum by a temporary partition. Among the paintings were two that signaled a move away from the artist's sunny palette of the first three years of the decade: the sumptuous *No. 1 (Royal Red and Blue)*, 1954, a vertical work in brazen blue; and the intense *No. 14*, 1951, an

almost square canvas of purple and red. "It is true," Kuh wrote in the Art Institute's bulletin, "that to enjoy Rothko's paintings seems less a thinking than a feeling process. . . . One tends to enter into his canvases—not merely look at them." Then she proceeded to explain that the exhibition showed "how completely the artist's late work relies on color. Here are canvases where relationships of color are so basic as to become both form and content. Depending chiefly on proportions and intensity of color relations, these paintings produce strange moods—sometimes somber and smoldering, sometimes ecstatic."[16] But she also referred elegantly to what she considered a minor disappointment: "It was hoped that through an informal correspondence some clear explanation of his work would emerge to be published later in a pamphlet accompanying the exhibition. But his misgivings were valid; it is not always feasible for an artist to write glibly about paintings still in progress."[17]

The tributes to the show matched Rothko and Kuh's considerable efforts in organizing it. "Rothko's work is charged with what we mean by matters of the spirit," Hubert Crehan declared in *Art Digest*, drawing a comparison with a "Biblical image of the heavens opening up and revealing a celestial light, a light sometimes so blinding, its brilliance so intense that the light itself became the content of the vision, within which were delivered annunciations of things closest to the human spirit. Rothko's vision is a focus on the modern sensibility's need for its own authentic spiritual experience. And the image of the work is the symbolic expression of this idea. Now it is virtually impossible to articulate in rational terms what this might be; we can have only intimations of it which come first to us from our artists."[18]

The show opened on October 18, 1954, to the delight of thousands of viewers, and before it closed on December 31, a press release from the Art Institute proudly announced that

the museum had purchased *No. 10, 1952*, for its permanent collection. "It is needless to tell you how greatly this transaction contributes to the peace of mind with which my present work is being done,"[19] Rothko admitted to Kuh. Still, the success of his first major solo show did not soothe Rothko's constant worries. "The art industry is a million dollar one," he explained to his friend the artist Ethel Schwabacher. "Twenty-five thousand people, museums, galleries, etc. etc. etc. are supported by it: everyone gets money out of it except the artist. I can exhibit my paintings in a hundred different exhibitions. But I do not get any money. I can lecture. But they do not pay for lectures. I am written about, shown everywhere but do not even get $1,300 a year."[20]

Things were about to change swiftly, though. In one of his many messages to Kuh, Rothko mentioned in passing, as if to downplay the significance of the event, "As I had informed you at our last meeting in New York, my relationship with the Betty Parsons Gallery was terminated last spring. In the event that there is any printed matter relating to the exhibition which involves credits, please have the pictures designated as 'lent by the artist.'"[21] In actuality, this revelation had much deeper ramifications. For an artist, to switch dealers was quite an adventure, and for Rothko, in particular, moving from Betty Parsons to Sidney Janis marked a shift into higher gear. Still, between Janis and Rothko, it all started unexpectedly, as Willem de Kooning amusingly related: "Sidney wanted him in the gallery. But Mark thought it was a waste of time because they [his paintings] wouldn't sell. . . . Then he said to Sidney, 'All right, if you can guarantee me $6,000 a year.' So Sidney said, 'That's rather silly, because there's four for you and two for me. I wouldn't even bother if I thought I couldn't sell more than $6,000, because there'd be nothing in it for me.' I don't know if he gave him a guarantee, but he said to Mark not to worry."[22]

Leo Castelli had recently interceded successfully on behalf of his friend Janis, suggesting to Pollock (in 1952) and de Kooning (in 1953) that they join Janis's gallery—a change that, according to the artists, they never had cause to regret. In Alfred Barr's words, Janis was "the most brilliant new dealer, in terms of business acumen, to have appeared in New York since the war."[23] As for the journalist John Brooks, he explained that "Janis's knack for selling pictures is undoubtedly related to his ability to explain their importance in the history of art and, at the same time, to communicate his own enthusiasm for them."[24] Born in 1896 in Buffalo, New York, Janis had made his fortune through a shirt-making factory and started collecting art in 1925 with his acquisition of a work by Whistler. But it was much later, in the fall of 1948—after being appointed to MoMA's Advisory Committee in 1934, after showing his private collection of modern European masters in various American museums, and after publishing a noted essay in 1946, "Abstract and Surrealist Art in America"—that this businessman-collector-writer finally opened his gallery on East Fifty-Seventh Street.

In April 1955, barely three months after the Chicago show, Rothko exhibited at the Sidney Janis Gallery for the first time. In doing so, Rothko added his name to an already prestigious list. Until he became interested in Pollock and de Kooning, Janis had exhibited exclusively renowned European Modernists. He then contributed to legitimizing the new American artists (they would later be known as Abstract Expressionists) by giving them the status of a historical avant-garde within the modern tradition. In a city still intimidated by what was happening in the art world, Janis gained respect and prestige for his ability to promote artists who, though established, had not previously sold well. Janis brought innovation to the art scene by organizing a series of museumlike exhibitions, showcased by excellent catalogues.[25] At a time when North American capitalism was accelerating, Janis's financial clout, thanks to his sales

of many European paintings, worked wonders. The inclusion
of most of the great European Modernists (Picasso, Klee, Mon-
drian, Kandinsky, Giacometti, Arp) in his gallery also reassured
his prestigious clientele, which included the country's most im-
pressive museums and collectors of modern art, both Ameri-
cans and Europeans.[26] And sales would only improve when, a
few years later, Congress passed a new tax law that would be
particularly advantageous to art collectors.

As for Rothko, while the dimensions of his paintings re-
mained gigantic, with new blue, green, yellow, and orange col-
ors, the painter's palette continued to evolve. In the first twelve
works he exhibited at the Janis gallery, his identity asserted
itself. One critic praised the work for its "breadth, simplicity
and the beauty of color dealt with on such a vast and subtly
modulated scale." Another spoke of this exhibition as "one of
the most enjoyable" in several years, and of "the international
importance of Rothko" as a "leader of postwar modern art."[27]
Only Emily Genauer and Howard Devree seemed to resist the
enthusiasm, the former going so far as saying that "Rothko's
pictures get bigger and bigger and say less and less."[28] "In com-
mon with a number of others," Devree admitted, "Rothko has
continued to increase the size of these canvases and the line has
now grown into big regular or fuzzy rectangular color-shapes;
and to accommodate them the canvases have grown larger
until one of the current crop all but fills a whole big wall of the
gallery." He went on to deliver some devastating remarks: "To
this reviewer the impact is merely optical rather than aesthetic,
the validity as a work of art negligible. Seemingly it has become
necessary for the color group to increase the size of their paint-
ings, with corresponding emptiness; to make impact and size
equivalent; and, as a corollary, they escape making any valid
statement." With statements such as "the impact is merely op-
tical" or "the validity as a work of art [is] negligible," Devree
hit hard, associating Rothko's paintings with "a set of swatches

prepared by a house painter for a housewife who cannot make up her mind."[29] Regardless, total sales from this exhibition amounted to $5,500, the highest ever for an artist at that time. At fifty-three, Rothko had at last achieved financial success.

The year 1957 was particularly prolific for the artist. He produced some forty works, reducing his range of colors to shades of red and brown, a definitive change from his Chicago exhibition four years earlier. His second exhibition at the Janis gallery, in January 1958, which included eleven works hung closely together, confirmed this evolution. This time, in contrast to the few sour notes of 1955, the critical reception was unanimous. "At the Janis Gallery, we encounter a solemn hush, rather than turbulence, in Mark Rothko's brooding and ghostly canvases, composed, as they basically are, in the simplest geometrical terms," Stuart Preston noted. "Subtly, fastidiously and impersonally painted, they are images of light and space, not in any naturalistic sense but, as it were, echoes of these. Big rectangles of misty, dark and often stormy color float majestically upward from the bottom of the canvases, in a movement sufficiently oblivious of the confines of the frame as to give the impression that they sail right out to invade the gallery. . . . It is tempting to charge the Whistler of the 'Nocturnes' with the same ancestral relationship to Rothko. But, whatever the likenesses, Whistler was a literary artist, whose abstract 'arrangements' ultimately come to terms with what he saw. With Rothko ends are the means and vice versa. His pictures are self-subsistent. Cut off from the visual world, their roots lie in the world of the artist's feeling (and very delicate and nuanced it is) for harmonies of form and color. In some cases this might be insufficiently nourishing ground. Not so with Rothko."[30]

This rave review must have delighted Rothko, for it echoed almost word for word the artist's recent statements on his own work, in which he mentioned being "interested only in expressing basic human emotions—tragedy, ecstasy, doom

and so on." Besides, he continued, "the fact that lots of people break down and cry when confronted with my pictures shows that I *communicate* those basic human emotions. . . . The people who weep before my pictures are having the same religious experience I had when I painted them."[31] As for the art historian Dore Ashton, she noted that the term "Abstract Expressionism," which was used to define the abstraction of Jackson Pollock, Willem de Kooning, and Franz Kline, whose works were based on impulses and intuitions, failed to properly define some other artists nonetheless associated with the movement: "Foremost among them is Rothko, whose abstractions, composed of simple squared forms bearing magical films of color, are most often characterized as 'transcendental.' That is, Rothko's canvases, contained, serene and serving as symbols for pure emotions such as joy or melancholy, appear to many critics to be concerned with abstract notions infinitely removed from smaller aspects of quotidian life often treated by other painters."[32]

Sumptuous whites and deep blacks against red, brown, and purple backgrounds create a symphony of silence and calm in the dazzling *No. 16 (Two Whites, Two Reds)*, 1957, and the more classic *Black over Reds (Black on Red)*, 1957. Unsurprisingly, the switch to the Sidney Janis Gallery coincided with a spectacular windfall for Rothko. The economic situation in the United States, without a doubt, played a crucial role in this phenomenon: the unprecedented inflation that had plagued the country in the aftermath of the Korean War (1951–1953) gave way to a period of economic stability and renewed confidence in Wall Street. The art market also took off, but until the mid-1950s, the trade for modern art remained dominated by European and a few prominent American artists. In 1955, the only American who could expect to receive more than $5,000 for a single work was Jackson Pollock. When his dramatic death in a car accident in Springs, New York, was announced on Au-

gust 11, 1957, the entire American art world was seized with intense emotion. A few months later, MoMA (shifting from its legendary indifference to American artists) acquired Pollock's *Autumn Rhythm* for $30,000[33] and transformed what had been conceived as a "mid-career show" for Pollock into a lavish commemorative retrospective. At the same time, Rothko's works started to trade in the vicinity of $5,000, with a permanent increase in the volume of his sales.[34]

Although Rothko had complained about his financial difficulties for years, this sudden material comfort became a new burden for him to worry about. According to Janis, "it was a tragedy that he couldn't enjoy it [his success]." Rothko, he said, "was a poor boy all his life; he was a poor boy and he just couldn't get used to riches. That money problem was an albatross around his neck, like the ancient Chinese, the wealthy, who would carry these big stone pieces of money around their necks. It weighed him down. . . . It depressed him."[35] This is when the notion of "journey of dispersion," proposed by Irving Howe, becomes relevant. Confronted with this sudden financial success, as an avant-garde painter and an avant-garde Jew, Rothko showed all the signs of the "torn away" personality described by Howe. "Nothing stimulated him more than a righteous fight against what he considered the commercialization of art, but as he became more successful, he too was threatened by the evils he had earlier denounced," Katharine Kuh recalled. "The conflict left him despondent, unsure and guilt-ridden."[36]

Mark Rothko's journey of dispersion was about to develop further, alternating between periods of highs and lows, much like the contrasting colors of his paintings. Among the highs were his inclusion in many prestigious museums and shows all over the world: successively the Guggenheim Museum in 1954; the Musée d'Art Moderne de la Ville de Paris in 1955; and *The*

New American Painting and Sculpture: The First Generation, a traveling exhibition organized by MoMA's International Council and shown in eight European countries from April 1958 to May 1959—Switzerland (Kunsthalle Basel), Italy (Galleria d'Arte Moderna, Milan), Spain (Museo de Arte Moderna, Madrid), Germany (Hochschule für Bildende Kunste, Berlin), the Netherlands (Stedelijk Museum, Amsterdam), Belgium (Palais des Beaux-Arts, Brussels), France (Musée National d'Art Moderne, Paris), and England (Tate Gallery, London), before returning to MoMA in May 1959. With *The First Generation*, American modern artists received acknowledgment from a number of European art critics, including the Berlin journalist Ludwig Glaeser, who considered the exhibition "as the art event of the year. The reasons are obvious," he went on, "even to a wider public: as demonstrated here, revolutions in modern painting still happen, and to revise a widespread prejudice—the youngest of them was made in America of all places."[37] The English painter Patrick Heron, for his part, admitted being "instantly elated by the size, energy, economy, and inventive daring of many of the paintings. . . . To me and those English painters with whom I associate, your new school comes as the most vigorous movement we have seen since the war. . . . We shall now watch New York as eagerly as Paris for new developments."[38]

Later in the 1950s Rothko gained even more visibility when ten of his paintings were chosen, along with those of Mark Tobey and sculptures by David Smith and Seymour Lipton, to represent the United States at the 1958 Venice Biennale, sparking the interest of many critics because, as Alan Bowness wrote, his work "in itself helps to give it the authentic flavour of the revolutionary."[39] But we owe to the professor and critic from Trieste, Gillo Dorfles, a childhood friend of Leo Castelli, the finest words on the artist. Dorfles saw in Rothko, in addition to "the other great personality who, although of Russian

origin, worthily represents modern American painting here . . .
the solitary figure . . . the only artist here who is moving in a
completely different direction. . . . Rothko's painting consti-
tutes a limit (as did Mondrian's in its time) and, at the same
time, a beginning: the beginning of a new tonalism. After 50
years of painting that focused almost entirely on color-material
and color-pigment, tonal painting re-emerges in a completely
different guise and with a totally new meaning."[40] And even
though Mark Tobey won the prize for his paintings that year,
Rothko was the one who became the darling of the press.

Whatever his achievements, those years were still hold-
ing some dark moments for Mark Rothko, including a falling
out with his old friends and fellow painters who still exhibited
at the Betty Parsons Gallery. Is it pure coincidence that con-
flicts with Clyfford Still and Barnett Newman occurred pre-
cisely at the time of Rothko's first show at the Sidney Janis
Gallery? How to interpret his old friends' venomous criti-
cisms as anything but resentment toward Rothko's quick rise
in the art world? Janis had invited Still[41] and Newman[42] to
the opening of this show, and their harsh and cruel letters to
Janis in response (excerpts of which are included in the preced-
ing two footnotes) should be interpreted as mere sociological
documents pertaining to the artistic milieu. Perhaps only Ir-
ving Sandler, who knew them all so well, succeeded in decod-
ing their overall meaning: "Still showed Rothko and Newman
the way to color-field abstraction. The three painters had been
close friends in the late 1940s, but in the 1950s they had a fall-
ing out. Still broke with Rothko when he wouldn't join him in
a campaign against the market mentality in the art world. . . .
Still and Newman stopped seeing each other when they began
an unseemly squabble over who did what first. . . . The arm-
wrestling over priority between Still and Newman became so
sweaty that both began to push back the dates of their works.

Still began to date paintings from the inception of the idea. Newman was as brazen."[43]

Let's instead leave Mark Rothko in his glory, and turn to an anonymous review written on the occasion of his 1958 Janis exhibition, one of the most eloquent texts his paintings ever inspired: "Mark Rothko . . . illuminated an icy New York with eleven new *nobilissime visioni*. They were as fine as his previous best, which is to say that anyone who has ever wondered what it was like to have seen with fresh eyes a masterpiece new from its creator's hand had only to go and look. The variety, the luxuriance Rothko's austerity permits, again astounded. . . . And Rothko's appeal is as thorough as that of a folk or fairy tale or any tale well told. The economy is part of the moral and part of the pleasure, and so is the inexorable beauty, like an ending that is truer than true and which even the most credulous cannot help but believe in."[44] With this glowing tribute, Mark Rothko's journey of dispersion—between assimilation and fragmentation—might well be coming to an end. With Katharine Kuh and Sidney Janis, his new professional agents, he enjoyed both fame and material success at last, yet he still experienced financial anxieties and painful personal conflicts. Were all these necessary parts of the difficult identity journey undertaken by the avant-garde painter, the avant-garde Jew that was Mark Rothko?

10

◆┅◆┅◆

From a Luxury Skyscraper to a Medieval Chapel—
The First Anchoring in Britain: 1958–1960

Rothko really loved England, and his affection for us and our
foibles was so candid and unaffected that it took some time to
realize that he was not joking, for even the inconveniences of
English life for Rothko had a certain charm.
—Bryan Robertson

"PARK AVENUE to Get New Skyscraper," the *New York
Times* announced on July 13, 1954. "Seagram plans a gleam-
ing 34-story headquarters. The move is a pledge of faith in
the growing prosperity of the American economy," Seagram &
Sons, Inc.'s president, Frank R. Schwengel, announced.[1] "With
Victor A. Fischel, president of Seagram-Distillers Corpora-
tion, he joined in announcing plans for the construction of a
$15,000,000 thirty-four story headquarters building on the east
side of Park Avenue from Fifty-second to Fifty-third Streets....
Speaking at a meeting of 700 sales and distribution person-

Mark Rothko with artist William Scott in Bath, England, 1959 (Photograph by James Scott. Copyright © James Scott Archives)

nel of Seagrams and its subsidiaries at the Waldorf-Astoria Hotel, Mr. Schwengel said: 'Major depressions are a thing of the past. Despite great maladjustments due to war and continuing political uncertainties, business activity in the United States has remained near its highest levels, except for minor and temporary declines'. . . . Increasing population, more and bigger families, more job opportunities, advancing technology including atomic power, would all unite, he said, to provide a 500-billion-dollar annual total of goods and services in this country."[2]

In the metropolis of the capitalist world, which was experiencing a formidable decade, the announcement of the Seagram Building construction caused a great stir among the city's in-

habitants. "The skyscraper, with its steel skeleton and its strong verticality, is the great American contribution to the architecture of the world," the architect and urban planner Harvey Wiley Corbett had said in 1932. "Cities of all sizes from all parts of America are now building skyscrapers, although they enjoy as much space as needed for horizontal expansion."[3] Since 1945, under the influence of eminent families, including the Rockefellers—who financed the construction of iconic buildings such as United Nations Plaza on the East River and Lincoln Center on the West Side—New York had turned into a political, demographic, and economic magnet, as well as a kind of parade ground for the star architects of the time. In only twenty years, with new additions like the Universal Pictures House at the corner of Park Avenue and Fifty-Sixth Street, the Lever House three blocks to the south, and the Guggenheim Museum on Fifth Avenue between Eighty-Eighth and Eighty-Ninth Streets, the city had been completely redesigned, turning into an immense, bustling construction site, creating new itineraries and new dynamics, and exposing New Yorkers to continuous displays of virtuosity, demolitions, and frenzied building. By 1965, the New York City map presented a deeply transformed topography.

In this battle of the titans, it was now the turn of the Bronfman family, owners of the Seagram Company, to pull out all the stops with the 1954 announcement of the Seagram Building. Under the foremanship of Samuel Bronfman's daughter, Phyllis Lambert, herself an architect, the family enlisted in the project world-renowned architects like Mies van der Rohe and Philip Johnson. The end result was a jewel of imposing dimensions: thirty-eight stories, more than five hundred feet high, embedded in an elegant structure of bronze, glass, and granite. In a memorable letter to her father, which began with the words "No, no, no, no, no," Phyllis (she was not yet thirty) insisted, "You must put up a building which expresses the best of

the society in which you live, and at the same time your hopes for the betterment of this society."[4] In the ensuing decades, this skyscraper would become the spearhead of the International Style, with its emphasis on new technologies, new materials—including steel and reinforced concrete—the absence of ornamentation, and the priority of volume over mass in a structural integrity that proves form serves function, and not the reverse. "Mies did all the thinking," Johnson explained. "I helped with the politics, and I did the interiors . . . but I didn't touch the design of the building. Pure Mies."[5]

With this project that Herbert Muschamp would describe as "the millennium's most important building,"[6] the Bronfman family also offered a notable innovation: instead of making its façade flush with the other buildings on the avenue, the architects decided to set the skyscraper back several yards and indulge in the luxury of a large pedestrian sidewalk in front of the building—wasted space, so to speak—enabling passersby to enjoy a small area fitted with fountains, where they could relax in the middle of the city. In addition to this innovation, a restaurant was planned for the ground floor of the northern section of the property. According to a headline in the *Evergreen Review*, it was to be "The Most Expensive Restaurant Ever Built"[7] or, in the words of the *New York Times*, "New York's New 4 1/2 Million Dollar Restaurant," "one of the most opulently decorated dining establishments in the United States."[8]

To enhance the majesty of what would become the legendary Four Seasons restaurant, Phyllis Lambert and Philip Johnson approached Mark Rothko and asked him to create a series of paintings for the walls of its smaller dining room. On June 15, 1958, the Seagram Company sent Rothko a purchase order amounting to the astronomical sum of $35,000, along with a $7,000 advance for the "decoration of the building." The restaurant's decor would also include the immense and sumptuous stage curtain designed in 1919 by Picasso for Diaghilev's Ballets

Russes in Paris, paintings by Stuart Davis, tapestries by Miró, and sculptures by Richard Lippold. While Rothko's works were being produced, Jackson Pollock's *Blue Poles*, courtesy of a private collector, would be hung temporarily in the small dining room.

A consummate professional, Rothko began by searching for a larger studio. He found a former YMCA at 222 Bowery, where he erected scaffolding that corresponded exactly to the dimensions of the Seagram Building's dining room. He began working in the fall of 1958, after spending the summer in his country house, preparing for this new professional venture. Just as he had done at the Art Institute of Chicago, Rothko kept thinking in terms of space, trying to shape the viewer's experience as a whole, except on a larger scale. According to his friend Dore Ashton, the painter then produced "a number of gouache sketches in which he allowed himself to play with color, and in which he experimented with sequences of shapes that implied a third dimension more emphatically than his recent large paintings. . . . These initial pictorial ideas with their occasional swelling forms; their clear preoccupation with rousing the senses, and their departure from the symmetries of earlier abstractions would go through many transformations as Rothko ordered and re-ordered his processional forms."[9] With their shades of blue, gray, red, and yellow applied in translucent coats, these sketches came off as overpoweringly fragile, like denser and more intimate miniatures of his monumental canvases.

Over the next year Rothko went on to produce three series of mostly horizontal works, thirty paintings in all, whose dimensions would coincide exactly with the walls of the dining room. He added, replaced, and eliminated sketches in his quest for creating a feeling that would draw the viewer into his works of art, as if by a magnet (Plate 11). According to his discussions with Ashton, he wished to "translate pictorial concepts into mu-

rals which would serve as an image for a public space,"[10] convey-
ing to the viewer in the restaurant a unified and harmonious re-
sidual image. These brand-new works—such as *Red on Maroon
Mural, section 5*, 1959; *Red on Maroon Mural, section 2*, 1959; and
Red on Maroon Mural, section 3, 1959—may recall letters of the
Hebrew alphabet: gimel, samekh, and mem sophit. Did Rothko
really intend to echo the Talmud in such a context? Did he al-
ready consciously have in mind the idea of leaning toward a
more spiritual dimension in his work?

Actually, the Seagram project initiated a crucial period
for the painter, and although the commission ended abruptly
it played a multifaceted role in his artistic evolution—first, by
revealing and exacerbating the tensions which put him in op-
position to his New York milieu, but also by prompting him
to anchor his work both geographically and historically in a new
setting. After eight months of intense work in New York, Rothko
was ready for some vacation time with his family. The summer of
1959 encapsulated so many elements for him—tensions, revela-
tions, discoveries, encounters, opportunities, fresh options—
that one is tempted to single it out as a magical moment of
maturation in Rothko's life. The period enabled him to interact
with different partners, personally and professionally; it con-
nected him with the culture of the old continent again; it pro-
vided him with the support of the younger British artists; fi-
nally, it helped him find a new harmony and understanding of
the core of his tensions with the Seagram project. A trove of
unpublished archives in the Whitechapel Gallery in London
—complementing Mark Rothko's own letters, as well as the
memories of Kate Rothko and John Fischer—help us flesh out
and document that very special summer, which unfolds as a
play in three acts.

Act 1—The Transatlantic Crossing: In June 1959, Rothko,
Mell, and their daughter, Kate, who was almost eight years old,
left New York for their second trip to Europe. Their destina-

tion was Naples. On the boat Rothko struck up an acquaintance-ship with the writer John Fischer—once he had determined that Fischer had no connection with the art world. Rothko confided in him for the eight days of the crossing, expressing his frustrations with the Seagram mural project. After each conversation, Fischer diligently transcribed Rothko's words, and eleven years later, after the painter's death, he described this encounter in *Harper's*, hoping that his notes would one day "become a useful appendix to contemporary art history." He wrote that "Rothko first remarked that he had been commissioned to paint a series of large canvases for the walls of the most exclusive room in a very expensive restaurant in the Seagram building—'a place where the richest bastards in New York will come to feed and show off. I'll never tackle such a job again,' he said, before disclosing very negative feelings towards the context of this assignment: 'In fact, I've come to believe that no painting should ever be displayed in a public place. I accepted this assignment as a challenge, with strictly malicious intentions. I hope to paint something that will ruin the appetite of every son of a bitch who ever eats in that room. If the restaurant would refuse to put up my murals, that would be the ultimate compliment.'"[11]

His first year of work on the Seagram murals had prompted Rothko to further expand the concept of a total environment that he had already envisioned earlier—at the time of his inclusion in MoMA's *Fifteen Americans*, as well as in his exhibitions at the Art Institute of Chicago and at the Sidney Janis Gallery. As he explained to Fischer later on, he had been mulling over that same idea: "After I had been at work for some time," he told him, "I realized that I was much influenced subconsciously by Michelangelo's walls in the staircase room of the Medicean Library in Florence. He achieved just the kind of feeling I'm after—he makes the viewers feel that they are trapped in a room where all the doors and windows are bricked up, so that all they can do is butt their heads forever against the wall."[12]

During the Atlantic crossing, Rothko went into great detail and unveiled to Fischer the process of his research on the Seagram project. He confirmed what he had already told Ashton—that he elaborated on it step by step, with three successive sets of panels. "The first one didn't turn out right," he told him, "so I sold the panels separately as individual paintings. The second time I got the basic idea, but began to modify it as I went along—because, I guess, I was afraid of being too stark. When I realized my mistake, I started again, and this time I'm holding tight to the original conception. I keep my malice constantly in mind. It is a very strong motivating force. With it pushing me, I think I can finish off the job pretty quickly after I get home from this trip."[13] Without a doubt, through those preciously transcribed words by Fischer one can sense the precision of Rothko's artistic intentions, but also his complex feelings and his growing confusion about the outcome of the whole project. Did he then intend to deliver the murals? Did he already sense that he might not? How to interpret the use of "malice" in the artist's words, if not as a sign of defiance? Why use this type of resentment as a personal motivation? What was really at stake in this commission from the Seagram Company? And with whom was he battling?

In staging the artist as demiurgic, in creating a closed cell for the viewer, in connecting to Michelangelo, Rothko was attempting to achieve no less than a drastically new form of dialogue with the public. What passed through his mind in those eight months of work? Obviously, it was no simple matter for him. Although a clear sign of professional legitimization and a marvelous opportunity to expand his own genius freely, ultimately the Seagram project became more of a curse than a blessing—consistent with his legendary opposition to the system. "'I hate and distrust all art historians, experts, and critics,'" Rothko further declared, according to Fischer. "'They are a bunch of parasites, feeding on the body of art. Their work not

only is useless, it is misleading . . .' Two of his special hates were Emily Genauer, who had described his paintings . . . as 'primarily decorations'—to him the ultimate insult—and Harold Rosenberg, whom he regarded as 'pompous.'"[14] But why did Rothko agree to embark upon what he considered an oppressive chore and work in the "enemy camp"? Why did it take him a whole year before he would start to reject the entire project so dramatically? Undoubtedly, many questions went through Rothko's mind during that year's summerlong trip to Europe, which included numerous visits to museums and archaeological sites—many opportunities for him to keep in close dialogue with the art and the history of Europe.

Act 2—The European Tour: "I remember very vividly we traveled to Paestum at the beginning of our trip," Kate Rothko later recollected. Fischer remembered that precise moment as well: on the train from Naples, the Fischers and the Rothkos had met two Italian students, who spontaneously offered to guide them in Paestum. After a morning spent walking among the ruins of the first Hera Temple, the Athena Temple, and the Poseidon Temple, dating from the seventh century BC, Mark Rothko marveled at their beauty, their state of preservation, and examined "each single architectural detail" carefully, before setting off for a picnic. The Italian students, who learned that Rothko was an artist, asked whether he had come to Italy in order to paint temples. "Tell them that I have painted Greek temples all my life, without knowing it," was his marvelous answer, reported by Fischer. Kate, somewhat exhausted by so much sightseeing, recalled: "We then spent time in Naples, at Pompeii, spent several weeks in Rome where I think my father's heart really lay in Italy. We spent many weeks in museums and touring the city."[15]

After Rome came Tarquinia—Rothko adored the colors of its Etruscan frescoes—then Florence and Venice, where they visited Peggy Guggenheim in her palazzo and arranged gon-

dola rides for Kate, along with the ritual photo with the pigeons in Piazza San Marco. Thanks to the Venice Biennale, which had taken place just a year before, the name of Mark Rothko was already well known there. According to Ashton, "he was treated like a king . . . and he obviously enjoyed the affectionate attention he received in Italy."[16] After Venice came Paris: "I write this in the Luxembourg gardens sipping beer, while Mell & Kate watch the marionettes," he explained to a couple of friends. "This morning St. Chapelle & Notre Dame. And we live at the Quai Voltaire overlooking the Seine and Louvre. So you see, things are exactly as they should be. . . . And all of this is relaxing and very unreal."[17] How different from the anger Rothko expressed during his first trip to Paris eight years earlier, when he railed against "foreign civilization" and even refused to send paintings there! Was he not at last immersing himself in European culture for the first time?

Act 3—The British Anchor: The apex of Rothko's growing awareness during that summer took place in Great Britain, where the tensions that were gnawing at him exacerbated his doubt over the Seagram project. I mentioned in a previous chapter how enthusiastically the English critics reacted to the *New American Painting and Sculpture* show when it was presented at the Tate Gallery four years earlier. The "elation" over Rothko's work expressed by the painter Patrick Heron became so great that the British artist acknowledged that he was even "ridiculed" for his "obsessive adulation of the newer American art."[18] Two years after the Tate exhibition, a new show—*Five Americans at ICA*—assembled works by Pollock, de Kooning, Rothko, and Still, among others, at the Institute of Contemporary Arts, the avant-garde London venue. Patrick Heron presided once again, later admitting with a touch of humor the extent of his admiration: "The painter I gave the highest marks to, so to speak, was Rothko, it was almost a rave about Rothko. . . . There was an earlier painting painted probably about 1949

. . . which had soft edge squares floating next to each other and that I liked very much and that I described in my review . . . and I said that Rothko was the most exciting, interesting of these new American artists. . . . It overlapped with the first of my stripe exhibitions at the Redfern Gallery, which was the subject of ridicule from the likes of John Russell who said these paintings consist purely of colored bands and stripes of differentiated color laid side by side. . . . I was really moving away from stripes . . . and the whole quality of 2 or 3 paintings in this show that had soft edges was incredibly close to that earlier Rothko[19] . . . that people in this country had never seen before."[20] To the young British avant-garde painters twenty years his junior, Rothko played the role of both mentor and model. And Patrick Heron was the first in line.

The Rothkos' British summer started with a visit to Somerset and the artist William Scott, who, the preceding year, represented England at the Venice Biennale while Rothko represented the United States. The photos taken by his son James show a convivial lunch, with Rothko wearing a tie, smoking, and seeming relaxed in the center of a group presided over by Scott, in an Irish sweater, who was next to Kate, wearing a striped Breton T-shirt and amid a flock of other children. Standing out most was Mell, beautiful, smiling, and elegant, in a black dress and sunglasses. Scott arranged for them to take a train trip to St. Ives, in Cornwall, where the Rothkos spent a few more days at the house of Peter Lanyon, an artist who had met Rothko earlier in New York. During his short stay in this tiny fishing village on the Cornish coast, under low skies and among granite houses surrounded by megaliths of Celtic myths, Rothko's growing detachment from the Seagram murals became even more pronounced.

A thriving sardine fishing port founded in the Middle Ages, St. Ives had ruled over the region for centuries, owing to its fleet of several hundred boats, until its commercial decline

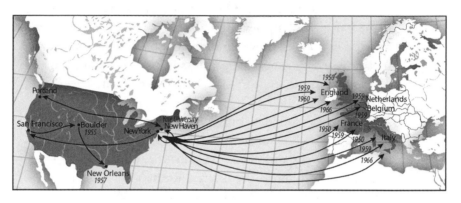

Mark Rothko's U.S. and transatlantic travels, 1950–1966.

in the late nineteenth century. Then, with its steep picturesque streets and slate-roof cottages, it started attracting artists: First, in 1811, it was Turner who painted scenes from the town; then, in 1884, it was Whistler's turn to be dazzled by the quality of its light. Mark Rothko was won over by St. Ives, its history and traditions, its beaches of Porthmeor to the north and Porthminster to the south and, on the market square, its granite church dating from 1434.[21] He learned that in 1928, following in the footsteps of Turner and Whistler, a new group had come to settle in St. Ives, thus founding an artists' colony, similar to those created by American painters in France toward the end of the nineteenth century—in Pont-Aven, Concarneau, and Giverny.[22]

Among the founders of the St. Ives Society of Artists were the painter Ben Nicholson and the sculptor Barbara Hepworth (his wife), along with Naum Gabo, the Russian-born Constructivist, who joined them later. Rothko felt immediately a part of this community that recalled in many respects his vacations with Milton Avery in upstate New York, or with Robert Motherwell in Louse Point. In St. Ives, the reception toward the Rothko family was warm and welcoming. Sheila Lanyon, who hosted them for a few nights at her family's place (Little Park House), found Rothko "a gorgeous lovable stout man," and Mell a "very beautiful and graceful" lady, and she was moved that "they were both worried about . . . their daughter Kate who was very silent and wouldn't play with her six children."[23]

Rothko was touched by the British artists' serious interest in his work, and over time he may well have come to regard them as disciples. Bryan Robertson, the curator of the Whitechapel Gallery in London, later recalled a telling anecdote that took place in New York. The year was 1965. Rothko and Robertson were viewing *The English Eye*, an exhibition of contemporary British art. "Rothko was impressed by certain

paintings of John Hoyland," Robertson wrote "and quite funny about them: 'Well,' Rothko said, after a preliminary inspection of a Hoyland fourteen footer, with his spectacles pushed tall on his forehead, 'if there has to be any post-Rothko painting I guess this is as good as you'll find.'" Finally, according to Robertson, Rothko "was also much affected by the death of Peter Lanyon—whom he had liked and admired" and who, according to the artist, had "a particularly English kind of good looks and dashing style"—and referred many times to the tragic ending of Lanyon's life through a gliding accident."[24]

During Rothko's stay, Peter Lanyon took control of the operations—he organized lavish parties to celebrate the arrival of Rothko as a star, and invited local abstract painters such as Paul Feiler, John Hoyland, and William Turnbull. Feiler, who was born in Frankfurt in 1918, remembered well Mark Rothko's visit to his studio, flanked by Peter Lanyon and Terry Frost, at three o'clock one afternoon. "They'd been drinking quite a lot . . . having visited on the way Alan Davie. I think they weren't too pleased to have seen Alan Davie who was somewhat arrogant. Alan Davie asked Rothko what's it like to be a famous American artist and Rothko said what's it like to be a young English artist. . . . They looked at my studio and . . . he looked at one of my Chinese mirrors that had a frame round it and that frame was extremely elaborate and I said as an excuse it's very good it's a little peasant and he said there's nothing wrong with a little peasant." Then they had tea in the garden.

In fact, according to Feiler, "There was an enormous amount of traffic to and fro from America to England and all those people who came to England came naturally to the source, which was St. Ives. And so if you went to the pub you could see . . . all the American painters who . . . were just dropping in. . . . If you went over to St. Ives . . . you inevitably went to the pub and inevitably you stood next to whoever."[25] John Hoyland, for his part, was struck by Rothko's "rather noble

head," although, he added, "I doubt if he liked his own appearance very much."[26] The 1956 *New American Painting and Sculpture* show at the Tate had struck Hoyland as a "mystifying" and "awesome" event. "We didn't know how to analyze it or put it in any kind of a historical context. . . . All the younger artists were very aware of Rothko and all aware that he'd done something remarkable which we felt, you know, sort of angry [about]."[27]

At that time, the power dynamics among the members of the artist community at St. Ives were anything but simple. Peter Lanyon had carefully excluded from the initial festivities important local personalities such as Barbara Hepworth and Ben Nicholson, as well as Rothko's early imitators and even his biggest promoter in England, Patrick Heron, who, born in St. Ives, had become one of the pillars of the colony. Those power struggles delayed the inevitable meeting between Heron and Rothko until the eve of the distinguished American guest's departure. Heron recalled: "William [Scott] said: 'You know, [Rothko]'s dying to meet you, because you have been so supportive of him' . . . and Lesley had rung me up and said . . . 'Mark Rothko has been in and he's very interested in your painting'; so from both [sides] . . . we wished to meet, but we wouldn't have done [so] if it hadn't been for Lindon Homon. . . . On the Rothkos' last day, Delia and myself [were invited] to coffee one morning, so that is how we were finally permitted [to meet,] that's how Peter was finally bypassed even though he was present on this occasion; and Rothko's first question to me was: 'And where do you live?' . . . We had this very pleasant meeting, I mean[,] I thought he was extremely nice. . . . Rothko explained to me and other people . . . : 'We've come here partly in the hope of conceiving again[,] you see our only daughter was conceived on a holiday in Britain.'"[28]

The Lelant Chapel episode that followed should be considered one of Rothko's final steps in his increasing estrange-

ment from American capitalist values; with the onset of the 1960s he would soon come to reject the political system which, in his mind, was epitomized by the Seagram murals project for the Four Seasons restaurant.[29] The Lelant Chapel was a ruined medieval structure on the east bank of the River Hayle, about two miles south of St. Ives. Rothko was much taken with it and seriously considered buying it and turning the building into a private museum. The questions Rothko had been asking himself for years about the essential goals of his work—Where to exhibit it? How to hang it? Where to place the viewer? Whom to paint for? What is the aesthetic experience?—as well as his obsessions about presentation and lighting, seemed to find a natural response in this new place. A sort of alchemy occurred in St. Ives, and the ruins of the Lelant Chapel—as remote as could be from Park Avenue and the Seagram Building—became the obvious alternative in Rothko's eyes, the ideal place to base his work. In August 1959, as he contemplated transforming Lelant Chapel into his own museum, it was most probably here, in this niche sheltered from the misdeeds of American consumerist society, that Mark Rothko decided to call off the Seagram project.[30]

Rothko and his family sailed back to New York, and at some point he contacted the Seagram representatives. "One evening, in a state of high emotion, he phoned to say that he was returning the advance down payment (a quite substantial sum) since under no circumstances would he permit the paintings to be installed in The Four Seasons," Katharine Kuh reported. "He had visited the recently completed restaurant for the first time at the dinner hour and come away traumatized by the experience. . . . While he was working on the project, his imagination plus a dash of wishful thinking projected an idyllic setting in which captivated diners, lost in reverie, communed with the murals. I'm afraid it never entered his head that the works would be forced to compete with a noisy crowd of con-

spicuous consumers. For him to allow his murals to become background decorations was intolerable."[31]

Others involved in the Seagram saga have since given their own perspective of the case. Phyllis Lambert openly admitted that "Rothko had this religious feeling about his work, and simply didn't want it hanging where it would serve merely as decoration. I kind of understood his point."[32] But Philip Johnson was less indulgent, stating that "Rothko knew perfectly well it would be an expensive restaurant."[33] On the other hand, Rothko's assistant Dan Rice confirmed Kuh's version. He clearly recalled the evening Rothko went to dinner with Mell at the Four Seasons to check out the space. "I had arrived early in the studio the morning after and he came through the door like a bull, as only Rothko could, in an absolute rage. He said explosively, 'Anybody who will eat that kind of food for those kinds of prices will never look at a picture of mine.'"[34] Dore Ashton felt that, to the various reasons already listed for calling a halt to the Seagram murals, should be added "his indignation that the original plan to have employees see the works was thwarted when it was decided to change the architecture. More likely Rothko had installed his works in an interior theater of his own with which no real place would ever compare."[35] Still, despite this incipient feeling of attachment to Britain, two exhibitions in the coming years would unexpectedly reassure Rothko about possible options for hosting his paintings in the United States.

11

---◆|◆|◆---

Years of Experimentation, Recognition, and Torment—The Second Anchoring in Britain: 1960–1964

During those years, he experimented ceaselessly, each painting a new adventure. He left little to chance, studying how the intensity, texture, and overall area of certain colors interacted.
—Katharine Kuh

IN 1921, Duncan Phillips offered the city of Washington, D.C., both his private residence and his personal collection, opening to the public what would be known as the Phillips Collection. He assembled his collection, one of the first in the United States devoted to modern art, in an extremely original way that revealed his patience as well as his contradictions. "It is worthwhile," Phillips wrote in describing his plans, "to reverse the usual process of popularizing an art gallery. Instead of the academic grandeur of marble halls and stairways and miles of chairless spaces, with low standards and popular attractions

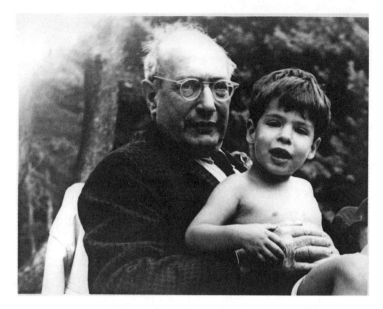

Mark Rothko and Christopher Rothko by the pool in London, c. 1966
(Unknown photographer. Copyright © 2013 Kate Rothko Prizel and
Christopher Rothko)

to draw the crowds, we plan to try the effect of domestic archi-
tecture, or rooms small or at least livable."[1]

It was Theodore Stamos, one of the "Irascibles," who first
drew the collector's attention to Rothko, pointing out obvious
parallels between him and Pierre Bonnard, of whom Phillips
was quite fond. "I told him that I think it's important that he
gets at least one [Rothko], and I told him why." He added that
Rothko was "so strongly related to Bonnard that if he looked
at some black and white Bonnards he would see it clearer, and
then focus on the color. We discussed that for a long time."[2]
Phillips noticed that the areas of flat color in Rothko's works
typically were boundless and intuitively structured within a
confined space, much as they were in Bonnard's. In 1957 Phillips
held a group show—his first exhibition that included Rothko—
and he purchased two of the artist's paintings that were on dis-

play: *No. 16/No. 12 (Mauve Intersection)*, 1949, and *No. 7 (Green and Maroon)*, 1953. Three years later he acquired *No. 16 (Henna and Green/Green and Red on Tangerine)*, 1956, and *Orange and Red on Red*, 1957, from a solo exhibition held at the Phillips Collection May 4–31, 1960. With the three 1950s paintings he created a separate "Rothko Room" in the museum, devoting one wall to each painting (a fourth painting was added in 1964). Seating was arranged so that viewers could settle comfortably in front of the canvases for as long as they wished. The room was painted gray and lit dimly in order to enhance the resonance of the paintings' colors. From the outset, the Rothko Room was designed as an interlude, one conducive to meditation, with Phillips himself referring to it as "a type of 'chapel.'"[3]

Rothko took great interest in the museum, visiting it often and even advising on the presentation of his works. On a snowy day in January 1961, while the artist was in Washington for President John F. Kennedy's inauguration, he visited the Phillips and noticed that three of his recent works had been added to the Rothko Room. Disapproving of their hanging and lighting, he instructed Phillips's assistants, who wanted to please the artist and so immediately obeyed, to make the adjustments. Returning from his travels a few days later, Phillips insisted on reinstating the original layout but then consented, after negotiations with Rothko, to one of his requests. Together with Katharine Kuh, Phillips was among the few in the United States who understood and respected the artist and his demands and who had the necessary finesse when interacting with him. "In the soft-edged and rounded rectangles of Mark Rothko's matured style," he wrote, "there is an enveloping magic which conveys to receptive observers a sense of being in the midst of greatness." He further added that Rothko's colors "cast a spell, lyric or tragic, which fills our existence while the moments linger. They not only pervade our consciousness but also inspire contemplation. Our minds are challenged by the relativities;

the relative measures of the two horizontal presences . . . each acting on the other. . . . Color-atmosphere in painting is as old as Giovanni Bellini and his mountain backgrounds. . . . But in Rothko there is no pictorial reference at all to remembered experience. What we recall are not memories but old emotions disturbed or resolved."[4]

The year 1961 marked the climax in Mark Rothko's lifetime of his public recognition as an artist, with a comprehensive exhibition of his work at MoMA. In retrospect, Katharine Kuh stressed the importance of the event for the painter himself, because it "radically changed his point of view. Until then, though he was occasionally skeptical and often pugnacious, he fundamentally believed in himself and more expressly in what he was doing; he knew his own worth."[5] On January 18, 1961, a MoMA press release announced that a "comprehensive exhibition of paintings by Mark Rothko [would take place] from January 18 to March 12." It detailed "54 works by the American artist dating from 1945 to the present. Included are eleven murals painted in 1958–1959, exhibited for the first time." It mentioned the "highly original style" of the "largely self-taught" artist and foresaw the exhibition as "the largest ever assembled," and noted that it included "4 early watercolors from the forties." But the "keystone" of the event, according to the release, would be the "eleven murals, some 15 feet long, from a series commissioned in 1958. In these dark red canvases," it insisted, "Rothko abandoned solid forms for open rectangles." Later, in a most poetic style, Peter Selz would rave about "these silent paintings with their enormous, beautiful, opaque surfaces [that] are mirrors, reflecting what the viewer brings with him. In this sense, they can be said to deal directly with human emotions, desires, relationships, for they are mirrors of our fantasies and serve as echoes of our experience. . . . They suggest the entrances to tombs, like the doors to the dwellings of the dead in Egyptian pyramids, behind which the sculptors

kept their kings 'alive' for eternity in the *ka*. . . . The whole se-
ries of murals bringing to mind an Orphic cycle . . . the artist
descending to Hades to find the Eurydice of his vision."[6]

In breaking his contract for the Four Seasons murals,
Rothko had irritated the architect Philip Johnson—who in
1930 had founded the Department of Architecture and Design
at MoMA and who remained one of the most active and gener-
ous trustees of the institution. How, then, did the decision of
exhibiting Rothko's abandoned work play in the complex bal-
ance of MoMA? The man who contacted Rothko on behalf
of the museum to arrange this major retrospective was Peter
Selz. He had joined the museum's team three years earlier and
immediately drew attention with his original exhibitions: *New
Images of Man* (1959)—in which he dared to show unknown art-
ists who celebrated the human form at a time when abstraction
seemed to advance ineluctably—and Jean Tinguely's *Homage to
New York* (1960)—an anarchic happening that heralded the rise
of performance art, in which the young Swiss artist detonated
one of his first machines in the MoMA sculpture garden.

Peter Selz, along with Alan Solomon of the Jewish Mu-
seum and, later, Henry Geldzahler at the Metropolitan Mu-
seum of Art, was one of New York's reigning curators in those
years.[7] An academic who received his Ph.D. from the Univer-
sity of Chicago,[8] he became chair of the art history depart-
ment at Pomona College in California. Like Rothko, he was
born into a European-Jewish family, but he came from Munich
and had immigrated to the United States in 1936, driven out
of Germany by the rise of Nazism. Visiting museums was an
integral part of his family's culture. In fact, his maternal grand-
father—a distant cousin of Alfred Stieglitz and Selz's men-
tor upon arriving in the United States—had worked as an art
dealer in Munich. For Rothko, though, who had already en-
countered various secular Jews in his professional trajectory—
from Peggy Guggenheim to Sidney Janis, Katharine Kuh, and

Phyllis Lambert—Peter Selz, who prided himself on always working with "artists who were not part of the mainstream,"[9] would be the one to stage Rothko's most prestigious exhibition in the United States.

This seemingly auspicious period of the MoMA exhibition, though, also marked the beginning of a painful period for the painter, because both professionally and personally he was feeling exposed. According to his friends, this solo show in this eminent museum created an unprecedented situation for the artist. Rothko felt "like being invited to dwell in Parnassus," Stanley Kunitz admitted. "Though he didn't want to show it, I think he was angry with himself for caring so much about it. He did behave like an obsessed man during that whole period."[10] In fact, according to Dan Rice, his assistant, Rothko "approached all public displays with great and horrendous turmoil, great anxiety. . . . Before an opening, he would throw up, more like the behavior of an entertaining artist, an actor. He literally had to go to bed as an exhibition approached. He'd be physically ill . . . just completely torn apart, physically as well as mentally."[11] On the day of the opening, John Fischer recalled, Rothko "began the evening in an agony of stage fright. Later, as one guest after another came to congratulate him—and usually to express an almost reverent admiration for his work—he relaxed and started to glow with affability."[12]

The exhibition was widely reviewed. Although most journalists wrote positive texts about it, the reaction on the whole remained lukewarm, signaling that more than one critic was still baffled by the direction the artist had taken. Of course, among this group were the usual opponents who continued to disparage his art. Emily Genauer sarcastically commented on "these works of the '50s [which] are less paintings, as a painting is generally conceived, than theatrical curtains or handsome wall decorations. [They remained] . . . as decorative as before, but for a funeral parlor."[13] In the same arrogant vein, John Cana-

day smugly described "Mr. Rothko's progressive rejection of all the elements that are the conventional ones in painting, such as line, color, movement and defined spatial relationships," before concluding that "this is nothing but high-flown nonsense if we begin with the assumption that the audience for painting today is anything but an extremely specialized one."[14] Equally patronizing was Max Kozloff: "Aesthetically, there is an exasperating struggle found throughout the exhibition. . . . When we come to those profoundly dark mural sections of 1958, we find Rothko . . . making his first major mistake. . . . Optically, darks do not permit very much resonance at all—a discovery the Impressionists made long ago."[15] As for Robert Goldwater, he warned readers against fantastical interpretations of Rothko's work and welcomed anything that could "relax the visual hold of these canvases, filter their immediacy, and push away their enigmatic, gripping presence."[16]

The antagonistic tone with which Rothko summarized the experience, as reported by John Fischer, was hardly surprising. "I want to be very explicit about this," Rothko told him, referring to MoMA. "They need me. I don't need them. This show will lend dignity to the Museum. It does not lend dignity to me."[17] But according to the critic Irving Sandler, Rothko's torment was subtler and went beyond the exhibition's reception. He was plagued with doubts not only about the intrinsic meaning of his work, but also about his legitimacy and his responsibility toward public expectations. Rothko was facing the dilemma of every creator who suddenly reaches a certain level of visibility, only to find himself abruptly undermined. "Rothko was skeptical whether his abstractions, because they were unprecedented, were comprehensible to anyone else," Sandler wrote. "This caused him great anxiety, exacerbated by the hostility they elicited. But he also spoke of being surprised not only that there was an audience for his work, but that his audience seemed to be waiting for 'a voice to speak to them' and responded totally

to it. There was a revolution in viewing, a 'well at last, that's exactly what should have been done.' This was a reaction based on life not on art. This is the thing to be explained."[18]

Sandler was right. "The thing to be explained," though, remained particularly complex for the artist. Furthermore, new events would soon threaten Rothko's position in the art world, among them the Golden Lion awarded to Robert Rauschenberg at the Venice Biennale in 1964, less than three years after Rothko's MoMA show, and the emergence of a world market for contemporary American art a decade later.[19] Following the end of World War II, Rothko epitomized the first generation of American masters, whom the next generation was trying to surpass, erase, and even bury. He was also an immigrant who, like so many critics, dealers, collectors, and curators, now represented an increasingly sizable segment of the art world in the United States. He had (often) experienced periods of rebellion and (occasionally) of attraction toward the institutions in his adopted country, all the while feeling the appeal of Europe via his fascination with the masters of the Old World and his affection for his young British disciples. Ultimately, Rothko represented a type of artist consumed with intellectual, cultural, spiritual, and political concerns. His "anxiety" about the intelligibility of his work, his "surprise" that it had found such a large audience, and his conviction that a "revolution in viewing" was at work all could be analyzed, in part, in the context of his genealogy and marked by the geopolitical upheavals of the twentieth century.

In her analysis of the painter's career, Katharine Kuh identified a connection between the turmoil caused by his MoMA show and his depression of subsequent years. In the decade preceding his suicide, she explained, Rothko "was always rebelling against something . . . whether it was the venality of art dealers, the condescension of museum curators, the timidity of collectors, the indifference of the public, or the pomposity of

critics. . . . However, his own wings were clipped after he was accepted by the same art establishment he had excoriated. . . . Success depleted him, and at the same time the fragile relationship between ethics and art no longer absorbed him."[20] I will return to the links between his public success and his private anxiety, and those between his solitary work life and his place in the institutional environment. I will return as well to the tensions between art and the marketplace, between the symbolic world and the financial one, and, ultimately, between the Old World and the United States.

During this excruciating period, Mark Rothko was saved by another British episode, as he had been two years earlier at the time of the Seagram murals—this time by an encounter with Bryan Robertson. During the early sixties, when many believed in "the renaissance of British art," Robertson had been described as its "leading impresario"[21] by the *Times*. When Robertson came up with the idea of presenting the MoMA exhibition at the Whitechapel Gallery in London, Rothko was still under the spell of St. Ives. He enthusiastically agreed to it, and even planned to travel to England for the opening. A mercurial, inventive, and generous personality, Robertson had taken on the curatorship of the gallery at the age of twenty-seven, ten years before he approached Rothko. He waged a merciless battle against his country's insularity by organizing spirited presentations of great native artists, past and current, before progressively exposing the British to the new generations from the United States.[22] He also pioneered a learning program, based on the conviction that art should be the basis of every education, and not merely an elective. "What I look for in art of any period," he later wrote, "is imaginative energy, radiance, equilibrium, composure, color, light, vitality, poise, buoyancy, a transcendent ability to soar above life and not be subjugated by it."[23] In 1960, his signal exhibition *This Is Tomorrow*, with its poster by Richard Hamilton, introduced the

concept of Pop Art and threw wide open the gates to everything that came from across the Atlantic.

No wonder that all of Rothko's requests were addressed with the fullest attention by the peerless Robertson. The smallest details were taken care of, from the color of the walls, which "should be made considerably off-white and umber and warmed by a little red. If the walls are too white, they are always fighting against the pictures which turn greenish because of the predominance of red in the pictures"; to the lighting, which "whether natural or artificial should not be too strong: the pictures have their own inner light and if there is too much light, the color in the picture is washed out and a distortion of their look occurs." As for the hanging of the works, "the larger pictures should all be hung as close to the floor as possible, ideally not more than six inches above it. . . . The exceptions to this are the pictures which . . . were painted as murals . . . : 1. Sketch for Mural, No. 1, 1958; 2. Mural Sections 2, 3, 4, 5, and 7, 1958–9; White and Black on Wine, 1958. The murals were painted at a height of 4'6" above the floor." Finally, regarding the grouping of the works: "all works from the earliest in the show of 1949 inclusive were hung as a unit. . . . The murals were hung as a second unit, all together."[24] Rothko's meticulous instructions required Robertson to display the paintings in a controlled environment, and so he did.

The critics, skeptical at first, one after the other started to praise what became another demonstration of Robertson's brilliance. The journalist of the *Evening Standard* admitted that he could "only applaud Mr. Robertson for his courage. Seen en masse, the sincerity and beauty of Rothko's paintings are undeniable. . . . By some curious alchemy of his own he charges his design with feeling. Each canvas has its particular mood, serene or buoyant or menacing. How he manages to conjure emotion out of such austere simplicity is impossible to analyse."[25] Others spoke of "ultimate examples of an untrans-

latable language,"[26] and "this brooding, tragic quality hanging over the paintings that finally prevents them from degenerating into nothing more than decorations."[27]

In what would remain as perhaps one of the finest testimonies of the artist-curator relationship, Robertson later recalled: "My strongest personal memory is of leaving the Whitechapel gallery with Rothko late one winter afternoon, when the daylight had practically gone. He asked me to switch all the lights off, everywhere; and suddenly, Rothko's colour made its own light: the effect, once the retina had adjusted itself, was unforgettable, smoldering and blazing and glowing softly from the walls—color in darkness. We stood there a long time and I wished everyone could have seen the world Rothko had made, in those perfect conditions, radiating its own energy and uncorrupted by artifice or the market place."[28] Rothko's letters to Robertson before and after the exhibition demonstrated his respectful deference and immense gratitude: "You have imparted that sense of celebration to an event which, ironically, is mingled for me with trepidation. I am cheered up, and know that you will be more than just to the pictures, to yourself and to me. I am also eager to see again all the artists whose stimulation and cordiality on our last visit have remained vivid."[29] John Hoyland, who had met Rothko in St. Ives, kept stressing the American painter's influence on his generation. "All the younger artists were very aware of Rothko and all are aware that he'd done something remarkable. . . . We tried to apply all the lessons we knew . . . and we couldn't."[30]

Immediately after his successful show in England, Rothko spent nearly nine months on murals commissioned in February 1961 for the dining hall of Harvard University's Holyoke Center. The murals again proved the value of his name in the early 1960s as well as his value on the market, as he received $100,000 for his work. On October 24, 1962, Harvard president Nathan Pusey traveled to New York to visit Rothko's stu-

dio and returned extremely pleased with the works. "Their colors," he said, "would reenact Christ's Passion, the dark tones of the triptych invoking His suffering on Good Friday and the lighter ones on the final panel His resurrection."[31] In January 1963, Rothko visited Harvard for the installation of his panels. He found that the space was too crowded with chairs and tables, the ceiling too low, the color of the walls inadequate, and, of course, the light too strong. Nonetheless, he eventually deemed the situation acceptable, and the murals were hung. The colors faded with time, however, and the paintings were taken down at some point. Thanks to new technology that allows colors to be re-created, they were exhibited again in November 2014.

In November 1962, another crisis arose for Rothko in the wake of *The New Realists* exhibition, presented by the Sidney Janis gallery. With the inclusion of Pop artists such as Jim Dine, Robert Indiana, Roy Lichtenstein, Claes Oldenburg, James Rosenquist, George Segal, and Andy Warhol, Janis decided to open his space to the younger American generation, some of whom his friend Leo Castelli had already shown in his gallery at 4 East Seventy-Seventh Street. Since 1958, Castelli had launched the careers of Jasper Johns, Robert Rauschenberg, Frank Stella, and Roy Lichtenstein, among others, and had done so with such panache that some people accused him of trying to bury the Abstract Expressionists. That criticism became very clear when, shortly before Janis's exhibition, Rauschenberg, who felt stifled by the previous generation's legacy, bought, erased, and signed a drawing by de Kooning in front of the Dutch-born artist in a radical, flamboyant, and legendary gesture.

Upon hearing the announcement of *The New Realists* show, Rothko and others decided to express their hostility publicly. But Sidney Janis found it "just as violent then as it was when they were less secure."[32] Despite the gallerist's efforts, Adolph Gott-

lieb, Philip Guston, Robert Motherwell, and Mark Rothko refused "to be associated with what they believed to be Johnnyscome-lately" and withdrew from the gallery "as a body." "I tried to induce them to stay," the dealer said, "explaining that the younger artists could not be considered competitive, but all in vain."[33] A few weeks later, Rothko signed with Frank Lloyd—"the man the art world loves to hate,"[34] according to Grace Glueck in the *New York Times*. Lloyd was the director of the Marlborough Gallery, which had been founded in London and opened a branch in Rome before establishing a foothold in New York through its association with the Gerson Gallery. With his huge fortune and considerable advantages, Lloyd (born Franz Kurt Levai in Vienna in 1911) had the reputation of enticing artists with contracts that no one else could match, earning him the displeasure and jealousy of his colleagues. This association would prove disastrous for Rothko's estate after his death.

In 1965, the reputation of Mark Rothko advanced a step further in Great Britain when the Tate Gallery's newly appointed director, Norman Reid (who had been chosen over Bryan Robertson), invited him to London. The following year, Rothko agreed to donate the Seagram murals to the Tate, insisting on keeping them as "a group that would establish a mood."[35] Reid sent him a plan of the gallery as well as a fold-out cardboard model. But Rothko demanded to be directly involved on-site. His declining health, however, precluded him from further travel to London. As a result, Norman Reid made the trip to New York, and in September 1969 they reached a final agreement at the artist's studio. On the part of Rothko, it stipulated that there would be "no other works of art of any kind except those created by [him] which are being given this date. . . . It may not be that all the paintings will be exhibited in that room at one time."[36]

What else can be said about this transatlantic crossing of

Rothko's art? Unhappy with his experience in New York, Rothko decided to choose London as the new home for a significant portion of his work. The country where he had considered turning a medieval chapel into his private museum would become the final destination of his Seagram murals—the final turning point in his career.

12

The Long-Awaited Chapel—The Expiatory
Sacrifice: 1964–1970

Like much of Rothko's work, these murals really seem to ask
for a special place apart, a kind of sanctuary, where they may
perform what is essentially a sacramental function. . . . Perhaps,
like medieval altarpieces, these murals can properly be seen
only in an ambiance created in total keeping with their mood.
—Peter Selz, 1961

The magnitude, on every level of experience and meaning, of
the task in which you have involved me, exceeds all of my pre-
conceptions. And it is teaching me to extend myself beyond
what I thought was possible for me. And, for this, I thank you.
—Mark Rothko to John and Dominique de Menil, 1966

As he worked on the chapel, which was to be the greatest ad-
venture of his life, his colors became darker and darker, as if he
were bringing us to the threshold of transcendence, the mystery
of the cosmos, the tragic mystery of our perishable condition.
—Dominique de Menil, 1972

ROTHKO'S CAREER trajectory can be viewed through the lens of his successive encounters with prominent art world figures—gallerists, curators, collectors, critics, artists—who sometimes influenced him deeply. For the last period of his life, the decisive encounter would be that of John and Dominique de Menil. In February 1965, they commissioned him to paint a series of panels for a chapel in Houston, the city where they lived. The Rothko Chapel tells the story of three European immigrants of the same generation, driven from Europe by the upheavals of history and crossing paths in their later years: Mark Rothko, whose family fled the pogroms of czarist Russia; and Jean and Dominique de Menil,[1] who fled Nazi-occupied France. They reached the United States twenty-eight years apart (Rothko in 1913, the de Menils in 1941), belonged to different social classes (Rothko was a bourgeois fallen on hard times; the de Menils were of the upper class, having made their fortune in the oil business, but whose radical left-wing views made them strikingly atypical within their world), were brought up in different religions (Rothko as a Jew, educated at the Talmud Torah in Dvinsk; Dominique as a Protestant, later converted to Roman Catholicism, her husband's religion), and held conflicting positions in the art world (the artist was often at odds with his collector-patron). Yet all three were engaged in similar and idiosyncratic paths within American society that prompted them to fight for their own choices and forge their newfound American identities through questioning and searching.

The de Menils were introduced to art during the summer of 1952 by their friend Father Marie-Alain Couturier, a Dominican whose "goal was no less than: to bring to an end . . . the absurd divorce which for the past century has separated the church from living art."[2] Couturier took the de Menils to the Matisse chapel in Vence and the Léger chapel in Audincourt, leading Dominique to remark: "We saw what a master could

do for a religious building when he is given a free hand. He can exalt and uplift as no one else."[3] Eventually, they turned their collection of Surrealist art, contemporary American art, and African art, gathered with exceptional taste and enthusiasm, into a private museum. In 1960, Dominique de Menil met Rothko in his New York studio for the first time.[4] Alerted to the fate of the Seagram murals (through the MacAgys),[5] she hoped to retrieve them for a chapel she and her husband intended to build in Houston. She was then chair of the art history department at the University of Saint Thomas, and in this capacity she curated many exhibitions. She formulated a project to re-think art history from all countries and periods, taking an approach similar to that of Rothko in *The Artist's Reality*. In particular, she devoted one of her most notable shows to the kind of patronage displayed by popes and architects at the time of the Renaissance, stressing in the catalog that "the list of Papal commissions reads like a summary of art history. With superb instinct, the Renaissance popes commissioned the best artists. It would be a fallacy to believe the choice was obvious or easy. Great artists have extreme conceptions. The greater they are, the more revolutionary they appear. Public opinion does not follow them. If Michelangelo was able to execute his plans for St. Peter's, it was due to the enlightment [*sic*] and determination of the Roman pontiffs."[6]

She later investigated the role of the collector in art history in a particularly original manner: "For a long time, I rejected the notion of 'collection.' The very word seemed pretentious. It implied a point of view, and I did not want to have a point of view. To discover treasures and bring them home if possible, yes, but the way you make a bouquet, without putting a great deal of thought into it, as you go along and for the delight of the eye. But flower after flower, bouquet after bouquet, you start thinking botanically. Then the great adventure begins, the endless quest through time and space. A thorough investiga-

tion at the heart of Man, the heart of the world. A new reflection on everything, but also a silent hearing of the sirens' song. Contemplation before the works of fullness whose power to enchant is never exhausted."[7] In the spring of 1964, after the death of her friend and colleague Jerry MacAgy, Dominique once again visited Rothko in his studio and suggested that he decorate the chapel she and her husband had commissioned none other than Philip Johnson to build. "He responded enthusiastically," she later recalled, "as if he had been waiting for such an opportunity ever since he had refused to deliver the paintings done for the Four Seasons restaurant in New York."[8] But, as we will see, two circumstances shattered the original arrangement: the conflict between Rothko and Johnson, rooted in Rothko's withdrawal from the Seagram project; and the health issues of the artist, who, after having survived a ruptured aneurysm in 1968, temporarily stopped working and, the following year, left his family and moved into his studio.

Johnson had been involved since 1957 in the de Menils' Houston plans, which included a chapel project for the University of Saint Thomas and the design, in a simplistic style, for their residence at 3363 San Felipe Street. In New York he often ran into John de Menil, who had become a trustee of MoMA. In keeping with Father Couturier's principles, the de Menils viewed their project as a collaboration of excellence between a great architect and a great artist. However, their desire failed to take into account Rothko's determination. According to Dominique de Menil, "It soon became obvious that the creativity of the artist and the creativity of the architect were working at cross-purposes. In fact, Rothko categorically rejected Johnson's idea of surmounting the chapel with a truncated pyramid that would diffuse light onto the walls. Yet, he did so with 'quiet obstinacy.'"[9] He wanted his paintings to enjoy in their definitive settings the same light that had presided at their conception. Motherwell believed that the conflict between the

two ran much deeper, perceiving it as the hostility between a *worldly man* and a *mensch*. "Mark was above all a *mensch*, you know, out of Dostoyevsky. And it would be as though he were dealing with a snobbish, flip dilettante in his eyes. . . . Philip is extremely worldly, and Mark intensely disliked worldly people. For him it was almost a category of sin to be worldly. . . . We always got along best when my life was in shambles. And then he was a marvelous friend. If everything was going very well, then there would be a greater distance because I suppose in his thinking I would be more worldly."[10]

Rothko produced twenty panels, fourteen of which were eventually hung in the chapel. Though Rothko mostly rejected any analogy of religious art to his work, he did mention to Dominique de Menil the strong impression the Byzantine church of Santa Maria Assunta in Torcello, near Venice, made on him. He had been deeply shaken by the mosaic of the Last Judgment over the altar, but his fears were soon swept away by the sight of the gold-background Madonna and Child opposite the altar, in the apse. This was precisely the tension, between condemnation and promise, "tragedy and hope," he sought to re-create in Houston.[11] In Dominique's words, Rothko arranged two paintings axially, one in the entrance and one in the apse, "as dialectically opposed as the mosaics in Torcello's church, the Last Judgment and the celestial vision of the Madonna and Child. These powerful images hovered in Rothko's mind and consciously he recreated the same tension. A hanging black field, an impending doom, at the entrance, is cancelled out by the central panel of the apse, painted in a warmer tone—a more vibrant purple."[12] Faced with the luminescent vibrations of these fourteen panels as soon as they step inside the octagonal chapel, visitors are caught in the tension between the closed canvas and the open canvases (at the entrance and the triptych in the north apse, respectively, on the model of Torcello). After the completion of his work, following Dominique's visit

to his studio on June 7, 1967, Rothko made changes to some of his canvases before storing them, as the construction of the chapel had not yet begun. A few months later, the architects Howard Barnstone and Eugene Aubry took over the project from Philip Johnson. The final result was minimalist: an octagonal brick structure with a flat roof, scrupulously adhering to Mark Rothko's wishes.

Inaugurated by the de Menils on February 27, 1971, nearly one year to the day after the artist's suicide, in front of members of various faiths, it was proclaimed "a sacred place, open to all, every day."[13] "Rothko left no letter to be read at the dedication ceremonies. Yet," in the words of Dominique de Menil, "those who approached him during the last crucial years know that, for him too, his last work was the result of his whole active life and that he considered it his masterpiece."[14] Over the years, the Rothko Chapel has become one of the world's most visited art sites, as well as a pilgrimage site for religious and political leaders including Archbishop Desmond Tutu, Dom Hélder Câmara, South Africa president Nelson Mandela, the Dalai Lama, and former U.S. president Jimmy Carter.

Eventually the entire de Menil family became involved in the project, before and after the artist's death. "Dear Daddy," wrote John de Menil's oldest daughter, Christophe, on February 13, 1970, "here are a few references on Rothko that I dug up. . . . This one is what you want. It's by Robert Rosenblum, a distinguished critic, and the title is 'The Abstract Sublime.' 'Like the mystic trinity of sky, water and earth that, in Friedrich and Turner, appears to emanate from one unseen source, the floating horizontal tiers of veiled light in the Rothko seem to conceal a total, remote presence, that we can only intuit and never fully grasp. These infinite glowing voids carry us beyond reason to the Sublime; we can only submit into their radiant depths.'" After quoting Rosenblum, the young woman, who was the first in her family to focus on contemporary art, com-

mented, "I think this guy is right about the mystical nature of Rothko. The de Menils must have realized it too. You and I feel it too, only we enjoy his remarkable sense of color as much or more as the fuzzy floating manner of the paint and the un-defined quality of it. Rothko painted with very thin oils—he really strained his canvas, not painted it. He learned his tech-nique from Miró. . . . They were dealing in a world outside reality. . . . I think he meant the chapel to be meaningful by the method he used: huge canvases like Monet's Waterlilies, sur-round you and take you to another world. The Paint floats in front of the surface, and it glows with an inner light. The color is calming and contemplative, and sort of mystical in itself."[15]

In fact, after Rothko decided to abandon his work on the Seagram murals, he transformed his technique significantly. Today, the Tate Gallery website offers a clear narrative of the last ten years of Mark Rothko's art. In particular, it highlights the connection between the Seagram murals (1958–1959) and the panels for the Houston chapel (1965–1967), which was his last commission.[16] The Tate analysis focuses on the year 1958, with *Four Darks in Red* (immediately preceding his work on the Seagram project), claiming that Rothko "began darkening his palette to counter the perception that his work was deco-rative."[17] Let us pause on this assertion for a moment: Even though one might well agree with 1958 as a meaningful date in the periodization of his work, should one reduce Rothko's final aesthetic evolution to a reaction against some hostile critics? Instead, could one not more accurately attribute such a devel-opment to the profound intellectual project already at the core of his artistic research, ever since he wrote *The Artist's Real-ity*? In fact, Mark Rothko's aesthetic research took the form of a long, coherent, and obsessive quest, as it became more and more evident during the last decade of his life, when his preoc-cupations went beyond a simple matter of palette.

Throughout the 1960s, technical concerns definitely took a

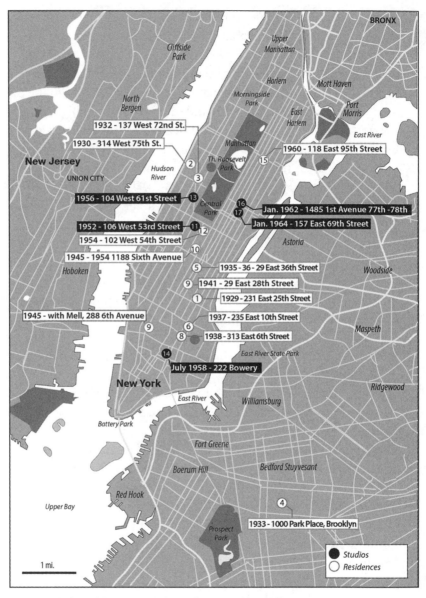

Mark Rothko's New York residences and studio locations, 1929–1970.

higher precedence in Rothko's work as he continued to develop his art, increasingly obsessing over radical forms of cohesion and pursuing his quest for higher standards. He aimed to offer the public not just a painting but also a whole environment, not a simple visit but a true experience, not a fleeting moment but a genuine revelation. This compelled him to innovate. Once more, Robert Motherwell was not wrong about Rothko's work when he attributed his originality, "not only from contemporaries, but from almost anybody's painting," to the fact that "he [not only] thought of it . . . but [also] made it and treated it as though it were a *presentation*—in Edgar Allan Poe's sense of the word. He was interested in the effect and the technique was to bring about a specific effect."[18] With this demanding approach, in trying to instill in the viewer a new sense of focus, in allowing him to enter into his work, Rothko initiated a sophisticated research, altering his media and using elaborate, almost alchemical methods that would not be decoded until long after his death.

In expressing his bewilderment over Rothko's working methods, Motherwell described him as "extremely secretive about all his procedures." Whenever the artist allowed colleagues into his studio, they would find it, like most studios, in almost complete disarray, yet Motherwell recalled that "the one thing that would be cleaned up [was] the paints[,] and the brushes would be hidden. One simply didn't raise the subject [of technique]."[19] On a day in the 1950s when Rothko had been drinking, Motherwell heard him express his admiration for Fra Angelico and, in reference to a fifteenth-century fresco, Rothko inadvertently let slip, "I did the underpainting, and then realized that was enough." "In those years," Motherwell explained, "he was definitely painting in egg tempera. . . . If you think of Piero della Francesca or the clarity of Florentine quattrocento painting and a peculiar soft clear beauty to the colors." Motherwell elaborated that this is a "particular quality that can't be done in oils, . . . And Mark obviously loved that quality. He

was a thin painter, which was almost unheard of in the twentieth century. . . . In that sense anyway, for a while Mark was a throwback to pre-oil painting. And I would guess, all his life there was something repugnant about normal oil painting to him, so that he would have always been searching for something, if he weren't going to use tempera, that would be very close to it."[20] Later, in the 1960s, according to Motherwell, Rothko developed an interest in the work of Helen Frankenthaler (Motherwell's wife), who was using a newly discovered medium that was about to become popular: acrylic paint.

In a notable article about the Rothko Chapel's frescoes, Carol Mancusi-Ungaro, an expert who worked for years on the technical conservation of the artist's last canvases, precisely revealed the secrets of their fabrication and the arcana of Rothko's creativity using information that she gathered partly from Ray Kelly, one of Rothko's last assistants. Kelly "demonstrated how Rothko primed cotton-duck canvases with dry pigment in rabbit-skin glue and then moderated the color with pigments in Liquetex medium. This process, undertaken by the assistants but meticulously directed by Rothko, constituted the plum monochromes. To create the black-form paintings, each day Rothko prepared a mixture of unmeasured amounts of oil paint, whole egg, damar resin, and turpentine and proceeded first to paint rectangles with tube oil paint on the colored grounds and then to brush the egg/oil emulsion on top." Kelly also explained that "each morning Rothko would instruct his assistants to tape and then create on the colored grounds a predetermined black rectangle, first with charcoal, then with tube oil paint, and finally with a fresh batch of egg/oil emulsion." This exemplified Rothko's highly sophisticated evolution: as his career progressed, he became, according to Mancusi-Ungaro, "increasingly more interested in issues of reflectance." So much so that by the time he started working on the Rothko Chapel, "he had practically eliminated color as a

major player,"[21] even if some of those canvases ranged from purple to colors verging on burgundy.

In addition to his commitment as an intellectual and an educator, Mark Rothko worked as a true scientist as well as a medieval craftsman, combining ancient techniques with recent discoveries. One day, he confessed to Roy Edwards, another of his assistants, that he had taken math seriously in high school, but that it "gradually gave away to the artist, who never quite forgot his background." His interests for geometry resurfaced when Rothko developed, in a particularly exact manner, the distance separating the shapes within his canvases from the border of the stretcher. For the chapel murals, Edwards commented, Rothko's "concern was to drive me to the point of exasperation, as I was constantly going up and down the ladder adjusting the height or width of the black ¼″ or ⅛″. I began to wonder what possible difference could this make on a painting approximately 12 × 15 feet in dimension."[22] The *very* space separating the black contours from the canvas borders tormented the artist obsessively, and one is tempted to believe that Rothko conceived it as *the* "entrance door" into the painting. "Was the black too confined?" Edwards wrote. "The space must become something that one can enter into, after all. The pictures are doorways to the unknown."[23] For this last commission, Rothko worked peacefully, surrounded by his assistants Roy Edwards and Ray Kelly, supported by his loyal friend Herbert Ferber (from whom he borrowed books on Florentine architecture), and assuaged by the respect his patrons displayed toward him—as if he were Piero della Francesca, an artist, mathematician, and geometer supported by the Bacci family in Arezzo to produce frescoes on the Legend of the True Cross in the basilica of Saint Francis.

Once he finished his work on the Houston chapel, Rothko followed through with Norman Reid in London, concerning the contract that would seal the transfer of his Seagram murals

to the Tate Gallery. During that time he worked all day long in his studio at 157 East Sixty-Ninth Street and then joined his family in the evening down the street at 118. In the spring of 1968, after an ordinary day (work at the studio, lunch with a friend, afternoon playtime with his son, Christopher, who would soon be five, and family dinner), Rothko felt a severe pain in the middle of his back and was rushed to New York Hospital, where he was diagnosed with a "dissecting aneurysm of the aorta" and kept in observation for hypertension and arteriosclerosis. When he was released from the hospital three weeks later, in good physical shape, his cardiologists prescribed a medical treatment intended to lower his tension and boost his overall condition. But to avoid a reoccurrence, they added, a healthy diet was critical, and Rothko ought to severely limit his consumption of alcohol and tobacco.

The last two years of the painter's life, from May 1968 to February 1970, were marked by his heart disease. Professionally, he still managed to produce art, including some drawings on paper during the summer of 1968 in Provincetown and the painting series "Black on Grey" in 1969. During that period, though, Rothko devoted himself mainly to managing his estate, of which he had never before taken a detailed inventory. At this point it was made up of some eight hundred canvases he had produced over the previous two decades and stored in warehouses scattered around the city. The Rothko of these years differed remarkably from the Rothko of the 1950s. He was a weakened man with a diminished capacity for work who became progressively more depressed and dependent. Unable to comply with his doctors' injunctions to get his life under control, he found himself in a downward spiral, battling alcohol and drug abuse, along with depression. On January 1, 1969, in the wake of increasing tension between him and his wife, Rothko decided to distance himself from his family and move into his studio, which made him even more vulnerable to the

predations of those in his entourage who didn't have his best interests in mind. Moreover, the artist, less and less productive but increasingly courted, became the administrator of his own estate, casting himself against type in the role of manager of his financial activities, on which he had always had a poor grasp.

Dore Ashton, who visited him in February 1969, a year before his death, recounted that Rothko "was wearing slippers and he shuffled, with a vagueness to his gait that I attributed to drinking. . . . His face, thin now, is deeply disturbed, the eyes joyless. He wanders. He is restless (he always was, but now it is frantic), he keeps picking up a cigarette, trying to light the wrong end. . . . He says he is a Renaissance painter, has nothing to do with painting today. . . . He is still a very shielded man to me."[24] Around this declining Rothko, various circles were being formed. Among them was a ballet of doctors—internist Dr. Albert Grokest, cardiologists Dr. Irving Wright and Dr. Allen Mead, and psychiatrist Dr. Nathan Kline—none of whom agreed on the appropriate treatments, with some prescribing antidepressants, others cautioning the patient about contraindications to taking such drugs. These squabbles sometimes gave rise to external manipulative interventions by gallery owners.

There was also the ballet of the art people. In the wake of his exhibitions in major museums, and thanks to the efforts of Sidney Janis, Rothko's work was increasingly sought after and was receiving a huge amount of attention. Museum directors and curators from around the world (Franz Meyer and Ernst Beyeler from Basel, Sir Norman Reid from London, William Rubin of MoMA, Henry Geldzahler of the Metropolitan Museum of Art, Thomas Messer of the Guggenheim Museum) were approaching him with multiple propositions—a Rothko Room at MoMA, a Rothko Room at the Tate Gallery, potential sales, and shows in the most prestigious institutions. His gallery owner friends, past and present (Betty Parsons, Grace Borgenicht, Katharine Kuh, and Arnie Glimcher), visited him

constantly, discussing his work as in the old days, or propos-
ing new sales to him. Visitors also included art historians such
as Robert Goldwater, a New York University professor with
whom Rothko committed himself to write, every day for two
hours, a book about his work.

There was the ballet of the artist friends, including fellow
painters Robert Motherwell, Jack Tworkov, and Jim Brooks,
the writer Bernard Malamud, and the composer Morton Feld-
man. In an even closer circle were his friendships with Rita
Reinhardt and his assistants, both the former ones (Dan Rice
and Ray Kelly) and the new ones (Jonathan Ahearn and Oliver
Steindecker). Of all his late achievements, an honorary doctor-
ate he received from Yale University on June 9, 1969, might
have moved him the most, as his acceptance speech suggests.
In it, he took the liberty of romanticizing his early years as an
artist on the theme of "the golden age," already a favorite sub-
ject of his in 1940, when he wrote *The Artist's Reality*. "When
I was a younger man," he explained, "art was a lonely thing: no
galleries, no collectors, no critics, no money. Yet it was a golden
time, for then we had nothing to lose and a vision to gain. Today
it is not quite the same." How not to point out in his description
the magnified nostalgia and idealization of a period that, three
decades earlier, he so vividly criticized and detested?

At the end of 1969, Mark Rothko was still physically able to
visit the Rothko rooms of two prestigious exhibitions: *The New
American Painting and Sculpture: The First Generation*, which
opened on June 18 at MoMA (which he enjoyed), and *New York
Painting and Sculpture: 1940–1970*, which opened on October
16 at the Metropolitan Museum of Art (which enraged him).
This display of enthusiasm surrounding his work would con-
tinue after his death, with the official opening of the Rothko
Room at the Tate Gallery in March 1970 and the inauguration
of the Rothko Chapel in Houston in February 1971. Despite
these honors, the weakened artist was at the center of the most

insidious ballet, danced by the men from the Marlborough Gallery, with whom he had signed a contract a few years earlier, after leaving Sidney Janis. Much has been written on this episode, one of the darkest relationships between art dealer and artist.[25] It would not come to a resolution until twelve years later, with a resounding condemnation of Marlborough's conduct. During the two last years of Rothko's life, Bernard Reis, Frank Lloyd, David McKinney, and others from Marlborough took advantage of the artist's vulnerability by badgering him into selling them many of his paintings under dubious circumstances. They also maliciously advised him on his will and foundation with the shameless intention of defrauding his heirs, while at the same time carefully sidelining those like Bill Rubin and Robert Goldwater, who could have discovered their intentions and derailed their plans.

On February 25, 1970, at nine in the morning, Rothko's assistant Oliver Steindecker found him dead in his studio, and Dr. Judith Lehotay, the pathologist who performed the autopsy, declared that it was a suicide. Six months later, Mell Rothko died from a heart attack at the age of forty-eight. The following year, Kate and Christopher would file a lawsuit against their father's gallery that would become one of the most compelling trials in the years that followed.

Once again, it is Robert Motherwell who offers the most personal observations about the last months in the life of Mark Rothko. In his studio at 157 East Sixty-Ninth Street, the artist's daily routine became simple and austere, at times even wretched, recalling the situation once described by Abraham Heschel: "Outwardly, a Jew might have been a pauper, but inwardly he felt like a prince, a kin to the King of Kings."[26] With his work on the chapel, did Rothko feel he was duly performing his last *mitzvah*? Toward the end of 1969, Rothko threw a big party in his studio, which he staged like a play, casting himself as the director as well as the main character. Accord-

The Rothko Chapel, Houston, Texas (Photograph by Sofia van der Dys. Copyright © 2008 by Photographer Sofia van der Dys)

ing to Robert Motherwell, who was among the guests, he acted like a king "deciding the favor of his courtiers on their presence or absence from court." He had hung his last paintings from the series *Black on Grey* in a circle and, for the four hours the event lasted, he did not leave the center of this imaginary circle, as if it carried some totemic power from which derived his own. "And the whole party in that sense," Motherwell explained, "was not a party at all, but a primal reception, where his magic was protecting him from all the terrors of unbridled humanity. And that for me . . . [was] the essence of his whole life apart from his creativity[,] that totemic [side]. With him it was these thin fields of color, literally his emblems, his shields, his magic formulae against the terrors of the world. And that's why he could be so ruthless in protecting it, because in a way, if he didn't protect it, he'd be dead."[27]

———◆◐◆———

Epilogue

When I was a little girl, my father would often sit next to me
with a map. He would show me this territory [at the cross-
roads of Latvia, Lithuania, and Poland], and say, "You cannot
really see, because now there are new borders, different from
those of my time. Still, this is where I was born."
—Kate Rothko Prizel

DAUGAVPILS, LATVIA, Wednesday, April 24, 2013, at noon.
With the pointed reminder above, Mark Rothko's daughter
Kate opened the dedication ceremony of the Marka Rotko
Mākslas Centrs (Mark Rothko Art Center) in the artist's native
city, a city whose name has changed more than once through-
out history. In September 1903, when the painter was born in
the Pale of Settlement, the area within the Russian Empire
where Jewish residents were required to live, it was Dvinsk. In
1920, when the city became part of the new Republic of Latvia,

it was renamed Daugavpils ("fortress on the Daugava River" in Latvian). Today, with a population of over a hundred thousand, at the borders of Lithuania, Belarus, and Russia, the second largest Latvian city seems rather quiet, off the mainstream European cultural routes. One gets there by means of a protracted three-hundred-kilometer ride from Riga, the country's capital, passing innumerable roadside stork nests, colorful wooden houses, and never-ending birch forests. On this radiant spring day, the northern light reflected on the surrounding lakes and rivers, dazzling the visitor with its almost unbearable purity. After two years of work, with a budget of six million euros, this 54,000-square-foot, straw-colored former ammunition depot, built in 1833 during the reign of Czar Nicholas I, has been turned into a museum, thanks to the vision and perceptiveness of its curator, Farida Zaletilo. For the day's festivities, the Latvian authorities—local and national, political and religious— went to great lengths to celebrate the event with much pomp.

From every corner of the world, the "Rothko community" (minus a few members) has converged on Daugavpils to attend the celebration. Approaching such a motley gathering, one can hear Hebrew, Yiddish, Polish, English, Russian, Latvian, German, and French. Kate Rothko Prizel and Christopher Rothko, the artist's children, traveled from New York, as did Kate's husband, the historian Ilya Prizel, and Marion Kahan, the administrator of the Rothko Family Collections. From Basel came Oliver Wick, the curator of impressive Rothko exhibitions at the Fondation Beyeler, near Basel, and the Palazzo delle Esposizioni, in Rome; from Warsaw, Agnieszka Morawińska, the director of the National Museum of Poland, who was busy preparing a show of paintings and drawings sent by the National Gallery of Art in Washington, D.C.; from Paris, Isy Morgensztern, who wrote and directed the beautiful 2003 documentary *Rothko: An Abstract Humanist*; from Riga, Karina Pētersone, former Latvian Minister of Culture and Director of the Latvian

Institute; and Ojars Sparitis, president of the Academy of Sciences, as well as the entire staff of the French embassy, including Ambassador Christophe Visconti and his cultural attaché, Denis Duclos. The French contingent also counted Bruno Chauffert-Yvart, an architect with the Monuments historiques, the state agency in charge of awarding national heritage protection to French buildings, who had flown to Riga for an academic lecture. As we were walking together, he pointed out the former arsenal's "stucco pilasters topped with lunettes and ribbed vaults," the adjacent brick fortress, and the ditch that surrounds it. The whole complex, he explained, like the city of Saint Petersburg, was built by the Russians in the wake of the Napoleonic Wars according to the French military architecture principles of Vauban and, a century later, Ledoux.

At the press conference for the event, Inna Steinbuka, Latvia's representative to the European Union, highlighted the involvement of the European Commission, which provided two-thirds of the project's budget. "Many doubted the necessity of creating such a center in Latvia," she admitted. "But I am convinced that this center will attract tourists and investors and develop many infrastructures." Next, Helēna Demakova, a former Latvian Minister of Culture, asserted that, in her opinion, with the opening of the Mark Rothko Center in Daugavpils, "the return of Mark Rothko is also a possibility of return to a small part of Eastern European Jewish culture. . . . From a general standpoint, the Jews were educated people. . . . This culture doesn't exist anymore. . . . When Rothko as a child left for the USA in 1913, a complete destruction of this culture was not to be foreseen. Was there anyone who could foresee that after 1940, no five-year-old son of a Daugavpils pharmacist will have the opportunity to study Talmud in *heder*, as Marcus Rothkovich did?" Demakova further emphasized the discontinuation in the Latvian art space and consciousness, adding that, in Latvia, "no monograph has yet been published about the twenti-

eth century Western modern art history." But Eduards Kļaviņš, professor of art history, noted, "We have to take into account the dramatic history of political factors in the twentieth century that . . . could destroy the context of Rothko art in Latvia." According to Kļaviņš, the fault lay with the Communist regime, since "the totalitarian rule determined the isolation of the Latvian art. Only gradually, the regime weakening and Latvian artists struggling to get free from the imposed Social Realism, a process [of Rothko's return to people's consciousness] started, even though abstract art was [still] a taboo." He added: "Rothko entered the consciousness of Latvian artists as late as the last decade of the twentieth century. He became known, his works became known, and he became a sort of a paradigm. In his respect, I can say that, today, Mark Rothko has come back to Latvia."

Behind the speeches one could sense deeper internal conflicts. But the artist's children refocused the discussion on both the genealogy and the work of their father. Thirteen years younger than Kate, Christopher is a poised and methodical man who bears a striking resemblance to his father. "This is a very exciting day for me," he declared. "It brings back the memory of my first trip to Latvia, when I traveled to celebrate my father's hundredth birthday, in September 2003. In the past, people would refer to him as an American artist born in Russia, but in actuality, his situation was altogether more interesting and more complex. During that trip, I became conscious of this land, which until then had remained legendary to me, and everything became concrete." Kate in turn referred to the impact this 2003 experience had on her: "During our first trip to Daugavpils," she explained, "we arrived on a bus which, to my great surprise, was stopped by a children's choir. They offered us bread and salt, just as was done in the Ukrainian village where my husband, as a child, used to spend his summer holidays. Besides, in Daugavpils so many different cultures seem to

meld that I had the immediate feeling it was my home; in fact, I thought that it could epitomize my father's return." Christopher outlined his projects: "I am busy with my father's archives, with the future shows: one will take place in Warsaw, the other one in The Hague. I was very involved with Oliver Wick at the Beyeler Foundation as well as in Rome, which was very meaningful, because my father loved the Italian Renaissance; in 2006, I also worked on the big but focused exhibition at the Tate Gallery in London. The public's interest for my father's work keeps growing, and the new shows concentrate on specific periods of his life, or on his interests in philosophy, literature, or intellectual matters in general. The great news is that the Mark Rothko Center in Daugavpils will soon become a new resource center."

That Kate and Christopher journeyed all the way from New York on this fine spring day of 2013 to loan six major paintings from their personal collection to the new center bearing their father's name, in their father's native city, is not without significance. This region was one severely affected by the savage practices of the Nazis' death squad, Einsatzgruppe A,[1] which, led by Brigadeführer-SS Walter Stahlecker, within just a few days between July and November 1941 nearly obliterated the entire local Jewish population during the infamous Rumbula massacre.[2] One passes the "silenced" Rumbula Forest on the long journey from Riga to Daugavpils. Ten years ago, struck by the loss of Jewish culture in this region, Kate and Christopher decided to fund the restoration of a Daugavpils synagogue, the last such remaining building in a city that once sheltered around fifty of them. Their gesture toward the Latvian citizens can certainly be considered a sort of *mitzvah*,[3] initiating, at the dawn of the twenty-first century, a new type of exchange with the territory where their father was born.

The two years I spent researching this book involved grappling with many parts of a complex puzzle, which I have tried

to piece together in these pages. My work led me to revisit the painter's career in the historical context of the wave of pogroms in early twentieth-century Russia and the golden age of capitalism in post–World War II America, and to relate these to the art world, including the many encounters, interactions, and displacements that influenced Rothko's aesthetic choices, technical innovations, and production of works within a constantly changing geopolitical frame. However, one thing in this Latvian ceremony struck me as particularly meaningful: it was as if an "International Rothko Organization" were reclaiming some of the ideas from *The Artist's Reality*, the manuscript Rothko wrote in 1940. In it, the painter expresses his attachment to his quest for unity through art, the only way, in his mind, to surpass history—a quest that coincides with one of the central tenets of Judaism, the *tikkun olam*, or "repairing the world." Wasn't Kate and Christopher's gesture precisely epitomizing that very idea? And, beyond their father's various individual quests and displacements, had they not, in fact, succeeded in putting the final touches to his project?

All in all, how not to rejoice in the face of the considerable momentum surrounding Mark Rothko's work, considering the vicissitudes it suffered after the artist's suicide in February 1970? Kate, then a premed student at Johns Hopkins, was nineteen, and Christopher only six. After their father's death, 798 of his works were "procured" by his dealer, Frank Lloyd, the director of the Marlborough Gallery, in unclear circumstances. The legal proceedings they initiated the following year became so emblematic of mounting financial and power pressures in the art world that they created, for a time, a widespread mistrust of art dealers among Americans. On March 8, 1975, New York County Surrogate's Court Judge Millard L. Midonick found Bernard Reis (who was not only the executor of Mark Rothko's estate, but also the director of the Rothko Foundation and a Marlborough Gallery employee)

guilty of conflict of interest and sentenced him to pay a fine of $9,250,000[4] in damages and interest to the artist's estate, and ordered the restructuring of the Rothko Foundation. As for Frank Lloyd, the director of the Marlborough Gallery, he was deemed an accomplice of Reis. Two years later, the verdict was upheld by the New York State Court of Appeals, which described Reis and Lloyd's conduct as "manifestly wrong and indeed shocking." On January 6, 1983, the court ordered Lloyd (Reis had died in the meantime) to fund research grants and organize a series of lectures and exhibitions in lieu of a four-year prison term,[5] right before Kate's decision that the Pace Gallery would represent her father from then on. That final act concluded legal proceedings that had been drawn out over twelve years. The new Rothko Foundation then expended tremendous effort to conserve and catalogue the artist's works, before donating them to museums, mainly the National Gallery of Art in Washington, D.C.

In the twenty-first century, the sale prices of Rothko's paintings at auction have consistently risen, eventually surpassing those of his contemporary colleagues—Pollock, de Kooning, Newman, Still—to reach staggering sums in the vicinity of $80 million. In 2011, Mark Rothko became the main character in *Red*, a successful Broadway play by John Logan that won six Tony Awards. Two years later, with *Mark Rothko: The Decisive Decade, 1940–1950*, the public was able to gauge the accomplishment of an artist who also thrived as a scholar, an intellectual, an educator, and a true pioneer. In November 2014, his Harvard Murals were placed on view again after a new MIT/ Harvard University technology was able to correct the erosion of their colors.

But it was on my last visit to Washington, D.C., that I could truly understand the dynamic effects that Rothko's art still engendered. At the Phillips Collection, Dorothy Kosinski and Klaus Ottmann had scrupulously maintained the original

Rothko room just as Duncan Phillips had set it up in 1960, with four paintings hung very low on an off-white wall in a square space, with little light and no labels, and keeping the old well-worn bench that Rothko had wanted there. Furthermore, Ottmann had recently commissioned a *Wax Room* from the artist Wolfgang Laib as an echo to the Rothko room, designating another meditative space in the institution. At the National Gallery, Harry Cooper, the curator of Modern Art, was discussing the Rothko exhibition tours planned both in the United States and in Asia over the next several years while the museum undergoes renovations, which would allow the artist to meet new audiences.

During the same period, I traveled to the Netherlands for the inauguration of an extraordinary Rothko exhibition at the Gemeentemuseum in The Hague, which ultimately became a blockbuster show and spawned a subtle and poignant documentary, *The Silence of Rothko*.[6] Inspired by Rothko's fascination with Fra Angelico, Franz Kaiser, the curator in The Hague, displayed some of the works one per cabinet, achieving a mesmerizing effect for the public.

On that fine spring day of April 2013, along with the Tate Gallery in London, the National Gallery in Washington, D.C., and the Rothko Chapel in Houston, the Mark Rothko Center in Daugavpils had become the fourth space in the world to hold a substantial permanent collection of works by the painter. Thus, the trajectory of Mark Rothko had come full circle. And it revealed how the immigrant child also became a true agent of transformation, a *passeur* who, by crossing boundaries, managed to bridge the many different cultural territories he had inhabited, taking risks up to the end as he fought to impose his idea of *art as an experience* through his last obsession with the light in the chapel.

NOTES

Chapter 1. The Charismatic Yacov Rotkovitch

Epigraph: Kenneth B. Moss, "At Home in Late Imperial Russian Modernity—Except When They Weren't: New Histories of Russian and East European Jews, 1881–1914," *The Journal of Modern History* 84:2, "The Jew in the Modern European Imaginary" (June 2012), 401–52; for his quote, see 409.

1. See Richard Pipes, "Catherine II and the Jews: The Origins of the Pale of Settlement," *Soviet Jewish Affairs* 5.2 (1975): 3–20.

2. Michael Davitt, *Within the Pale: The True Story of the Anti-Semitic Persecutions in Russia* (London: Hearst and Blackett, 1903), 160.

3. See Richard H. Rowland, "Geographical Patterns of the Jewish Population in the Pale of Settlement of Late Nineteenth Century Russia," *Jewish Social Studies*, 48:3–4, Indiana University Press, 206–34.

4. A Yiddish word designating small Jewish villages at that time.

5. Quoted in Joshua Rubenstein, *Leon Trotsky: A Revolutionary's Life* (New Haven: Yale University Press, 2011), 28.

6. "Jewish Massacre Denounced," *New York Times*, April 28, 1903.

7. Davitt, *Within the Pale*, 176.

8. Many specifics about this period came from Michael Stanislawski, *For Whom Do I Toil? Judah Leib Gordon and the Crisis of Russian Jewry* (New York: Oxford University Press, 1988), as well as from conversations with Steven J. Zipperstein and Paul Gradvohl, to whom I am very grateful for their generosity and their expertise.

9. Unpublished account by Debby Rabin, Rothko's grandniece, letter to the author.

10. "The Black Hundreds" was the generic name for some loyalist groups—later to be formally organized in such bodies as the Union of the Russian People—who equated Jews with "revolutionary activities" during the massive demonstrations in the events of the Russian Revolution between 1905 and 1907.

11. See James E. B. Breslin, *Mark Rothko: A Biography* (Chicago: University of Chicago Press, 1993), 15.

12. Interview of Moïse Roth by Ruth Cloudman, Archives of American Art, Smithsonian Institution, 2–3; see Breslin, *Rothko: A Biography*, 15.

13. Interview with the author, Daugavpils, April 24, 2013.

14. Talmud Torah, which literally means "study of the Torah," designates the public courses (*heder*) funded by the community, as opposed to the private heder.

15. *Heder* designated the most widely accepted system of elementary education in Eastern Europe. A heder education instilled the foundation of Jewish culture through the study of the fundamental texts, the Talmud, Torah, and Michna.

16. Debby Rabin, unpublished account.

17. M. Stanislawski: *For Whom Do I Toil?* 147.

18. Irving Howe, *World of Our Fathers: The Journey of the East European Jews to America and the Life They Found and Made* (New York: Simon & Schuster, 1976), 22.

19. Ibid.

20. Breslin, *Rothko: A Biography*, 21.

21. Debby Rabin, unpublished account.

22. Mark Zborowsky and Elizabeth Herzog, *Olam* (Paris: Terre Humaine, Plon, 1992), 80–96; *Life Is with People* (New York: International Universities Press, 1952).

23. See Abraham J. Heschel, "The Inner World of the Polish Jew," introduction to Roman Vishniac, *Polish Jews: A Pictorial Record* (New York: Schocken, 1965), 7–17.

24. Giorgio Agamben, "Idea dello studio," in *Idea della prosa* (Cuaderni Quodlibet, Macerata, 2002), 43–45. [Trans.]

25. For these details, see the interviews mentioned in Breslin, *Rothko: A Biography*, 18, 19.

26. The departure was the most dramatic for the two older brothers, Moise, aged nineteen, and Albert, aged seventeen. Because of the risk that Moise would be drafted, they had to leave Russia as quickly as possible on the sly by finding "smugglers" to take them to Germany by night hidden in a sleigh, before they could sail for the United States on board the *Frankfurt* from the port of Bremen.

27. Debby Rabin, unpublished account.

28. Joseph Roth, *Job: The Story of a Simple Man*, 1930, trans. Ross Benjamin (Brooklyn: Archipelago Books, 2010).

29. In Yiddish, a *goy* refers to a "non-Jew."

30. Roth, *Job*, 102.

31. Ibid., 108.

32. Letter from Rav Kook to Betsalel upon its founding in Jerusalem in 1908; quoted in Georges Hansel, "Esthétique et idolâtrie," in *Tradition et modernité dans la pensée juive* (Paris: Festival international de la culture juive, 1983), 59–73. On the same subject, see also Daniel Auswaks, "Le beau et le vrai," ibid., 75–93.

33. At Ellis Island, the spelling of the name Rotkovitch was changed to Rothkowitz. In a letter to the author, on December 12, 2012, Christopher Rothko writes, "Rotkovitch is the way the family was known in the old country. I have always heard that the family was particularly unhappy with the way their name was changed. They very much identified as Russian, and this Americanized,

Polish version of their name was offensive to them. My understanding is that [it played a role when, later on,] all three brothers changed their name [it was] not simply to sound less Jewish—after all, they could have chosen names much further away from their Jewish roots than Roth or Rothko." The altered spelling will be used in subsequent chapters.

34. See Breslin, *Rothko: A Biography*, 22.

Chapter 2. A Diligent Student in Portland, Oregon

1. On the concept of "chain migration," see Suzanne W. Model, "Work and Family: Black and Immigrants from South and East Europe," in *Immigration Reconsidered: History, Sociology and Politics*, ed. Virginia Yans-McLaughlin (New York: Oxford University Press, 1990), 130–59.

2. Debby Rabin, unpublished account.

3. Steven Lowenstein, *The Jews of Oregon, 1850–1950* (Portland: Jewish Historical Society of Oregon, 1987), 69.

4. Ibid., 84.

5. Ibid., 93–94.

6. Ibid., 95.

7. Christopher Rothko, interview with the author, July 20, 2012.

8. Invaluable documentation on Rothko's time in Portland was provided to me by Anne LeVant Prahl, curator of collections at the Oregon Jewish Museum, as well as from an anonymous article, "Rothko's Portland," June 17, 2009, www.portlandart.net/archives/2009/06/rothkos_portlan.html.

9. Account by Jacob Weinstein, quoted in Lowenstein, *The Jews of Oregon*, 116.

10. Ibid., 117.

11. Quoted in Breslin, *Mark Rothko: A Biography*, 36.

12. Useful information on Lincoln High School is provided in Breslin, *Rothko: A Biography*, 36–37, as well as in the documents sent to me by Anne LeVant Prahl of the Oregon Jewish Museum, including a text titled "Lincoln High School *Cardinal*, 1921," Archives of the Oregon Jewish Museum, Augusta Reinhardt Papers IND 91.

13. *Neighborhood,* February 1920, 3, 5, Archives of the Oregon Jewish Museum, Neighborhood House Collection ORG 10.

14. *Neighborhood,* May 1921, 5, 7, Archives of the Oregon Jewish Museum, Neighborhood House Collection ORG 10.

15. Marcus Rothkowitz, "A Year's Perspective," *Neighborhood,* Official Organ of the Neighborhood House 2:1 (June 1920), 1.

16. Quoted in Lowenstein, *The Jews of Oregon,* 130.

17. Ibid., 131.

18. Quoted in Breslin, *Rothko: A Biography,* 40–42.

19. Quoted in ibid., 44.

20. Otto Fried, interview with the author, Paris, June 28, 2012.

21. Quoted in Breslin, *Rothko: A Biography,* 32.

Chapter 3. The Years of Chaos

Epigraph: Dan A. Oren, *Joining the Club: A History of Jews and Yale,* 2nd ed. (New Haven: Yale University Press, 2000), 44.

1. See Ruth Gay, *Jews in America: A Short History* (New York: Basic Books, 1965), 80.

2. See Breslin, *Rothko: A Biography,* 49 (italics original).

3. "schmates," which originally means "rag" in Yiddish, came to mean by extension the textile trade.

4. Oren, *Joining the Club,* 96.

5. Ibid., 45.

6. Ibid., 46.

7. Ibid., 42.

8. Ibid., 84.

9. Ibid., 86.

10. See Breslin, *Rothko: A Biography,* 49.

11. Oren, *Joining the Club,* 101.

12. Ibid., 87.

13. Born in Frankfurt, Jacob Schiff arrived in the United States after the Civil War. He became such a well-known banker, businessman, and philanthropist in the United States that people came to speak of "the Schiff era." Among his feats of note is his personal decision to provide financial aid to the Japanese empire in 1904 and 1905 (there was talk of an amount in the neighbor-

hood of $200 million) to avenge the Jewish people at the time of the demonstrations of antisemitism in the Russian Empire and, more specifically, after the Kishinev pogrom.

14. Oren, *Joining the Club*, 92.

15. *Yale Saturday Evening Pest*, February 17 and April 7, 1923.

16. Markus Rothkowitz, *Saturday Evening Pest*, March 17, 1923.

17. Oren, *Joining the Club*, 96.

18. Mark Rothko to Katharine Kuh, 1954, quoted in Breslin, *Rothko: A Biography*, 55.

19. Among other publications, he then illustrated the *Menorah Journal* for the Federal Advertising Agency.

20. Lewis Browne, "The Jew Is Not a Slacker," *North American Review* 207 (June 1918).

21. Ibid.

22. See Paul Reitter, *On the Origins of Jewish Self-Hatred* (Princeton: Princeton University Press, 2012).

Chapter 4. The Metamorphosis of Marcus Rothkowitz

Epigraph: Leo Steinberg, "Introduction," in *The New York School: Second Generation*, exhibition catalogue (New York: Jewish Museum of the Jewish Theological Seminary of America, 1957), 4–8.

1. The critics noted his "peculiarly suggestive style, with its dependence on masses and comparative indifference to establishing any markedly definite form." Breslin, *Rothko: A Biography*, 97–98.

2. See the chapter "A Chilly Wind from the East Had Blown on Our Artists," in Annie Cohen-Solal, *Painting American, The Rise of American Artists (Paris 1867–New York 1948)* (New York: Alfred A. Knopf, 2001), 225–33.

3. "Cubists Migrate: Thousands Mourn," *New York Times*, March 16, 1913.

4. Max Weber, speech on his class with Henri Matisse, 1951. Max Weber papers, Archives of American Art, Smithsonian Institution, 13.

5. See the chapter "The Modernists' Transatlantic Shuttle," in

Annie Cohen-Solal, *Painting American, The Rise of American Artists (Paris 1867–New York 1948)* (New York: Alfred A. Knopf, 2001), 204–11.

6. Jerome Myers, *Artist in Manhattan* (New York: American Artists Group, 1940), 27.

7. Interview with William J. Glackens, "The American Section," *Art and Decoration*, March 1913.

8. John Singleton Copley [to Captain R. G. Bruce?], 1767, in *Letters and Papers of John Singleton Copley and Henry Pelham, 1739–1776* (New York: Kennedy Graphics/Da Capo Press, 1970), 65–66.

9. Max Weber, speech on his class with Henri Matisse, 1, 5.

10. See "The Reminiscences of Max Weber," Oral History Research Office, Columbia University, 1958. My thanks to Katie Peters and Joy S. Weber of Santa Fe. See also Percy North, *Max Weber* (Santa Fe: Gerald Peters Gallery, 2000).

11. "Tribute to Milton Avery," January 7, 1965, in Mark Rothko, *Writings on Art* (New Haven: Yale University Press, 2006), 149.

12. Meyer Schapiro, "The Introduction of Modern Art in America: The Armory Show," in *Modern Art: 19th and 20th Centuries* (New York: George Braziller, 1979), 173.

13. As the anthropologist Arjun Appadurai put it. See Annie Cohen-Solal, "The Ultimate Challenge for Alfred H. Barr, Jr.: Transforming the Ecology of American Culture, 1924–1943," in *Abstract Expressionism in Context*, ed. Joan Marder (New Brunswick: Rutgers University Press, 2006). See also Arjun Appadurai and Carol A. Breckenridge, "Museums Are Good to Think: Heritage on View in India," in *Museums and Communities: The Politics of Public Culture*, ed. Ivan Karp, Steven D. Levine, and Christine Mullen Kraemer (Washington, D.C.: Smithsonian Institution Press, 1991).

14. American Abstract Artists, "How Modern Is the Museum of Modern Art?" (New York: Privately printed, April 15, 1940); Irving Sandler and Amy Newman, eds., *Defining Modern Art: Selected Writings by Alfred H. Barr Jr.* (New York: Abrams, 1986), 250.

15. Quoted in B. H. Friedman, *Gertrude Vanderbilt Whitney: A Biography* (New York: Doubleday, 1978), 559.

16. Interview with Joseph Solman, May 6–8, 1981, Archives of American Art, Smithsonian Institution.

17. Joseph Solman, "The Easel Division of the WPA Federal Art Project," in *The New Deal Art Projects: An Anthology of Memoirs*, ed. Francis V. O'Connor (Washington, D.C., 1972), 122.

18. Joseph Solman, *The Villager*, October 3–9, 2007.

19. *New York Times*, December 22, 1935.

20. "The Ten Are Staging Their First Group Show," *New York Post*, December 21, 1935.

21. L[ouis] S[chanker] in *The Ten: Whitney Dissenters*, exhib. cat., 1938; reprinted in Rothko, *Writings on Art*, 16–17.

22. Ibid.

23. Interview of Avis Berman with Bernard B. Braddon and Sidney Paul Schectman, New York, October 9, 1981, Archives of American Art, Smithsonian Institution.

24. Ibid.

25. *New York Sun*, December 1933.

26. John Dewey, *Art as Experience* (New York: Penguin/Perigree Books, 2005), 189, 285.

27. "New Training for Future Artists and Art Lovers," *Brooklyn Jewish Center Review*, 14, February–March 1934, 10–11; reprinted in Rothko, *Writings on Art*, 1–2.

28. "Scribble Book," ca. 1934, in *Writings on Art*, 6 and 10.

29. *The New York School, Second Generation*, 4–8.

30. *The Jewish Century* (Princeton: Princeton University Press, 2004), 207.

31. "The Museum Course," in "Tales of an Epoch" (unpublished memoir, 1957–1958), 164. Paul Sachs papers, Harvard Art Museums Archives, Harvard University.

32. Ibid., 175.

33. Ibid., 169.

34. Ibid.

Chapter 5. In Search of a New Golden Age

Epigraph: Mark Rothko, *The Artist's Reality* (New Haven: Yale University Press, 2004), xxiv.

1. *Official Guide Book of the New York World's Fair 1939* (New York: Exposition Publications, 1939).

2. Rothko, *Artist's Reality*, xxiv–xxv.

3. This brings to mind the father-son relationship in the Rothkowitz family. It was Marcus, the youngest child, who was responsible for reciting the Kaddish for a year at the synagogue in Portland in memory of his father, and it was Marcus who in his play *Duty* (1921) returned to the theme, featuring a father who tried in vain to save his son from hanging. One might suggest that by publishing and writing an introduction to his father's unpublished text, Christopher Rothko, who was only six when his father took his life in 1970, was carrying on the Rothkowitz tradition of reversing father and son roles.

4. Rothko, *Artist's Reality*, 1.

5. Ibid., 3.

6. Ibid.

7. Ibid., 125.

8. Ibid., 4.

9. Ibid., 6.

10. Ibid., 123.

11. Ibid., xxiv.

12. Ibid., xxvi.

13. Ibid., 16.

14. Ibid.

15. Ibid., 17.

16. Ibid., 14.

17. Ibid., 14, 10.

18. Ibid., xxiv.

19. Walter Benjamin, "Theses on the Philosophy of History," in *Illuminations* (New York: Schocken, 1969), 257.

20. Sidney Janis, *Abstract and Surrealist Art in America* (New York: Reynal and Hitchcock, 1944), 118; reprinted in Rothko, *Writings on Art*, 41.

21. Jean-Paul Sartre, "Ce que fut la création des Mouches," *La Croix*, January 20, 1951.

22. Edward Alden Jewell, *New York Times*, February 17, 1943.

23. Ibid.

24. Christopher Rothko, "Introduction," *Artist's Reality*, xxvii.

25. With works like *Oedipus* (1940), *Antigone* (1941), and *Tiresias* (1944).

26. Interview with Elaine de Kooning conducted by Phyllis Tuchman, August 27, 1981, Archives of American Art, Smithsonian Institution.

27. These exhibitions were accompanied by more modest presentations in museums and public institutions in New England, like Smith College Museum of Art, Yale University Museum, and the Wadsworth Atheneum (Breslin, *Rothko: A Biography*, 155). From 1942 on, the Federation's annual exhibitions were held at the Wildenstein Gallery.

28. Mark Rothko, letter to Joseph Liss, February 3, 1941, Mark Rothko Files, National Gallery of Art, Washington, D.C.

29. Dore Ashton, "The Federation in Retrospect," http://www.fedart.org/about.htm.

30. Barnett Newman, Foreword, *American Modern Artists*, exhib. cat. (Riverside Museum, January 17–February 27, 1943); reprinted in Barnett Newman, *Selected Writings and Interviews*, ed. John P. O'Neill (New York: Knopf, 1990), 29–30.

31. Barnett Newman, "Response to the Reverend Thomas F. Mathews, First International Congress on Religion, Architecture, and the Visual Arts, held in New York and Montreal August 26–September 4 1967"; reprinted in Newman, *Selected Writings*, 137.

32. Ileana Sonnabend, interview with the author, March 25, 2005, New York.

33. Annika Marie, *The Most Radical Act: Harold Rosenberg, Barnett Newman and Ad Reinhardt* (Ann Arbor: ProQuest, 2007), 285. See the film *Portrait de Pierre: Pierre Matisse, un vie* by Gero von Boehm, ZDF, 1995.

34. Adolph Gottlieb, "Jackson Pollock: An Artists' Symposium, Part 1," *Art News*, April 1967; quoted in Matthew Spender, *From a High Place: A Life of Arshile Gorky* (New York: Knopf, 1999), 196.

35. Claude Lévi-Strauss, *De près et de loin* (Paris: Odile Jacob, 1988), 54. *Conversations with Claude Lévi-Strauss* (Claude Lévi-

Strauss, Didier Eribon), trans. Paula Wissing (Chicago: University of Chicago Press, 1991).

36. "New York post- et préfiguratif," in *Le Regard éloigné* (Paris: Plon, 1983), 350.

37. Ibid., 345–46, 355; quoted in English from *The View from Afar*, trans. Joachim Neugroschel and Phoebe Hoss (Chicago: University of Chicago Press, 1992), 254.

38. For all these meetings, accounts by Dolorès Vanetti, interview with the author, January 27, 1996, New York, and Claude Lévi-Strauss, interview with the author, September 3, 1989, Paris as well as "New York post- et préfiguratif."

39. For the influence of Europeans on Americans in the forties, see the catalogue by Riva Castelman and Guy Davenport: *Art of the Forties*, Museum of Modern Art, New York, 1991.

40. Leonard Wallock and Dore Ashton, *New York: Cultural Capital of the World 1940–1965* (New York: Rizzoli, 1988), 124.

41. James Thrall Soby, Preface, *Artists in Exile*, catalogue of an exhibition held at the Pierre Matisse Gallery, March 3–29, 1942. For quotations from the catalogue, see http://www.modernism101 .com/featured.php.

42. See Philip Rylands, "Peggy Guggenheim and 'Art of This Century,'" in Siobhan M. Conaty, ed., *Art of This Century: The Women* (New York: Stonybrook Foundation, Guggenheim Museum, 1997), 9–13.

43. See Rylands, "Peggy Guggenheim and 'Art of This Century'"; Rylands, "Peggy Guggenheim"; Guggenheim, *Out of This Century*; Prandin, "Peggy Guggenheim"; Vail, *Peggy Guggenheim*.

44. Alfred H. Barr, Jr., introduction (written in 1956) to Guggenheim, *Confessions of an Art Addict*, 13–14.

45. Robert Motherwell, quoted in Emile De Antonio and Mitch Tuchman, *Painters Painting: A Candid History of the Modern Art Scene, 1940–1970* (New York: Abbeville Press, 1984), 44.

46. Since 1936, along with Josef Albers, Hans Hofmann, Carl Holty, Harry Holtzman, and George K. L. Morris, they had been promoting the idea that "abstract" signifies a direct, untrammeled relationship of the elements of plastic expression. Though, as we

have seen, they included Ilya Bolotowsky and Louis Schanker, two members of The Ten, Rothko was still antagonistic to the simplicity of their project.

47. This exhibition, in which Rothko showed *Syrian Bull*, 1943, and Gottlieb showed *Persephone*, was held from June 2 to 26, 1943, at the Wildenstein Gallery. The "statement catalog" noted, "As a nation, we are being forced to outgrow our narrow political isolationism and forced acceptance of cultural values on a truly global plane."

48. Draft 1 of a letter to editor by Rothko and Adolph Gottlieb, 1943, *Writings on Art*, 30.

49. Draft 5 of a letter to editor by Rothko and Adolph Gottlieb, 1934, *Writings on Art*, 33.

50. Mark Rothko and Adolph Gottlieb, letter of June 7, 1943, to the *New York Times* (published June 13, 1943), *Writings on Art*, 36.

51. Ibid., 36.

52. Transcript of a radio program by Mark Rothko and Adolph Gottlieb broadcast on WNYC, "The Portrait and the Modern Artist," *Art in New York*, dir. H. Stix, October 13, 1943. The complete text is available online at www.neiu.edu/~wbsieger/Art201/201Read/201-Rothko.pdf and is reprinted in Rothko, *Writings on Art*, 37–40.

53. Ibid., 39–40.

54. Breslin, *Rothko: A Biography*, 159.

55. Interview with Jack Kufeld conducted by Avis Berman, October 5, 1981, Smithsonian Archives of American Art, http://www.aaa.si.edu/collections/oralhistories/transcripts/Kufeld81.htm.

56. Barnett Newman, introduction to *American Modern Artists*, Riverside Museum, January 17–February 27, 1943; reprinted in Newman, *Selected Writings*, 29–30.

Chapter 6. Between Surrealism and Abstraction

Epigraph: "Personal Statement, 1945," in Rothko, *Writings on Art*, 45; originally published in David Porter, *Personal Statement, Painting Prophecy, 1950* (Washington, DC: Gallery Press, 1945).

1. Serge Guilbaut, *How New York Stole the Idea of Modern*

Art: Abstract Expressionism, Freedom and the Cold War, trans. Arthur Goldhammer (Chicago: University of Chicago Press, 1983), 65.

2. Barnett Newman, "What about Isolationist Art?" in Thomas Hess, *Barnett Newman,* exhib. cat. Tate Gallery, June 28–August 6, 1972 (London: Tate Gallery Publications, 1972), 21–22.

3. See Breslin, *Rothko: A Biography,* 209.

4. Mark Rothko to Sonia Allen, November 15, 1944, in ibid., 602, n. 33.

5. Jean-Paul Sartre, "La fin de la guerre," *LTM,* October 1945, 64; quoted in English from "The End of the War," in *The Aftermath of War (Situations III),* trans. Chris Turner (London: Seagull Books, 2008), 67–68.

6. Samuel Kootz, Introduction to the catalogue of the exhibition *Byron Browne Show* at the Pinacoteca Gallery, New York, March 15–31, 1943. Quoted in Serge Guilbaut, *How New York Stole,* 70.

7. Deirdre Robson, "The Avant-garde and the On-guard: Some Influence of the Potential Market for the First Generation Abstract Expressionists in the 1940's and 1950's," *Art Journal,* vol. 47, no. 3 (Fall 1988), 218.

8. Grace Glueck, "Art: Rothko as Surrealist in His Pre-abstract Years," *New York Times,* May 1, 1981.

9. Edward Alden Jewell, "Art: Some Moderns," *New York Times,* December 10, 1944, review of the exhibition *40 American Moderns* at Howard Putzel's 67 Gallery.

10. Mark Rothko to Sonia Allen, November 15, 1944, quoted in Breslin, *Rothko: A Biography,* 208.

11. Edward Alden Jewell, "Art: Diverse Shows," *New York Times,* January 14, 1945.

12. Hans Hofmann, Lee Krasner, André Masson, Matta, Jackson Pollock, Richard Poussette-Dart, Arshile Gorky, Adolph Gottlieb, Mark Rothko, Joan Miró, Hans Arp, and Pablo Picasso.

13. Edward Alden Jewell, "Academe Remains Academe," *New York Times,* May 20, 1945.

14. Mark Rothko, "Letter to the Editor," *New York Times,* July 8, 1945; reprinted in Rothko, *Writings on Art,* 46.

15. Ibid.

16. Clement Greenberg, "Review of the Exhibition 'A Problem for Critics,'" *Nation*, June 9, 1945; reprinted in Clement Greenberg, *Collected Essays and Criticism*, vol. 2: *Arrogant Purpose (1945–1949)*, ed. John O'Brian (Chicago: University of Chicago Press, 1986), 28–30.

17. Letter of July 31, 1945, to Barnett Newman; reprinted in Rothko, *Writings on Art*, 47.

18. Edward A. Jewell, "Modern Artists to Open Annual," *New York Times*, September 12, 1945.

19. Barnett Newman, "The Plasmic Image," in *Selected Writings and Interviews*, ed. John P. O'Neill (Berkeley: University of California Press, 1992), 154–155.

20. Ibid.

21. Letter from Mark Rothko to Louis and Annette Kaufman, of May 17, 1946, Louis Kaufman Papers, Smithsonian Archives of American Art.

22. Edward Alden Jewell, "Art: Hither and Yon," *New York Times*, April 28, 1946.

23. Letters to Barnett Newman of June 17 and August 1946; reprinted in Rothko, *Writings on Art*, 49–51.

24. *Possibilities*, Winter 1947–1948, 1, copy in author's archives.

25. Philip Pavia, quoted in *Painters Painting* (New York: Abbeville Press, 1984), 39.

Chapter 7. Toward Absolute Abstraction

Epigraph: Barnett Newman, "The Sublime Is Now," *Tiger's Eye*, 6 (1948). Quoted in *Action/Abstraction: Pollock, de Kooning, and American Art: 1940–1976* (New York: Jewish Museum and Yale University Press, 2008), 18.

1. John P. O'Neill, ed., *Clyfford Still* (New York: Metropolitan Museum of Art, 1979), 21.

2. That came a few years later, when Harold Rosenberg described the Action Painters: "The American Action Painters," *Art News*, 51, no. 8 (December 1952).

3. O'Neill, *Clyfford Still*, 21.

4. Mark Rothko, "Introduction" in *First Exhibition Paintings: Clyfford Still* (New York: Art of This Century Gallery, 1946); reprinted in Rothko, *Writings on Art*, 48.

5. Katharine Kuh, interview with Avis Berman, not dated, 14, Archives of American Art, Smithsonian Institution.

6. Letter from Clyfford Still to Betty Parsons, September 20, 1946, Betty Parsons Papers, Archives of American Art, Smithsonian Institution.

7. Marcia Bystryn, "Art Galleries as Gatekeepers: The Case of Abstract Expressionists," *Social Research: An International Quarterly*, 45, no. 2 (Summer 1978), 397.

8. Howard Devree, "Diverse New Shows," *New York Times*, March 9, 1947.

9. Interview with Ernest Briggs conducted by Barbara Shikler in New York, July 12, 1982, Archives of American Art, Smithsonian Institution, http://www.aaa.si.edu/collections/oralhistories/transcripts/briggs82.htm.

10. Letter from Mark Rothko to Clay Spohn, February 2, 1948, in Rothko, *Writings on Art*, 60.

11. Letter from Mark Rothko to Herbert Ferber, San Francisco, September 1947, ibid., 53.

12. Letter from Mark Rothko to Barnett Newman, San Francisco, July 19, 1947, ibid., 52.

13. Letter from Mark Rothko to H. Ferber, San Francisco, September 1947, ibid., 54.

14. Letter from Mark Rothko to Clay Spohn, New York, September 24, 1947, ibid., 55–56.

15. Ibid., 55.

16. "The Ides of Art," *Tiger's Eye*, December 1947; reprinted in Rothko *Writings on Art*, 57.

17. "The Present Prospects of American Painting and Sculpture," *Horizon*, October 1947, reprinted in Clement Greenberg, *Collected Essays and Criticism*, vol. 2: *Arrogant Purpose (1945–1949)*, ed. John O'Brian (Chicago: University of Chicago Press, 1986), 160–70.

18. Clement Greenberg, "Reviews of Exhibitions of Hedda

Sterne and Adolph Gottlieb," *Nation*, December 6, 1947; reprinted in Greenberg, *Collected Essays*, vol. 2, 160–70.

19. Clement Greenberg, "The Situation at the Moment," *Partisan Review*, January 1948; reprinted in Greenberg, *Collected Essays* vol. 2, 192–93.

20. Quoted in Florence Rubenfeld, *Clement Greenberg: A Life* (New York: Scribner, 1997), 107.

21. Philip Pavia, interview, 1965, Oral History Collection, Archives of American Art, Smithsonian Institution.

22. Letter from Mark Rothko to Clay Spohn, February 2, 1948, in Rothko, *Writings on Art*, 60.

23. Ibid., 62.

24. Press releases, April 1 and 5, 1949, Museum of Modern Art archives, http://www.moma.org/docs/press_archives/1310/releases /MOMA_1949_0024_1949-04-01_490401–22.pdf?2010, http:// www.moma.org/docs/press_archives/1311/releases/MOMA_1949_ 0025_1949-04-05_490405–23.pdf?2010.

25. Ibid.

26. Before closing her gallery in May 1947, Peggy Guggenheim had symbolically devoted her last exhibition to van Doesburg, and on May 31, 1947, in the *Nation*, Clement Greenberg, always quick to assess the reciprocal positions of artists, had remarked that "already in 1917" if van Doesburg had shown "crispness and originality" and in comparison with his compatriot Mondrian, "greater openness," at this time he "still belonged to the open, all-embracing, almost irresponsible hopefulness of the first quarter of our century." Clement Greenberg, "Review of Exhibitions of Theo Van Doesburg and Robert Motherwell," *Nation*, May 31, 1947, reprinted in Greenberg, *Collected Essays*, vol. 2, 150–52.

27. By 1927, Alfred Barr had discovered the power of the Dutch avant-garde during his European travels as a student. "Nowhere more than in Holland," he wrote at the time, "are the old and the new so abruptly, so piquantly contrasted. . . . In the same street opposite Gothic and Baroque facades are shop-fronts of the most aggressive and complete modernity." Alfred H. Barr, Jr., "Dutch Letter," *The Arts*, January 1928. Barr was then in a good position

to present the exceptional advances of De Stijl and celebrate "van Doesburg, this poet, theoretician, architect, publisher and painter . . . for organizing in Leyden in 1917, together with Mondrian the painter, J. J. P. Oud the architect and Vantongerloo the sculptor, the most important design laboratory in the world, during five years." Trained in Paul Sachs's Museum Course at Harvard in the 1920s to become a "guide for the American people," in a country still trailing Europe's advances, Barr undertook an extreme Modernist policy at the time of the two world wars, the rise of Fascism, and the geographical displacements and demographic changes that radically altered the geopolitics of the art world.

28. Leo Castelli, interview with the author, November 5, 1995, New York.

29. Press release, April 5, 1949, Museum of Modern Art archives, http://www.moma.org/momaorg/shared/pdfs/docs/press _archives/1323/releases/MOMA_1949_0037_1949-05-03_490503 -35.pdf?2010.

30. "Diverse New Shows," *New York Times*, April 3, 1949.

31. "Notes from an Interview by William Seitz," in Rothko, *Writings on Art*, 77.

32. Clement Greenberg, "The New York Market for American Art," *Nation*, June 11, 1949; reprinted in Greenberg, *Collected Essays*, vol. 2, 322.

33. Dorothy Seiberling, "Jackson Pollock: Is He the Greatest Living Painter in the United States?" *Life*, August 8, 1949. The article included photographs of Pollock at work by Martha Holmes and Arnold Newman.

34. Rubenfeld, *Clement Greenberg*, 110.

35. About the social status of the artist in American society and its long fight to be recognized see Neil Harris, *The Artist in America*, and Annie Cohen-Solal, *Painting American, The Rise of American Artists (Paris 1867–New York 1948)* (New York: Alfred A. Knopf, 2001).

36. Ortega y Gasset, *Partisan Review*, August 1949.

37. *The Intersubjectives*, exhib. cat., September 14–October 3, 1949, Kootz Gallery Records, Archives of American Art, Smithsonian Institution.

38. Steven Naifeh and Gregory White Smith, *Jackson Pollock: An American Saga* (New York: Clarkson N. Potter, 1989), 597–98.

39. Greenberg, "The New York Market for American Art," 320.

40. Interview with Robert Motherwell, November 24, 1971, Archives of American Art, Smithsonian Institution http://www.aaa.si.edu/collections/interviews/oral-history-interview-robert-motherwell-13286.

41. Irving Sandler, *Sweeper-up after Artists* (London: Thames and Hudson, 2003), 26.

42. Robert Goodnough, "Two Postcripts," *Artforum*, September 1965, 32.

43. Philip Pavia, *Club without Walls: Selections from the Journals of Philip Pavia*, ed. Natalie Edgar (New York: Midmarch Arts Press, 2007), 46.

44. Establishment artists, in reference to an expression used by Harold Rosenberg.

45. Pavia, *Club without Walls*, 24.

Chapter 8. With the Rebel Painters, a Pioneer

Epigraph: Stuart Preston, "Chiefly Abstract," *New York Times*, April 8, 1951.

1. *Congressional Record*, 81st Congress, 1st session, p. 11,584 (August 16, 1949), quoted in Richard Hofstadter, *Anti-Intellectualism in American Life* (New York: Alfred A. Knopf, Vintage Books, 1963), 14–15.

2. Letter from Mark Rothko to Barnett Newman, July 27, 1949, in Rothko, *Writings on Art*, 63.

3. Clement Greenberg, *The Collected Essays and Criticism*, vol. 1: *Perceptions and Judgments* (Chicago: University of Chicago Press, 1986), 133.

4. Ibid., 171.

5. Clement Greenberg, "Decline of Cubism," *Partisan Review*, no. 3 (1948), 369.

6. Thomas B. Hess, "Seeing the Young New Yorkers," *Art News*, May 1950, 23.

7. *Claude Berri rencontre Leo Castelli,* conceived and realized by Ann Hindry (Paris: Renn Productions, 1990), 25.

8. Sidney Janis, 1981, Archives of American Arts, Smithsonian Institution. See Annie Cohen-Solal, *Leo and His Circle: The Life of Leo Castelli* (New York: Alfred A. Knopf, 2010), 161.

9. "Le rôle des galeries," Leo Castelli, Daniel Cordier, and Ileana Sonnabend, comments compiled by Alfred Pacquement, August 1976, in *Paris-New York, 1908–1968* (Paris: Gallimard and Centre Georges Pompidou, Paris, 1991), 271–77.

10. Castelli, quoted in Emile De Antonio and Mitch Tuchman, *Painters Painting: A Candid History of the Modern Art Scene, 1940–1970* (New York: Abbeville Press, 1984), 90.

11. Michel Seuphor, "Paris-New York," *Art d'aujourd'hui,* March 17, 1951.

12. Speech given at Yale University, January 1946, of which there is a copy in the author's archives.

13. Howard Devree, "In New Directions," *New York Times,* January 8, 1950.

14. Rothko, *Writings on Art,* 68.

15. Letter from Mark Rothko to Barnett Newman, April 6, 1950, in Rothko, *Writings on Art,* 66.

16. Leo Castelli, interview with the author, November 1985.

17. Ibid.

18. Stanley Kunitz, oral history interview with Avis Berman, December 8, 1983, Archives of American Art, Smithsonian Institution, http://www.aaa.si.edu/collections/interviews/oral-history -interview-stanley-kunitz-12071.

19. Letter from Mark Rothko to Herbert Ferber, September 2, 1952, in Rothko, *Writings on Art,* 82.

20. Letter to Barnett Newman, August 7, 1950, in Rothko, *Writings on Art,* 70.

21. Clement Greenberg, "The Present Prospects of American Painting and Sculpture," *Horizon,* October 1947, 29.

22. Quoted in Naifeh and Gregory Smith, *Jackson Pollock,* 658.

23. Ibid.

24. Ibid., 637.

25. Conrad Marca-Relli, interview with Dorothy Sekler, New York, June 10, 1965, Archives of American Art, Smithsonian Institution.

26. See Bruce Altshuler, "Downtown, Ninth Street Show, New York, May 21-June 10, 1951," in *The Avant-Garde in Exhibition: New Art in the 20th Century* (New York: Harry N. Abrams, 1994), 156–73; Irving Sandler, *The Triumph of American Painting: A History of Abstract Expressionism* (New York: Harper and Row, 1976); Irving Sandler, "The Club, How the Artists of the New York School Found Their First Audience—Themselves," *Artforum* 4 (September 1965), 27–31; and Fred W. McDarrah, *The Artist's World in Pictures* (New York: Dutton, 1961).

27. Ludwig Sander, interview with Paul Cummings, February 14, 1969, Archives of American Art, Smithsonian Institution.

28. *Claude Berri rencontre Leo Castelli*, 27. See also Cohen-Solal, *Leo and His Circle*, op. cit., 178.

29. On this subject, see also Sandler, *Sweeper-Up*, 22.

30. Ernest Briggs, oral history interview with Barbara Shikler, July 12–October 21, 1982, Archives of American Art, Smithsonian Institution.

31. Stuart Preston, "Chiefly Abstract," *New York Times*, April 8, 1951.

32. Undated letter, Betty Parsons Gallery records and personal papers, Archives of American Art, Smithsonian Institution.

33. Sandler, *Triumph of American Painting*, 175.

34. Dorothy C. Miller, oral history interview with Avis Berman, May 14, 1981, Archives of American Art, Smithsonian Institution.

35. Mark Rothko, "How to Combine Architecture, Painting, and Sculpture," *Interiors*, May 10, 1951; reprinted in Rothko, *Writings on Art*, 74.

36. Howard Devree, "Diverse Americans: Fifteen in Museum of Modern Art Show—New Work by Nordfeldt and Laurent," *New York Times*, April 13, 1952.

37. Ibid.

38. Letter from Dorothy Miller to Alfred Barr, April 26, 1952, Dorothy C. Miller Papers, Museum of Modern Art Archives.

39. Ibid.

40. Letter from Mark Rothko to Herbert Ferber, August 19, 1952, in Rothko, *Writings on Art*, 80.

41. Rothko, *Writings on Art*, 83–84.

Chapter 9. The Avant-Garde Jewish Painter and His Journey of Dispersion

Epigraph: Irving Howe, *World of Our Fathers*, 583.

1. In *World of Our Fathers*, Irving Howe considers the career of East European Jewish painters and sculptors who had to emigrate to the United States. More specifically, he tries to analyze their inclusion into artistic styles, which follows a slow and gradual process. "Precisely this was absent and, indeed, impossible in the immigrant milieu," he admits. Therefore, he comes to the conclusion that "to become a painter was in a crucial sense to cut oneself from the Jewish community, certainly to a greater extent than was true for the Jewish writers, who if they did not continue in a direct line from Yiddish literature were nonetheless influenced by it in ways they could not always know." In this respect, Howe's concept of a "voyage of dispersion" should be understood in its social acceptation. See *World of Our Fathers*, 583.

2. The "dynamic agents" are those who, around the artist, set up the conditions of production, give him visibility, and are responsible for his professional insertion: critics, gallery owners, teachers, collectors, curators, and museum directors, while the "manifest agent" is the artist himself.

3. Letter from Mark Rothko to Katharine Kuh, July 28, 1954, in Rothko, *Writings on Art*, 93.

4. Ibid., 94.

5. Letter from Mark Rothko to Katharine Kuh, May 1, 1954, in Rothko, *Writings on Art*, 89.

6. Letter from Mark Rothko to Katharine Kuh, ca. 1954, in Rothko, *Writings on Art*, 98. The date of the letter must be September 20 (A.C.-S.).

7. Ibid., 108.

8. Christopher Rothko, correspondence with the author, May 3, 2013.

9. Katharine Kuh, *My Love Affair with Modern Art* (New York: Arcade Publishing, 2006), 145–46.

10. Letter from Mark Rothko to Katharine Kuh, July 14, 1954, in Rothko, *Writings on Art*, 90.

11. Ibid.

12. Letter from Mark Rothko to Katharine Kuh, September 25, 1954, in Rothko, *Writings on Art*, 99.

13. Ibid.

14. Letter from Mark Rothko to Petronel Lukens, September 12, 1954, in Rothko, *Writings on Art*, 96–97.

15. Letter from Mark Rothko to Katharine Kuh, September 25, 1954, ibid.

16. Katharine Kuh, "Mark Rothko," *Art Institute of Chicago Quarterly*, 48, no. 4 (November 15, 1954).

17. Ibid.

18. Hubert Crehan, "Rothko's Wall of Light: A Show of His New Work at Chicago," *Art Digest*, November 1, 1954.

19. Letter from Mark Rothko to Katharine Kuh, January 11, 1955, in Rothko, *Writings on Art*.

20. Mark Rothko, interview with Ethel Schwabacher, February 20, 1955, Ethel Schwabacher Papers, Archives of American Art, Smithsonian Institution.

21. Letter from Mark Rothko to Katharine Kuh, September 27, 1954, in Rothko, *Writings on Art*, 101.

22. "Willem de Kooning Remembers Mark Rothko, 'His House Had Many Mansions,'" interview with Joseph Liss, *Art News*, January 1979.

23. John Brooks, "Why Fight It? Profiles: Sidney Janis," *New Yorker*, November 12, 1960.

24. Ibid.

25. Deirdre Robson, "The Avant-garde and the On-guard: Some Influences on the Potential Market for the First Generation Abstract Expressionists in the 1940s and Early 1950s," *Art Journal*, 47, no. 3, 218.

26. Brooks, "Why Fight It?"

27. Thomas B. Hess, *Art News*, 1955.

28. Emily Genauer, "Bad Press for U.S. Art Show in Paris Examined," *New York Herald Tribune*, April 17, 1955.

29. Howard Devree, "Aims and Results: Extreme Abstraction in Color Reaches Dead End," *New York Times*, April 17, 1955.

30. Stuart Preston, "Vanguard Advances: New Directions Taken in Recent Shows," *New York Times*, February 2, 1958.

31. "Notes from a Conversation with Selden Rodman, 1956," in Rothko, *Writings on Art*, 119–120.

32. Dore Ashton, "Art. Lecture by Rothko: Painter Disassociates Himself from the 'Abstract Expressionist' Movement," *New York Times*, October 31, 1958.

33. The amount is all the more mind-boggling in that MoMA had balked at paying $8,000 for the painting during Pollock's lifetime.

34. Deirdre Robson, "The Market for Abstract Expressionism: Time Lag between Critical and Commercial Acceptance," *Archives of American Art Journal*, 25, no. 3 (1985), 21–22.

35. Sidney Janis interviewed by Avis Berman, October 15–November 18, 1981, Archives of American Art, Smithsonian Institution.

36. Kuh, *My Love Affair with Modern Art*, 145.

37. Ludwig Glaeser, *Herrenjournal*, quoted in a press release of January 16, 1959, Museum of Modern Art.

38. Patrick Heron, "The Americans at the Tate Gallery," *Arts Magazine*, 30, no. 6 (March 1956), 16.

39. Alan Bowness, "Shorter Notices—The 1958 Biennale," *Burlington Magazine*, 100, no. 669 (December 1958), 436.

40. Gillo Dorfles, "Marks and Gestures at the XXIX Biennale," *Aut-Aut*, no. 47 (September 1958), 284–89; quoted in *Mark Rothko*, exhib. cat. (Rome: Palazzo delle Esposizioni, October 6, 2007–January 6, 2008), 203.

41. Letter from Clyfford Still to Sidney Janis, April 4, 1955, Alfonso Ossorio Papers, Archives of American Art: "For several years now I have been unable to avoid the morbid implications of

Rothko's works, and the shrewd ambivalence of his verbalisms and acts. His need for sycophants and flattery, and his resentment of everyone, or every truth, that might stand in his path to bourgeois success, could no longer be ignored. In fact he was compelled to remind me of it one day when he grinned and announced that he 'never had any illusions that we ever had anything in common.' Be assured that it gave no pleasure, that afternoon three years ago, to be told that what I had considered to be gestures of concurrences were merely intended to conceal the claw of exploitation. Rothko requires that his paintings be read as an exercise in Authoritarian imagery. When they are hung in tight phalanx, as he would have them hung, and flooded with the light he demands that they receive, the tyranny of his ambition to suffocate or crush all who stand in his way becomes fully manifest. This is the way he would have his work seen, and act, in the Modern Museum show of the '15.' This, he has stated, is his highest ambition. . . . Not I, but himself has made it clear that his work is of frustration, resentment and aggression. And that it is the brightness of death that veils their bloodless febrility and clinical evaluations."

42. Letter from Barnett Newman to Sidney Janis, April 9, 1955, in Barnett Newman, *Selected Writings and Interviews*, 200–202: "I am frankly bored with the uninspired, or to put it more accurately, I am bored with the too easily inspired. It was Rothko who said to me that it does not matter that an artist 'looks' at other painters. It is not what he 'sees' but what he 'does' with what he 'sees' that counts. . . . It was Rothko who in 1950 said to me that he could not look at his work because it reminded him of death. Why should I look at his death image? I am involved in life, in the joy of the spirit. When Rothko returned from Europe, it is obvious that he 'saw' enough of this sense of life in my work to 'see' how he could subjugate it, just as previously he had 'looked' at the work of other artists for the same reasons. I must unequivocally separate myself from Rothko because he has publicly identified himself with me so that the expression of my own personal integrity becomes for him a shield whereby he can achieve perpetual

surrender. He may do what he wishes, but I do not want his surrender to reflect on my intention not to."

43. Irving Sandler, *A Sweeper-up After Artists* (London: Thames and Hudson, 2004), 98.

44. "Reviews and Previews," *Art News*, March 1958, 12.

Chapter 10. From a Luxury Skyscraper to a Medieval Chapel

Epigraph: Bryan Robertson, "Mark Rothko," *Spectator*, March 6, 1970.

1. The wine and spirits company founded in Waterloo, Ontario, in 1857, became the world's largest distiller of alcoholic beverages. The original company was purchased by Joseph E. Seagram (already a partner) in 1883. In 1924, Samuel Bronfman founded Distillers Corporation Limited in Montreal, which prospered during the 1920s when Prohibition was in effect in the United States. Bronfman bought Seagram's in 1928.

2. *New York Times*, July 13, 1954.

3. Harvey Wiley Corbett, *America as Americans See It* (New York: Harcourt, Brace and Company, 1932), 94.

4. Phyllis Lambert, *Building Seagram* (New Haven: Yale University Press, 2013), 220.

5. Calvin Tomkins, "Profiles: Forms under Light," *The New Yorker*, May 23, 1977, 43–80.

6. Herbert Muschamp, "Best Building: Opposites Attract," *New York Times*, April 18, 1999.

7. B. H. Friedman, "The Most Expensive Restaurant Ever Built," *Evergreen Review*, no. 10 (1959).

8. "$4.5 Million Restaurant to Open Here," *New York Times*, July 16, 1959.

9. Dore Ashton, *About Rothko* (Oxford: Oxford University Press, 1983), 153.

10. Ibid., 158.

11. John Fischer, "The Easy Chair: Mark Rothko, Portrait of the Artist as an Angry Man," *Harper's*, July 1970; reprinted in Rothko, *Writings on Art*, 131.

12. Ibid.

13. Ibid., 131.

14. Ibid., 132.

15. Kate Rothko, *About My Father Mark*, video by Maria Teresa de Vito, uploaded December 9, 2008, at the time the Rothko exhibition at the Palazzo delle Esposizioni in Rome (October 6, 2007–January 8, 2008); https://www.youtube.com/watch?v=EV8kgi6T_Es.

16. Ashton, *About Rothko*, 146.

17. Letter from Mark Rothko to Elise Asher and Stanley Kunitz, July 1959, in Rothko, *Writings on Art*, 141.

18. Patrick Heron interviewed by Mel Gooding in Eagles Nest, 1996, Interviews for *Rothko in Britain*, Whitechapel Gallery Archive.

19. Heron is referring to Rothko's "Multiform" period in the late 1940s.

20. Patrick Heron interviewed by Mel Gooding in Eagles Nest, 1996, Interviews for *Rothko in Britain*, Whitechapel Gallery Archive.

21. Cornwall's entire history could be read in its monuments: from the New Stone Age, the gigantic dolmens of Chun Quoit, the mysterious quartz circles composed of carved menhirs of Boscawen-un, all facing east, and the enigmatic holed stone of Men-an-Tol, which bore curative powers (naked children were passed through the aperture to cure them of rickets and rheumatism); from the Stone Age, the ruins of the town of Carn Euny, with its functional tunnels dug into the rock; and from the Early Middle Ages, the spectacular Tintagel Castle, where King Arthur was said to have been born (the Gaulish monk Nennius referred to him as dux bellorum, a warlord rather than a king). There was also the Lizard Peninsula, with its magnificent promenades through wild heather, its bird sanctuaries, and the lighthouse that inspired Virginia Woolf's 1927 novel *To the Lighthouse*.

This was the country the British artist Bernard Leach had found in 1920 when he and the Japanese craftsman Shoji Hamada decided to build a climbing (noborigama) kiln (in Japanese an

anagama kiln) at Higher Stennack. This type of ancient ceramic oven, imported from Korea to Japan by way of China in the fifth century, used wood rather than gas or electricity and, in addition to ensuring round-the-clock production, emitted fly ash, which mixed with the minerals of the clay during the firing to create a unique natural glaze on the ceramic surface. Over the years, Leach and Hamada's workshop gradually became one of the most famous ceramic studios in the world, transforming this remote corner of the island into a hub of intercultural experimentation between East and West. Leach and Hamada had based their principles on their conviction that by following the ancient principles of the East in their ceramic work, they could initiate a new lifestyle integrating design, art, and craftsmanship—thus bridging the gap between Western and Eastern philosophy. Born in Hong Kong in 1887, the son of a British diplomat, Leach had spent the early part of his life in Japan, before studying in London and Tokyo, acquiring the rare education to which only bicultural individuals have access. Thanks to Leach and Hamada, St. Ives grew into one of those sophisticated cultural niches—like Alfred Stieglitz's Gallery 291, not long before, in the heart of Manhattan—from which emanated a magical energy.

22. Such communities greatly improved the working conditions of the U.S. artists, who supported each other and who were supported by the entire village; in turn, they started importing this model to their own country—on the East Coast at Cos Cob, Old Lyme, Shinnecock Hill, Woodstock, and Annisquam, and even in New Mexico at Santa Fe and Taos. They were the most enthusiastically received by the Native Americans of the Southwest. "I think of Sante Fe as a hope," Robert Henri confessed in 1916. "There is a place in America—and this place is Santa Fe—, where an artist can feel he is in a place which invites. The painters are all happy. . . . And here painters are treated with that welcome and respect that is supposed to exist only in certain places in Europe" (Robert Henri to Dr. Edgar L. Hewett, Kansas, November 9, 1917, Archives of American Art, Robert Henri dossier; see Annie Cohen-

Solal, *Painting American* [New York: Alfred A. Knopf, 2001], 241). But one might suspect that the St. Ives community also referred itself to the model of the local Pre-Raphaelite painters, like Dante Gabriel Rossetti, Edward Burne-Jones, William Morris, and their friends, who rooted their tradition in medieval and Renaissance Italy.

23. Sheila Lanyon, Interviews for *Rothko in Britain*, July 15, 2011, Whitechapel Gallery Archive.

24. Bryan Robertson, "Mark Rothko," *Spectator*, March 6, 1970.

25. Paul Feiler, Interviews for *Rothko in Britain*, July 15, 2011, Whitechapel Gallery Archive.

26. John Hoyland, Interviews for *Rothko in Britain*, July 22, 2011, Whitechapel Gallery Archive.

27. Ibid.

28. Patrick Heron interview.

29. *The Seagram Mural Project*, Tate Gallery Liverpool, 1959, 14.

30. Accounts vary as to the exact date when the artist halted the project: September 1959 according to some, spring 1960 according to others. In view of the information provided above, I would tend toward the earlier date.

31. Kuh, *My Love Affair with Modern Art*, 155.

32. Mark Lamster, "A Personal Stamp on the Skyline," *New York Times*, April 3, 2013.

33. Tomkins, "Forms under Light."

34. Interview with Dan Rice in *Mark Rothko: The 1958–9 Murals*, exhib. cat. (New York: Pace Gallery, October 28–November 25, 1978).

35. Ashton, *About Rothko*, 156.

Chapter 11. Years of Experimentation,
Recognition, and Torment

Epigraph: Kuh, *My Love Affair with Modern Art*, 160.

1. *The Eye of Duncan Phillips, from Renoir to Rothko*, exhibition catalogue (New Haven: Yale University Press, 1999), 109.

2. "Mark Rothko (1903–1970) The Rothko Unit," http://www
.phillipscollection.org/research/american_art/miscellaneous/rothko
-unit.htm.

3. Ibid.

4. Ibid.

5. Kuh, *My Love Affair with Modern Art*, 159.

6. Press release, January 18, 1961, Museum of Modern Art.

7. Alan Solomon was the curator of the American Pavilion
at the Venice Biennale in 1964, when Robert Rauschenberg, sup-
ported by Leo Castelli and Ileana Sonnabend, won the Golden
Lion, a first for his country. See Cohen-Solal, *Leo and His Circle*,
chapter 22, 286–304. Solomon arrived in New York from Cornell
University, where he had chaired the department of art history.

8. At the suggestion of Professor Ulrich Middeldorf, an anti-
Nazi German who emigrated to the United States, he worked on
the sociopolitical context of German Expressionism. This type of
approach was quite rare at the time in American universities.

9. Elizabeth Station, "Life Embraces Art: A New Biography
Chronicles the Remarkable Career of Peter Selz and His Contri-
butions to Modern Art History," *Tableau*, Fall 2012 (October 18,
2012).

10. Stanley Kunitz, oral history interview, December 8, 1983,
Archives of American Art, Smithsonian Institution.

11. Interview with Rice, *Mark Rothko, the 1958–9 Murals*,
209.

12. John Fischer, "Portrait of the Artist"; in Rothko, *Writings
on Art*, 133.

13. Emily Genauer, *Herald Tribune*, January 21, 1961.

14. John Canaday, "Is Less More, and When for Whom?"
New York Times, January 22, 1961.

15. Max Kozloff, "Mark Rothko's New Retrospective," *Art
Journal*, 20, no. 3 (Spring 1961), 148–49.

16. Robert Goldwater, "Reflections on the Rothko Exhibi-
tion," *Arts*, March 1961.

17. Fischer, "Portrait of the Artist"; in Rothko, *Writings on
Art*, 133.

18. Irving Sandler, *Mark Rothko: Paintings, 1948–1969* (New York: Pace Gallery, 1983), 37.

19. If we consider that after so many fruitless attempts, the Scull sale at Sotheby's Parke Bernet in 1973 launched a market in which the prices were to skyrocket, a development that would benefit the work of Mark Rothko nearly thirty years later.

20. Kuh, *My Love Affair with Modern Art*, 146.

21. "Bryan Robertson, the Leading Impresario of the Renaissance of British Art," obituary, *The Times* (London), November 19, 2002.

22. Deciding early on that New York had dethroned Paris, Robertson decisively contributed to creating contacts between British and American artists, quite unlike what was happening in France.

23. Bryan Robertson, Introduction, in *45–99: A Personal View of British Painting and Sculpture* (Cambridge: Kettle's Yard, 1999), 47.

24. Letter from Mark Rothko to the Whitechapel Gallery, 1961, in Rothko, *Writings on Art*, 145–46.

25. *Evening Standard* (London), October 11, 1961.

26. Eric Newton, *Manchester Guardian*, October 14, 1961.

27. Alan Bowness, *The Observer* (London), October 15, 1961.

28. Bryan Robertson, "Mark Rothko," *The Spectator*, March 6, 1970.

29. Letter from Mark Rothko to Bryan Robertson, September 12, 1961, Whitechapel Gallery Archives, WAG/EXH/2/79/1.

30. John Hoyland, Interviews for *Rothko in Britain*, Whitechapel Gallery Archive.

31. Karyn Esielonis, "The History of Rothko's Harvard Murals," in Marjorie B. Cohn, ed., *Mark Rothko's Harvard Murals* (Cambridge, Mass.: Center for Conservation and Technical Studies, Harvard University Art Museums, 1988), 7.

32. Lee Seldes, *The Legacy of Mark Rothko* (Toronto: Holt, Rinehart & Winston of Canada, 1974). 49.

33. Quoted in Laura De Coppet and Alan Jones, *The Art Dealers* (New York: Cooper Square Press, 2002), 40.

34. Grace Glueck, "The Man the Art World Loves to Hate," *New York Times*, June 15, 1975.

35. Norman Reid, memorandum of discussion with Rothko, January 8, 1969, in *The Seagram Mural Project* (Liverpool: Tate Gallery, 1959), 15.

36. Ibid.

Chapter 12. The Long-Awaited Chapel

Epigraph 1: Peter Selz, "Introduction," in *Rothko*, exhibition catalogue (New York: Museum of Modern Art, 1961).

Epigraph 2: Mark Rothko to John and Dominique de Menil, January 1, 1966, http://www.rothkochapel.org.

Epigraph 3: Dominique de Menil, speech at the dedication of the Rothko Chapel, Houston, Texas, February 27, 1971, http://www.rothkochapel.org.

1. In the United States, they Americanized their family name to de Menil, and Jean translated his first name to John.

2. Susan J. Barnes, *The Rothko Chapel, An Act of Faith*, A Rothko Chapel Book (Austin: University of Texas Press, 1989), 31–35. See also Sheldon Nodelman, *The Rothko Chapel: Paintings, Origins, Structure, Meaning*, The Menil Collection (Austin: University of Texas Press, 1997).

3. http://www.rothkochapel.org.

4. For Dominique de Menil's biography, see Calvin Tomkins's excellent profile, "The Benefactor," *New Yorker*, June 8, 1998, 52–67. On the family's political commitment, see Josef Helfenstein and Laureen Schipsi, eds., *Art and Activism: Project of John and Dominique de Menil*, The Menil Collection (New Haven: Yale University Press, 2010.)

5. Jermayne (Jerry) MacAgy was an outstanding Houston curator. Her husband, Douglas, had been Rothko's colleague in San Francisco.

6. Dominique de Menil, introduction to *Builders and Humanists: The Renaissance Popes as Patrons of the Arts*, exhibition catalogue (Houston: University of St. Thomas, Art Department, March–May 1966).

7. *La Rime et la raison, les collections Ménil (Houston, New York)*,

exhib. cat. (Paris: Ministère de la Culture—Réunion des Musées nationaux, 1984).

8. Dominique de Menil, "The Rothko Chapel," in *The Rothko Chapel: Writings on Art and the Threshold of the Divine* (New Haven: Yale University Press, 2010).

9. Ibid., 4.

10. Interview with Robert Motherwell by Dominique de Menil and Susan Barnes, May 10, 1980, Menil Archives, The Menil Collection, Houston, Texas.

11. Ibid.

12. Dominique de Menil, "The Rothko Chapel," 1971, 251.

13. Dominique de Menil.

14. "The Rothko Chapel," Menil Archives, The Menil Collection, Houston, Texas. Unsigned undated manuscript that appears to have been written by Dominique de Menil before the dedication of the chapel, perhaps as a draft of her article "The Rothko Chapel," *Art Journal (College Art Association)*, vol. 30, no. 3 (Spring 1971).

15. Letter from Christophe de Menil to John de Menil, Menil Archives, The Menil Collection, Houston, Texas.

16. The present Tate website devoted to Rothko is organized as follows: Room 1: The Seagram Murals between New York and London; Room 2: *Four Darks in Red*, 1958; Room 3: The Seagram Murals; Room 4: Material History; Room 5: Towards the Houston Chapel; Room 6: Black-Form Paintings; Room 7: Seagram Studies; Room 8: Brown and Gray works on paper; Room 9: Black on Gray. http://www.tate.org.uk/whats-on/exhibition/rothko/room.

17. http://www.tate.org.uk/whats-on/exhibition/rothko/room-guide/room-2-four-darks-red-1958.

18. Motherwell interview, 1980.

19. Ibid.

20. Ibid.

21. Carol Mancusi-Ungaro, "Embracing the Humility in the Shadow of the Artist," in Mark Leonard, ed., *Personal Viewpoints:*

Thoughts about Painting Conservation (Los Angeles: Getty Conservation Institute, 2001), 85–86, 89.

22. Roy Edwards, "Mark Rothko, A Personal Reflection," manuscript, 1977, Menil Archives, The Menil Collection, Houston, Texas.

23. Ibid.

24. Quoted in Alfred A. Breslin, op. cit., page 511.

25. See, among numerous other works, Seldes, *The Legacy of Mark Rothko*.

26. Roman Vishniac, *Polish Jews: A Pictorial Record* (New York: Schocken Books, 1987).

27. Motherwell interview, 1980.

Epilogue

1. The Einsatzgruppen (Task forces) can be defined as those paramilitary death squads which were responsible for the most brutal mass killings of civilians under Hitler's regime. As Einsatzgruppe A advanced in the Baltic states, it actively recruited local nationalists and antisemitic groups. In July 1941, a pogrom in Riga killed 400 Jews. Then, Einsatzgruppe A commander Stahlecker appointed Latvian nationalist Viktors Arājs to head the Arājs Kommando, a Sonderkommando of about 300 men, mostly university students. Together, Einsatzgruppe A and the Arājs Kommando killed 2,300 Jews in Riga on 6–7 July. Within six months, Arājs and his men would kill about half of Latvia's Jewish population. Of the roughly 83,000 Jews who fell into German hands in Latvia, no more than 900 survived; and of the more than 20,000 Western Jews sent into Latvia, only some 800 lived through the deportation until liberation. This was the highest percentage of eradication in all of Europe. See Erich Haberer: "Intention and Feasibility: Reflections on Collaboration and the Final Solution," *East European Jewish Affairs*, 31 (2001).

2. By all accounts, the Rumbula Massacre remains one of the worst Holocaust atrocities until the death camps: within a single week, between November 30 and December 8, 1941, about 25,000

Jews were forced out of Riga, marched to the forest and had to dig their own common grave, before they were executed en masse.

3. In Hebrew, *mitzvah* means a good (charitable) act that must be carried out by every member of the Jewish community.

4. Or the equivalent amount in artworks.

5. The damages were assigned a dollar value, and the Marlborough Gallery eventually decided to return the paintings rather than pay. The restitution of these works, which made possible the creation of the Rothko Family Collections and the enlargement of the collections of the Mark Rothko Foundation at the National Gallery, was essential. It is also thanks to this restitution that all the major Rothko exhibitions in the world in the past thirty-five years could be mounted, as well as the loan of works to the new Rothko Center in Daugavpils. See also Seldes, *The Legacy of Mark Rothko*.

6. *De Stilte Van Rothko*, produced by Lies Janssen and directed by Marjoleine Boonstra, was commissioned by the Dutch public broadcaster AVROTROS.

BIBLIOGRAPHY

Books

Abécassis, Armand, *La Pensée juive*, t. I: *Du désert au désir*, Le Livre de poche, Paris, 1987; t. II: *De l'état politique à l'éclat prophétique*, Librairie générale française, Paris, 1987.

Agamben, Giorgio, *Idée de la prose*, trans. G. Macé, Christian Bourgois, Paris, 1988. (Orig. pub.: *Idea della prosa*, Cuaderni Quodlibet, Macerata, 2002.)

Allen, Donald (ed.), *The Collected Poems of Frank O'Hara*, University of California Press, Berkeley, 1995.

Altshuler, Bruce, "Downtown, Ninth Street Show, New York, May 21–June 10, 1951," in *The Avant-Garde in Exhibition, New Art in the 20th Century*, Harry N. Abrams, New York, 1994.

Anfam, David, *Mark Rothko: The Works on Canvas, Catalogue Raisonné*, Yale University Press, New Haven (CT), 1998.

Antonio, Emile de, and Tuchman, Mitch, *Painters Painting, A Candid History of the Modern Art Scene 1940–1970*, Abbeville Press, New York, 1984.

Appadurai, Arjun, and Beckenridge, Carol A., "Museums Are Good to Think: Heritage on View in India," in Ivan Karp, Christine Mullen Kreamer, and Steven D. Lavine (eds.), *Museums and Communities: The Politics of Public Culture*, Smithsonian Institution Press, Washington, DC, 1991.

Arasse, Daniel, "La solitude de Mark Rothko," in *Anachroniques*, Gallimard, Paris, 2006.

Ashton, Dore, *About Rothko*, Oxford University Press, Oxford, 1983.

———, *The School of New York: A Cultural Reckoning*, Penguin, New York, 1972.

Auswaks, Daniel, "Le beau et le vrai," in *Tradition et modernité dans la pensée juive*, Festival international de la culture juive, Paris, 1983.

Baal-Teshuva, Jacob, *Pictures as Drama*, Taschen Books, Cologne, 2003.

Baigell, Matthew, *Artist and Identity in Twentieth Century America*, Cambridge University Press, Cambridge, 2001.

———, *Jewish Artists in New York: The Holocaust Years*, Rutgers University Press, New Brunswick (NJ), 2002.

Barnes, Susan J., *The Rothko Chapel: An Act of Faith*, A Rothko Chapel Book, University of Texas Press, Austin (TX), 1989.

Benjamin, Walter, *Sur le concept de l'histoire*, IX, 1940, *Œuvres choisies*, trans. M. de Gandillac, R. Rochlitz, and P. Rusch, "Folio/Essais," Gallimard, Paris, 2000.

Breslin, James E. B., *Mark Rothko: A Biography*, University of Chicago Press, Chicago, 1993.

Castelli, Leo, Cordier, Daniel, and Sonnabend, Ileana, "Le rôle des galeries," interview with Alfred Pacquement, August 1976, in *Paris–New York, 1908–1968*, éditions Gallimard and Centre Georges-Pompidou, Paris, 1991.

Chave, Anna C., *Mark Rothko, Subjects in Abstraction*, Yale University Press, New Haven (CT), 1989.

Clark, Timothy J., *Farewell to an Idea: Episodes from a History of Modernism*, Yale University Press, New Haven (CT), 1999.

Cohen-Solal, Annie, *Leo & His Circle: The Life of Leo Castelli*, Alfred A. Knopf, New York, 2010.

———, *Painting American: The Rise of American Artists, Paris 1867–New York 1948*, Alfred A. Knopf, New York, 2001.

———, "The Ultimate Challenge for Alfred H. Barr, Jr.: Transforming the Ecology of American Culture, 1924–1943," in Joan Marter (ed.), *Abstract Expressionism (The International Context)*, Rutgers University Press, New Brunswick (NJ), 2007.

Coppet, Laura de, and Jones, Alan, *The Art Dealers*, Cooper Square Press, New York, 2002.

Crane, Diana, *The Transformation of the Avant-Garde: The New York Art World, 1940–1985*, University of Chicago Press, Chicago, 1987.

Crow, Thomas, *The Rise of the Sixties: American and European Art in the Era of Dissent*, Yale University Press, New Haven (CT), 1996.

Crow, Thomas, and Philipps, Glenn (eds.), *Seeing Rothko*, with essays by David Antin, Dore Ashton, Thomas Crow, John Elderfield, Briony Fer, Charles Harrison, Miguel Lopez-Remiro, Sarah Rich, and Jeffrey Weiss, with an introduction by Glenn Phillips and a bibliography of Rothko's own writings, Getty Publications, Los Angeles (CA), 2005.

Davitt, Michael, *Within the Pale: The True Story of Antisemitic Persecutions in Russia*, Hearst and Blackett, London, 1903.

Dewey, John, *Art as Experience*, Penguin/A Perigee Book, New York, 2005.

Dobzynski, Charles, *Anthologie de la poésie yiddish, Le Miroir d'un peuple*, Gallimard, Paris, 2000.

Esielonis, Karyn, "The History of Rothko's *Harvard Murals*," in Marjorie B. Cohn (ed.), *Mark Rothko's Harvard Murals*, Center for Conservation and Technical Studies, Harvard University Art Museums, Cambridge (MA), 1988.

Ford, Charles Henri (ed.), *Parade of the Avant-Garde, 1940–1947*, Thunder's Mouth Press, New York, 1991.

Fried, Michael, *Art and Objecthood: Essays and Reviews*, University of Chicago Press, Chicago, 1998.

Friedman, B. H., *Gertrude Vanderbilt Whitney: A Biography*, Doubleday, New York, 1978.

Gay, Ruth, *Jews in America: A Short History*, Basic Books, New York, 1965.

Glimcher, Marc (ed.), *The Art of Mark Rothko: Into an Unknown World*, Clarkson N. Potter, New York, 1991.

Greenberg, Clement, *Collected Essays and Criticism*, vol. 1: *Perceptions and Judgments (1939–1944)*, John O'Brian (ed.), University of Chicago Press, Chicago and London, 1986.

——, *Collected Essays and Criticism*, vol. 2: *Arrogant Purpose (1945–1949)*, John O'Brian (ed.), University of Chicago Press, Chicago and London, 1986.

——, *Collected Essays and Criticism*, vol. 3: *Affirmations and Refusals (1950–1956)*, John O'Brian (ed.), University of Chicago Press, Chicago and London, 1993.

——, *Collected Essays and Criticism*, vol. 4: *Modernism with a Vengeance (1957–1969)*, John O'Brian (ed.), University of Chicago Press, Chicago and London, 1993.

Guggenheim, Peggy, *Confessions of an Art Addict*, André Deutsch, London, 1960.

——, *Out of This Century*, Dial Press, New York, 1946.

Guilbaut, Serge, *How New York Stole the Idea of Modern Art: Abstract Expressionism, Freedom and the Cold War*, trans. Arthur Goldhammer, University of Chicago Press, Chicago, 1983.

Hansel, Georges, "Esthétique et idolâtrie," in *Tradition et modernité dans la pensée juive*, Festival international de la culture juive, Paris, 1983.

Harris, Neil, *The Artist in American Society*, University of Chicago Press, Chicago, 1970.

Helfenstein, Josef, and Schipsi, Laureen (eds.), *Art and Activism: Projects of John and Dominique de Menil*, The Menil Collection, Yale University Press, New Haven (CT), 2010.

Hindry, Ann, *Claude Berri rencontre Leo Castelli*, Renn Productions, Paris, 1990.

Hiromoto, Nobuyuki, *Mark Rothko*, Kodansha, Tokyo, 1993.

Hofstadter, Richard, *Anti-Intellectualism in American Life*, Alfred A. Knopf/Vintage Books, New York, 1963.

Howe, Irving, *World of Our Fathers: The Journey of the East Euro-*

pean Jews to America and the Life They Found and Made, Simon & Schuster, New York, 1976.

Hughes, Robert, *American Visions: The Epic History of Art in America*, Alfred A. Knopf, New York, 1997.

Janis, Sidney, *Abstract and Surrealist Art in America*, Reynal & Hitchcock, New York, 1944.

Karp, Ivan, Kreamer, Mullen, and Lavine, Steven D. (eds.), *Museums and Communities: The Politics of Public Culture*, Smithsonian Institution Press, Washington, DC, 1991.

Kedourie, Élie (dir.), *Le Monde du judaïsme, Histoire et civilisation du peuple juif*, trans. A. Fillon and M. Buysse, Thames & Hudson, Paris, 2003 (orig. ed. 1979).

Kuh, Katharine, *My Love Affair with Modern Art*, Arcade Publishing, New York, 2006.

Lacorne, Denis, *De la religion en Amérique: Essai d'histoire politique*, Gallimard, Paris, 2007.

Lambert, Phyllis, *Building Seagram*, Yale University Press, New Haven (CT), 2013.

Leuchtenburg, William E., *The FDR Years: On Roosevelt and His Legacy*, Columbia University Press, New York, 1995.

Lévi-Strauss, Claude, *De près et de loin*, Odile Jacob, Paris, 1988.

————, *Le Regard éloigné*, Plon, Paris, 1983.

Logan, John, *Red*, Dramatists Play Service Inc., New York, 2011.

Lowenstein, Steven, *The Jews of Oregon, 1850–1950*, Jewish Historical Society of Oregon, Portland (OR), 1987.

Mancusi-Ungaro, Carol, "Embracing the Humility in the Shadow of the Artist," in Mark Leonard (ed.), *Personal Viewpoints: Thoughts about Painting Conservation*, The Getty Conservation Institute, Los Angeles (CA), 2001.

Marienstras, Élise, *Les Mythes fondateurs de la nation américaine*, François Maspero, Paris, 1976.

Martel, Frédéric, *De la culture en Amérique*, Gallimard, Paris, 2006.

McDarrah, Fred W., *The Artist's World in Pictures*, Dutton, New York, 1961.

Meltzer, Milton, *Taking Root: Jewish Immigrants in America*, Farrar, Straus & Giroux, New York, 1976.

Menil, Dominique de, *Builders and Humanists: The Renaissance Popes as Patrons of the Arts*, Art Department, University of St. Thomas, Houston (TX), 1966.

Model, Suzanne W., "Work and Family: Blacks and Immigrants from South and East Europe," in Virginia Yans-McLaughlin (ed.), *Immigration Reconsidered: History, Sociology and Politics*, Oxford University Press, New York, 1990.

Moulin, Raymonde, *L'Artiste, l'institution et le marché*, Flammarion, Paris, 1992.

Muhlmann, David, *Territoires de l'exil juif*, Desclée de Brouwer, Paris, 2012.

Myers, David D., *Resisting History, Historicism and Its Discontents in German-Jewish Thought*, Princeton University Press, Princeton (NJ), 2003.

Myers, Jerome, *Artist in Manhattan*, American Artists Group, New York, 1940.

Naifeh, Steven, and Smith, Gregory W., *Jackson Pollock: An American Saga*, Clarkson N. Potter, New York, 1989.

Nodelman, Sheldon, *The Rothko Chapel: Paintings, Origins, Structure, Meaning*, University of Texas Press, Austin (TX), 1997.

North, Percy, *Max Weber*, Gerald Peters Gallery, Santa Fe (NM), 2000.

O'Hara, Frank, *Art Chronicles, 1954–1966*, George Braziller, New York, 1975.

O'Neill, John P. (ed.), *Barnett Newman, Selected Writings and Interviews*, University of California Press, Berkeley (CA), 1992.

———, *Clyfford Still*, Metropolitan Museum of Art, New York, 1979.

Oren, Dan A., *Joining the Club: A History of Jews and Yale*, Yale University Press, New Haven (CT), 2000.

Pavia, Philip, *Club without Walls: Selections from the Journals of Philip Pavia*, Natalie Edgar (ed.), Midmarch Arts Press, New York, 2007.

Polcari, Stephen, *Abstract Expressionism and the Modern Experience*, Cambridge University Press, Cambridge (MA), 1991.

Prandin, Ivo, "Peggy Guggenheim," *Profili veneziani del Novecento*, Supernova, Venice, 1999.

Reitter, Paul, *On the Origins of Jewish Self-Hatred*, Princeton University Press, Princeton (NJ), 2012.

Ringel, Fred Julius, *America as Americans See It*, Harcourt, Brace and Company, New York, 1932.

Robertson, Bryan, *'45–99. A Personal View of British Painting and Sculpture*, Kettle's Yard Gallery, Cambridge, 1999.

Rosenberg, Harold, *Discovering the Present: Three Decades in Art, Culture, & Politics*, University of Chicago Press, Chicago, 1973.

———, *La Tradition du nouveau*, trans. Marchand, éditions de Minuit, Paris, 1998.

Rosenblum, Robert, "The Surrealist Years, 1944–1946," in *The Art of Mark Rothko: Into an Unknown World*, Mark Glimcher (ed.), Clarkson N. Potter, New York, 1991.

Roth, Joseph, *Le Poids de la grâce*, trans. P. Hofer-Bury, Calmann-Lévy, Paris, 1965 (orig. ed. 1930).

Rothko, Mark, *The Artist's Reality: Philosophies on Art*, Yale University Press, New Haven (CT), 2004.

———, *Writings on Art*, edited and annotated by Miguel Polez-Remiro, Yale University Press, New Haven (CT), 2006.

Rubenfeld, Florence, *Clement Greenberg: A Life*, Scribner, New York, 1997.

Rubenstein, Joshua, *Leon Trotsky: A Revolutionary's Life*, Yale University Press, New Haven and London, 2011.

Rylands, Philip, "Peggy Guggenheim," in Luca M. Barbero, *Spazialismo, Arte Astratta, Venezia 1950–1960*, Il Cardo, Vicenza, 1996.

———, "Peggy Guggenheim and *Art of This Century*," in Siobhan M. Conaty (ed.), *Art of This Century: The Women*, The Stony Brook Foundation-Guggenheim Museum, New York, 1997.

Sachs, Paul, *Tales of an Epoch* (unpublished), 1957–1958, Paul J. Sachs Papers, *Tales of an Epoch*, file 40, Harvard Art Museums Archives, Harvard University Press, Cambridge (MA).

Sandler, Irving, *A Sweeper-Up After Artists*, Thames and Hudson, London, 2003.

———, *The Triumph of American Painting: A History of Abstract Expressionism*, Harper and Row, New York, 1976.

Sandler, Irving, and Newman, Amy, *Defining Modern Art: Selected Writings by Alfred H. Barr, Jr.*, Harry N. Abrams, New York, 1986.

Sartre, Jean-Paul, "La fin de la guerre," *Situations, II*, Gallimard, Paris, 1948.

———, *Un théâtre de situations*, texts selected and presented by Michel Contat and Michel Rybalka, Idées, Gallimard, Paris, 1973.

Sawin, Martica, *Surrealism in Exile and the Beginning of the New York School*, MIT Press, Cambridge and London, 1995.

Schapiro, Meyer, *Modern Art: 19th & 20th Centuries*, George Braziller, New York, 1979.

Seldes, Lee, *The Legacy of Mark Rothko*, Holt, Rinehart and Winston of Canada, Toronto, 1978.

Slezkine, Yuri, *The Jewish Century*, Princeton University Press, Princeton (NJ), 2006.

Soussloff, Catherine M. (ed.), *Jewish Identity in Modern Art History*, University of California Press, Berkeley (CA), 1999.

Spender, Matthew, *From a High Place: A Life of Arshile Gorky*, Alfred A. Knopf, New York, 1999.

Stanislawski, Michael, *For Whom Do I Toil? Judah Leib Gordon and the Crisis of Russian Jewry*, Oxford University Press, New York, 1988.

Steinberg, Leo, *Other Criteria: Confrontations with Twentieth-Century Art*, Oxford University Press, New York, 1972.

Stevens, Mark, and Swan, Annalyn, *De Kooning: An American Master*, Alfred A. Knopf, New York, 2005.

Vishniac, Roman, *Polish Jews: A Pictorial Record*, with an introduction by Abraham J. Heschel, Schocken Books, New York, 1987.

Wallock, Leonard, and Ashton, Dore, *New York: Cultural Capital of the World, 1940–1965*, first ed.: Rizzoli, New York, 1988.

Weber, Max, and Gruber, Carol Singer, *The Reminiscences of Max Weber*, Oral History Research Office, Columbia University, New York, 1958.

Wendt, Ingrid, and St. John, Primus (eds.), *From Here We Speak: An Anthology of Oregon Poetry*, Oregon State University Press, Corvallis (OR), 1964.

Zborowski, Mark, and Herzog, Elizabeth, *Life Is with People: The Culture of the Shtetl*, with an introduction by Margaret Mead, Schocken Books, New York, 1962.

Exhibition Catalogues

By author

Bartelik, Marek (ed.), *Mark Rothko: Paintings from the National Gallery of Art in Washington*, Exh. cat., National Museum in Warsaw, Warsaw, 2013. Texts by Harry Cooper, Lukasz Kiepuszewski, Catherine Dossin, Norman L. Kleeblatt, Alexander Nemerov, Christopher Rothko, Nicolas Grospierre.

Borchardt-Hume, Achim (ed.), *Rothko: The Late Series*, Tate Publishing, London, 2008. Texts by Briony Fer, David Anfam, Morgan Thomas, et al.

Castleman, Riva (ed.), *Art of the Forties*, with an essay by Guy Davenport, The Museum of Modern Art, New York, 1991.

Clearwater, Bonnie, *Mark Rothko: Works on Paper*, Exh. cat., American Federation of Art and The Mark Rothko Foundation, Hudson Hills Press, New York, 1984. Introduction by Dore Ashton.

Collins, Bradford R. (ed.), *Mark Rothko, The Decisive Decade, 1940–1950*, Columbia Museum of Art and Skira Rizzoli, New York, 2012. Texts by David Anfam, Harry Cooper, Ruth Fine, Todd Herman, Christopher Rothko.

Compton, Mark (ed.), *The Seagram Mural Project*, Exh. cat., Tate Gallery, Liverpool, 1959.

Geldzahler, Henry, *New York Painting and Sculpture: 1940–1970*, Dutton, New York, 1969.

Grele, Sophie (ed.), *Rothko*, Exh. cat., Musée d'art moderne de la ville de Paris, Paris, January 14–April 18, 1999. Texts by Suzanne Pagé, Jean-Louis Andral, Jean-Michel Foray.

Hobbs, Robert C., "*Mark Rothko*," in *Abstract Expressionism: The Formative Years*, Exh. cat., Herbert F. Johnson Museum of Art, Cornell University, Ithaca, 1978.

Kleeblatt, Norman L. (ed.), *Action/Abstraction: Pollock, de Kooning,*

and American Art: 1940–1976, Exh. cat., The Jewish Museum, New York/Yale University Press, New Haven (CT), 2008. Texts by Debra Bricker Balken, Morris Dickstein, Douglas Dreispoon, Charlotte Eyerman, Mark Godfrey, Caroline A. Jones, Irving Sandler.

Newman, Barnett, "Foreword," in *American Modern Artists*, Exh. cat., Riverside Museum, New York, January 17–February 27, 1943.

Omer, Mordechai, and Rothko, Christopher (eds.), *Mark Rothko*, Tel Aviv Museum of Art, Tel Aviv, 2007.

Robertson, Bryan, "Introduction," in *'45–99: A Personal View of British Painting and Sculpture*, Exh. cat., Kettle's Yard Gallery, Cambridge, 1999.

Rose, Bernice, *Bonnard/Rothko: Colour and Light*, Exh. cat., Pace Wildenstein, New York, 2004.

Sandler, Irving, *Mark Rothko: Paintings, 1948–1969*, Exh. cat., Pace Gallery, New York, 1983.

S[chanker], L[ouis], *The Ten: Whitney Dissenters*, Exh. cat., Mercury Galleries, New York, 1938.

Selz, Peter, *Mark Rothko*, Exh. cat., MoMA, 1961. Texts by Peter Selz and Robert Goldwater.

Soby, James Thrall, "Foreword," in *Artists in Exile*, Exh. cat., Pierre Matisse Gallery, New York, March 3–29, 1942.

Steinberg, Leo, "Introduction" in *The New York School: Second Generation. Paintings by Twenty-Three Artists*, Exh. cat., Jewish Museum of the Jewish Theological Seminary of America, New York, March 10–April 28, 1957, 4–8.

Wick, Oliver (ed.), *Mark Rothko*, Exh. cat., Palazzo delle Esposizioni, Rome, October 6, 2007–January 6, 2008. Contributions by Michelangelo Antonioni, Gillo Dorfles, Christopher Rothko.

By title

Black Paintings, Exh. cat., Haus der Kunst, Munich, 2006.

Clyfford Still, Exh. cat., Hirshhorn Museum and Sculpture Garden, Smithsonian Institution, Washington, DC, in associa-

tion with Yale University Press, New Haven (CT), 2001. With texts by David Anfam, Neal Benezra, Brooks Adams, James T. Demetrion.

In the Tower: Mark Rothko, Exh. brochure., National Gallery of Art, Washington, DC, 2010. Text by Harry Cooper.

La Rime et la raison, les collections Ménil (Houston, New York), Exh. cat., Ministère de la Culture—Réunion des Musées nationaux, Paris, 1984. Texts by Hubert Landais, Dominique de Menil, Walter Hopps, Bertrand Davezac, Jean-Yves Mock.

Mark Rothko, National Gallery of Art, Washington DC, 1998. Texts by Jeffrey Weiss, John Gage, Barbara Novak, Brian O'Doherty, Carol Mancusi-Ungaro, Jessica Stewart, Mark Rosenthal.

Mark Rothko, Tel Aviv Museum of Art, Tel Aviv, 2007. Texts by Christopher Rothko, Ester Dotan, John Gage, et al.

Mark Rothko: Into an Unknown World 1949–1969, Garage Centre for Contemporary Culture, Moscow, 2010. Texts by Andrei Tolstoy and Irving Sandler.

Mark Rothko: 1903–1970, Exh. cat., Tate Gallery, London, 1987. Texts by Bonnie Clearwater, Michael Compton, Dana Cranmer, Robert Goldwater, Robert Rosenblum, Irving Sandler, David Sylvester.

Mark Rothko: The 1958–9 Murals, Pace Gallery, New York, October 28–November 25, 1978. Interview by Arne Glimcher with Dan Rice.

Mark Rothko: Uit De Collectie de National Gallery of Art, Washington, Exh. cat., Gemeentemuseum den Haag, The Hague, 2014. Texts by Benno Tempel, Earl A. Powell, Franz-W. Kaiser, Harry Cooper, Joost Zwagerman.

Newman, Rothko, Still: Search for the Sublime, C&M Arts, New York, 1994. Text by Irving Sandler.

On the Sublime: Mark Rothko, Yves Klein, James Turrell, Guggenheim Publications, 2001. Texts by Tracey R. Bashkoff et al.

Rothko/Giotto, Exh. cat., Gemäldegalerie, Berlin/Himer Verlag, Munich, 2009. Texts by Gerhard Wolf, Stefan Weppelmann, Karin Gludovatz, Regina Deckers, Katharina Christa Schüppel, Manuela de Giorgi, Pia Gottschaller.

Rothko/Sugimoto: Dark Paintings and Seascapes, Pace Gallery, London, 2012. Text by Richard Shiff.

Shaping a Generation: The Art and Artists of Betty Parsons, Exh. cat., Heckscher Museum of Art, Huntington, New York, 1999. Texts by Betty Parsons and Anne Cohen de Pietro.

The Eye of Duncan Phillips: From Renoir to Rothko, Exh. cat., Yale University Press, New Haven, 1999.

The Intersubjectives, Kootz Gallery, New York, September 14–October 3, 1949.

The Rothko Book, Tate London, 2007. Texts by Bonnie Clearwater and Mary Bustin.

Journal Articles

Baigell, Matthew, "Clement Greenberg, Harold Rosenberg and Their Jewish Issues," *Prospects: An Annual of American Cultural Studies*, 30 (2005): 651–64.

Bystryn, Marcia, "Art Galleries as Gatekeepers: The Case of Abstract Impressionists," *Social Research: An International Quarterly*, 45, no. 2 (Summer 1978).

Gibson, Ann, and Polcari, Stephen (eds.), Special Issue: "New Myths for Old: Redefining Abstract Expressionism," *Art Journal*, 47, no. 3 (Autumn 1988).

Menil, Dominique de, "The Rothko Chapel," *Art Journal* (College Art Association), vol. 30, no. 3 (Spring 1971).

Pipes, Richard, "Catherine II and the Jews: The Origins of the Pale of Settlement," *Soviet Jewish Affairs*, 5, no. 2 (1975).

Promey, Sally M., "The 'Return' of Religion in the Scholarship of American Art," *The Art Bulletin* (College Art Association), vol. 85, no. 3 (September 2003).

Robson Deirdre, "The Market for Abstract Expressionism: Time Lag between Critical and Commercial Acceptance," *Archives of American Art Journal*, 25, no. 3 (1985).

Rowland, Richard H., "Geographical Patterns of the Jewish Population in the Pale of Settlement of Late Nineteenth Century Russia," *Jewish Social Studies*, vol. 48, nos. 3–4 (Summer–Autumn 1986), 207–34, Indiana University Press, Bloomington (IN).

Schapiro, Meyer, "The Nature of Abstract Art," *Marxist Quarterly*, vol. 1 (January–March 1937).

Newspaper and Magazine Articles

Anonymous, *Evening Standard* (London), October 11, 1961.

Ashton, Dore, "Art: Lecture by Rothko, Painter Disassociates Himself from the 'Abstract Expressionist' Movement," *New York Times*, October 31, 1958.

Barr, Alfred H., Jr., "Dutch Letter," *The Arts*, January 1928.

Bowness, Alan, "Shorter Notices—The 1958 Biennale," *Burlington Magazine*, vol. 100, no. 669 (December 1958).

———, *The Observer* (London), October 15, 1961.

Brooks, John, "Why Fight It? Profiles: Sidney Janis," *New Yorker*, November 12, 1960.

Browne, Lewis, "The Jew Is Not a Slacker," *North American Review*, 207 (June 1918).

Canaday, John, "Is Less More, and When for Whom?," *New York Times*, January 22, 1961.

Crehan, Hubert, "Rothko's Wall of Light: A Show of His New Work at Chicago," *Art Digest*, November 1, 1954.

"Cubists Migrate: Thousands Mourn," *New York Sun*, March 16, 1913.

Devree, Howard, "Aims and Results: Extreme Abstraction in Color Reaches Dead End," *New York Times*, April 17, 1955.

———, "Diverse Americans, Fifteen in Museum of Modern Art Show—New Work by Nordfeldt and Laurent," *New York Times*, April 13, 1952.

———, "Diverse New Shows," *New York Times*, March 9, 1947.

———, "Diverse New Shows," *New York Times*, April 3, 1949.

———, "In New Directions," *New York Times*, January 8, 1950.

Dorfles, Gillo, "Marks and Gestures at the XXIX Biennale," *Aut-Aut*, no. 47, September 1958.

"$4.5 Million Restaurant to Open Here," *New York Times*, July 16, 1959.

Fried, Michael, "New York Letter," *Art International*, May 25, 1963.

Friedman, B. H., "The Most Expensive Restaurant Ever Built," *Evergreen Review*, no. 10, 1959.

Genauer, Emily, *Herald Tribune*, April 17, 1955.

———, *Herald Tribune*, January 21, 1961.

Glueck, Grace, "Art: Rothko as Surrealist in His Pre-Abstract Years," *New York Times*, May 1, 1981.

———, "The Man the Art World Loves to Hate," *New York Times*, June 15, 1975.

Goldwater, Robert, "Reflections on the Rothko Exhibition," *Arts*, March 1961.

Goodnough, Robert, "Two Postscripts," *Artforum*, September 1965.

Gottlieb, Adolph, *Nation*, December 6, 1947.

———, "Jackson Pollock: An Artists Symposium, Part 1," *Art News*, April 1967.

Greenberg, Clement, "Decline of Cubism," *Partisan Review*, no. 3 (1948).

———, "The New York Market for American Art," *Nation*, June 11, 1949.

———, "The Present Prospects of American Painting and Sculpture," *Horizon*, October 1947.

———, "Review of the Exhibition 'A Problem for Critics,'" *Nation*, June 9, 1945.

———, "Reviews of Exhibitions of Hedda Sterne and Adolph Gottlieb," *Nation*, December 6, 1947.

———, "The Situation at the Moment," *Partisan Review*, January 1948.

Heron, Patrick, "The Americans at the Tate Gallery," *Arts Magazine*, vol. 30, no. 6 (March 1956).

Hess, Thomas B., "Seeing the Young New Yorkers," *Art News*, May 1950.

———, "U.S. Painting: Some Recent Directions," *Art News*, December 1955.

Jewell, Edward Alden, *New York Times*, February 17, 1943.

———, "Academe Remains Academe," *New York Times*, May 20, 1945.

———, "Art: Diverse Shows," *New York Times*, January 14, 1945.

———, "Art: Hither and Yon," *New York Times*, April 29, 1946.

———, "Art: Some Moderns," *New York Times*, December 10, 1944.

———, "Modern Artists to Open Annual," *New York Times*, September 12, 1945.

"Jewish Massacre Denounced," *New York Times*, April 28, 1903.

Judd, Donald. "Mark Rothko," *Arts Magazine*, September 1963.

Kozloff, Max, "Mark Rothko's New Retrospective," *Art Journal*, vol. 20, no. 3 (Spring 1961).

Kuh, Katharine, "Mark Rothko," *Art Institute of Chicago Quarterly*, vol. 48, no. 4 (November 15, 1954).

Lamster, Mark, "A Personal Stamp on the Skyline," *New York Times*, April 13, 2013.

Laverne, George, *Art Digest*, May 1, 1955.

Muschamp, Herbert, "Best Building; Opposites Attract," *New York Times*, April 18, 1999.

Newton, Eric, *Manchester Guardian* (Manchester), October 14, 1961.

Ortega y Gasset, José, "In Search of Goethe from Within," *Partisan Review*, XVI (August 1949).

Polcari, Stephen, "Abstract Expressionism and the Modern Experience," Cambridge University Press, 1991.

———, "The Intellectual Roots of Abstract Expressionism: Mark Rothko," *Arts Magazine*, 54 (September 1979).

Preston, Stuart, "Chiefly Abstract," *New York Times*, April 8, 1951.

———, "Reviews and Previews," *Art News*, March 1958.

———, "Vanguard Advances: New Directions Taken in Recent Shows," *New York Times*, February 2, 1958.

Robertson, Bryan, "The Leading Impresario of the Renaissance of British Art," *Times* (London), November 19, 2002.

———, "Mark Rothko," *Spectator*, March 6, 1970.

Rosenberg, Harold, "The American Action Painters," *Art News*, vol. 51, no. 8 (December 1952).

———, "Is There a Jewish Art?," *Commentary*, July 1966 (lecture), The Jewish Museum, New York.

Rosenblum, Robert, "The Abstract Sublime," *Art News*, February 1961.

Rothkowitz, Marcus, "A Year's Perspective," *The Neighborhood, Official Organ of the Neighborhood House*, vol. 2, no. 1 (June 1920).

Rothkowitz, Markus, *Yale Saturday Evening Pest*, March 17, 1923.

Sandler, Irving, "The Club, How the Artists of the New York School Found Their First Audience—Themselves," *Artforum*, 4 (September 1965).

Seiberling, Dorothy, "Jackson Pollock: Is He the Greatest Living Painter in the United States?," *Life Magazine*, August 8, 1949.

Solman, Joseph, *Villager*, October 3–9, 2007.

Station, Elizabeth, "Life Embraces Art: A New Biography Chronicles the Remarkable Career of Peter Selz and His Contributions to Modern Art History," *Tableau*, October 18, 2012.

"The Ten Are Staging Their First Group Show," *New York Post*, December 21, 1935.

Tomkins, Calvin, "The Benefactor," *New Yorker*, June 8, 1998.

———, "Profiles: Forms under Light," *New Yorker*, May 23, 1977.

"Willem de Kooning Remembers Mark Rothko: 'His House Had Many Mansions,'" *Art News*, January 1979.

Archives

Archives of American Art, Smithsonian Institution: Mark Rothko's correspondence, interviews with Philip Pavia (1965), Robert Motherwell (1971), Elaine de Kooning (1981), Jack Kufeld (1981), Dorothy C. Miller (1981), Sidney Janis (1981), Stanley Kunitz (1983), Ludwig Sander (1969), Joseph Solman (1981), Bernard Braddon and Sidney Paul Schectman (1981), Katharine Kuh (no date available), Ernest Briggs (1982), Mark Rothko (1955).

Menil Archives, The Menil Collection, Houston, Texas: interview with Robert Motherwell (1980), Roy Edwards's manuscript: *Mark Rothko, A Personal Reflection*.

National Gallery of Art, Washington, DC.

Archives of the Oregon Jewish Museum, Neighborhood House Collection ORG 10.

Whitechapel Gallery Archive: Rothko Audio Track Listing, *Interviews for Rothko in Britain*. Organized by Nayia Yiakoumaki, Curator, Archive Gallery. These include:

Paul Feiler, taped on July 15, 2011, in Kerris, Cornwall, where Paul Feiler had met Mark Rothko in 1959. Duration: 9' 44."

Sheila Lanyon, taped on July 15, 2011, in Newlyn, Cornwall, who welcomed Mark, Mell, and Kate Rothko in St. Ives during August 1959. Duration: 3' 31."

John Hoyland, taped on July 22, 2011, in London. The painter visited Mark Rothko's exhibition in 1961, before meeting the artist in New York later. Duration: 12' 18."

Patrick Heron, interviewed by Mel Gooding, Eagle's Nest, 1996. Some of Patrick Heron's comments are parts of the interview he did for "National Life Stories: Artists' Lives" in 1996. For more information on "Artists' Lives" consult: http://www.bl.uk/nls/artists as well as the British Library Sound Archive catalogue http://cadensa.bl.uk, reference catalogue C466. The estate of Patrick Heron and National Life Stories at the British Library. Duration: 26' 05."

Websites

http://www.aaa.si.edu/collections/interviews/oral-history-interview-robert-motherwell-13286 (interview transcript, Archives of American Art)

http://www.aaa.si.edu/collections/oralhistories/transcripts/briggs82.htm (interview transcript, Archives of American Art)

http://www.aaa.si.edu/collections/oralhistories/transcripts/Kufeld81.htm (interview transcript, Archives of American Art)

http://www.moma.org/docs/press_archives/1310/releases/MOMA_1949_0024_1949-04-01_490401-22.pdf?2010

http://www.moma.org/docs/press_archives/1311/releases/MOMA_1949_0025_1949-04-05_490405—23.pdf?2010

http://www.neiu.edu/~wbsieger/Art201/201Read/201-Rothko.pdf (text from New York City broadcast on radio station WNYC, "The Portrait and the Modern Artist," *Art in New York*, dir. H. Stix, October 13, 1943)

http://www.phillipscollection.org/research/american_art/miscel
laneous/rothko-unit.htm

http://www.portlandart.net/archives/2009/06/rothkos_portland
.htm (anonymous article, "Rothko's Portland")

http://www.rothkochapel.org

http://www.tate.org.uk/whats-on/exhibition/rothko/room

http://www.tate.org.uk/whats-on/exhibition/rothko/room
-guide/room-2-four-darks-red-1958

https://www.youtube.com/watch?v=ev8kgi6T_ Es (video, Kate
Rothko, "About My Father, Mark," 2008)

ACKNOWLEDGMENTS

MARK ROTHKO is the last part of my research on U.S. artists, which I conducted as a social history and which took the form of a trilogy. In *Painting American: The Rise of American Artists, Paris 1867–New York 1948*, I decided to adopt a broad historical time frame and analyze, in a cross-cultural perspective, the importance of collectors, critics, and museum directors after the end of the Civil War; it appeared that with the emergence of urban centers, the creation of a new social class, and the ritual travel of painters to Paris, the status of the U.S. artist slowly started to evolve. In *Leo & His Circle: The Life of Leo Castelli*, I concentrated on the most emblematic gallerist of the second half of the twentieth century. I analyzed his mastery in empowering the U.S. artist both at home and abroad, and the different strategies he conceived: creating a genealogy for American art, forging new links between market and museum, inventing new marketing strategies, launching a network of satellite galleries around the world.

But how could I have come to work on Mark Rothko if David

Rieff had not brought the interesting Jewish Lives Series to my attention? Following up on David's suggestion, Georges and Valerie Borchardt, my agents in New York, organized the link with Yale University Press, suggesting that I take up a project on the artist Mark Rothko as the natural culmination of the previous books on collectors and dealers. At Yale University Press, the confidence shown by Ileene Smith, the documentation provided by John Palmer and Erica Hanson, and Jeffrey Schier's editing talent played a decisive role, while Linda Kurz, Victoria Meyer, and Anne Bihan brought to the project their enthusiasm and competence. I had become acquainted with Rothko's art during my years at the French embassy in the United States, viewing it in public and private collections around the country and especially in Houston, where I had the privilege of meeting often with Dominique de Menil, who introduced me to the Rothko Chapel and explained her underlying vision in great detail.

When I began my research, it was Christophe de Menil—John and Dominique's oldest daughter—who gave me access to family archives in Houston. I received the best possible help from Geraldine Aramanda, Michelle Ashton, and Suna Umari (respectively, archivist at the Menil Collection and program director and historian at the Rothko Chapel in Houston), as well as from Henry Mandell (Project Manager for The Estate of Mark Rothko in New York) and Laili Nasr (at the National Gallery, Washington, D.C.). Contacts with the Rothko family were crucial: my gratitude goes to all of them, including Debby Rabin, who, from Portland, sent me very interesting letters and documents. Finally, Jean-Louis Andral—he had curated the memorable Rothko exhibition at the Musée d'art moderne de la ville de Paris in 1999—agreed to lend his expertise and reread the French text.

Jean-Michel Bloch, Paul Gradvohl, Jacqueline Frydman, and Marco Pacioni helped me decipher the context and outcomes of Marcus Rotkovitz's years as a Talmudic student in Dvinsk. Answers to my questions concerning the specific culture of Portland, Oregon, were provided by Dick and Barbara Lane, as well as by Otto and Micheline Fried; and Anne LeVant Prahl, curator of col-

lections at the Oregon Jewish Museum, sent me new and fascinating material. Concerning Rothko's years at Yale, Una Bergmane generously unearthed articles from the *Yale Saturday Evening Pest* for me. As for Rothko's relationship to Great Britain, James Mayor astutely alerted me to the St. Ives Society of Artists and shared his memories of the figure of Bryan Robertson. At the Whitechapel Gallery, Nayia Yiakoumaki and Gary Haines provided me with access to some fascinating correspondence as well as to the interviews of Rothko's British "disciples." Finally, Sir Nicholas Serota, director of the Tate Gallery, suggested that I contact Suzanna Heron, who very graciously offered me access to her personal archives. In Latvia, the first supporters of the project were the French ambassadors Michel Foucher and Stéphane Visconti, as well as the cultural counselor Denis Duclos and his team in Riga. In Daugavpils, I had a chance to speak at length with Farida Zaletilo, curator at the Mark Rothko Art Center, and to interview Iossif Rochko, president of the Jewish community. In Riga, finally, I was introduced to the huge complexity of the Latvian Jews thanks to a magical encounter with various personalities who became friends: Karina Pētersone, Inna Steinbucka, and Maris Gaitlis, as well as Leon Gondelman. Their information was supplemented in Paris by Michael Prazan's work.

The whole team at Actes Sud—Françoise Nyssen, Jean-Paul Capitani, Anne-Sylvie Bameule, Marie-Amélie Le Roy, Aïté Bresson, and Sophie Patey—understood my intentions and supported the considerable work involved with the illustrations, photos, and maps, while Catherine Lapautre took over with talent and skill at the Borchardt Agency. My assistants—successively: Madeleine Roger-Lacan, Masha Shpolberg, Madeleine Compagnon, Jeanne Devautour, and Sabrina Tarasoff—contributed to this book with enthusiasm, curiosity, and passion, each linking the history of Rothko to her own history, her own research. For their help with the English text I am grateful to Donald Pistolesi, Stephanie Dissette, and Fabrice Robinet.

My friends Marc Blondeau, Marc Perrin de Brichambaut, and Monique Tuffelli believed in this book and gave their indispens-

able material support at a difficult time; Antoine de Tarlé and Frédéric du Laurens commented on the draft manuscript, often under challenging circumstances. But this project could not have been completed without Marc Mézard's numerous insights and comments; his input has so permeated certain passages that I cannot even discern which ideas are his and which are mine. To all, I want to express gratitude and affection.

June 2011–November 2014
New York, Paris, Cortona

INDEX

"Pl." followed by a number refers to a work in the color plate section. Page numbers in italic refer to photographs or maps.

Mural (Pollock, 1943), 84
Muschamp, Herbert, 157
Musée d'Art Moderne de la Ville de
 Paris, 150
Museum for Non-Objective Painting,
 66. *See also* Guggenheim Museum
Museum of Modern Art (MoMA):
 *Americans 1942: 18 Artists from 9
 States* exhibition, 79; *Artists for
 Victory* exhibition, 79; *Cubism
 and Abstract Art* exhibition, 59;
 Education Department, 139; *Eleven
 Europeans in America* exhibition
 (1946), 82; European art acquired
 around 1949, 109–10; *Fantastic Art,
 Dada, Surrealism* exhibition, 59;
 Fifteen Americans exhibition (1952),
 132–35; influence on Rothko, 59–60;
 Janis and, 146; Matisse's *The Red
 Studio* acquired, 108–9; and *The
 New American Painting and Sculpture*
 traveling exhibition, 151, 198; *New
 Images of Man* (1959 exhibition), 175;
 policy re European vs. American
 art, 92, 134; Pollock retrospective,
 150; Rothko comprehensive exhibi-
 tion (1961), 174–78, 179–81; Rothko
 Room proposed, 197; Rothko's feel-
 ings about, 108
Museum of Non-Objective Art (New
 York), 60
Myers, Jerome, 55
myth, and Rothko's work, 76–78,
 85–86, 89, 92–94, 104, 174–75

N. & S. Weinstein, 24, 29
Naimark, Max, 22, 23, 38, 42, 44
National Council of Jewish Women,
 23, 24, 25–26
Neighborhood (publication), 31–34
Neighborhood House (Portland), 23,
 25, 31, 34. See also *Neighborhood*
*New American Painting and Sculpture,
 The: The First Generation* (exhibi-
 tion), 151, 163, 168, 198
New Images of Man (MoMA exhibition,
 1959), 175

Newman, Annalee, 97
Newman, Barnett: art of, 106; art stud-
 ies, 49, 58; and the Betty Parsons
 Gallery shows, 103; and the Club,
 129; on coming together as Ameri-
 can modern artists, 86; on expres-
 sionism, surrealism, and subjective
 abstraction, 95–96; on the future
 of American art, 79; Greenberg on,
 106; inactive period, 79–80, 95; and
 the Irascibles, *124*, 122–23, 126; on
 isolationist painting, 79, 88–89; on
 making cathedrals out of ourselves,
 99; and the Ninth Street Show,
 130; Rothko's conflict with, 152–53,
 232–33(n42); Rothko's friendship
 with, 97, 135; Rothko's letters to, 117,
 125, 127; and the Subjects of the Art-
 ists School, 113
New Realists, The (Janis Gallery exhibi-
 tion, 1962) 182–83
New School of Design, 48
newspaper boys, 34–35
New York City: European influ-
 ence on art scene in, 54, 55, 58,
 80–82, 98, 109; New York World's
 Fair (1939–40), 70; redesigned,
 156; Rothko's early years in New
 York's art world, 48–49, 52–54; San
 Francisco contrasted with, 107–8;
 Seagram Building & Four Seasons
 restaurant, *154–58* (*see also* Seagram
 murals); Seuphor on the New York
 art scene, 120; transformation into
 capital of modernism, 54, 55–56,
 58–60, 80–82, 127 (*see also* Ten, The);
 "uptown" vs. "downtown" artists,
 114–15, 128–31. *See also specific muse-
 ums, galleries, individuals, and groups*
*New York Painting and Sculpture:
 1940–1970* (exhibition at The Met-
 ropolitan Museum of Art), 198
New York Post, 62
New York Sun, 64
New York Times: on the anti-Jewish
 riots in Kishinev, 3–4; on the
 Armory Show (1913), 54; on the

ABOUT THE AUTHOR

Annie Cohen-Solal, who was born in Algeria, studied in Paris and received her Ph.D. degree from the Sorbonne. She has held academic positions at these institutions: Freie Universität Berlin, Hebrew University of Jerusalem, New York University, École des hautes études en sciences sociales, and École normale supérieure in Paris, and she has been a professor at the University of Caen. After the publication of *Paul Nizan, communiste impossible* (Grasset, 1980), she was commissioned by André Schiffrin to write the first biography of Jean-Paul Sartre. *Sartre: A Life* (Pantheon Books, 1987) has been translated into more than a dozen languages and occasioned a four-year book tour. In 1989 she became *conseiller culturel* to the French embassy in the United States, in residence in New York, where an introduction to Leo Castelli prompted her to shift her interest to the art world. After winning the Académie des Beaux-Arts's Prix Bernier for her book *Painting American: The Rise of American Artists, Paris 1867–New York 1948* (Alfred A. Knopf, 2001), she received the 2010 ArtCurial contem-

porary Art Book Prize for *Leo & His Circle: The Life of Leo Castelli* (Alfred A. Knopf, 2010); both books were widely translated. In 2014, she was appointed *conseiller spécial* and *commissaire générale* of *Magiciens de la terre 2014* by Alain Seban, President of the Centre Pompidou in Paris. Beginning in April 2015, following the suggestion of Margaret Levi—director of the Center for Advanced Study in the Behavioral Sciences, Stanford University—Cohen-Solal, together with Jeremy Adelman, will lead a five-year interdisciplinary research group on the theme "Crossing boundaries." Her most recent books include: *Une renaissance sartrienne* (Gallimard, 2013); *New York 1945–1965*, with Paul Goldberger and Robert Gottlieb (Vendome Press, 2014); and *Magiciens de la terre, une exposition légendaire*, with Jean-Hubert Martin (Xavier Barral et éditions du Centre Pompidou, 2014). She currently resides in Paris and in Cortona, Italy.